手机慢门摄影与后期从入门到精通

夜景、人像、车轨、烟花、星空、光绘、丝绢流水、延时视频全攻略

龙飞 编著

清华大学出版社
北京

内 容 简 介

本书由华为摄影课程讲师、"手机摄影构图大全"公众号创始人编写,内容根据26万学员喜欢的慢门摄影技巧,从3条线出发,帮助读者快速成为手机慢门摄影与后期高手。

一条是拍摄技术线,详细介绍手机慢门摄影的功能和参数,包括曝光、白平衡、长曝光、对焦、测光、背景虚化、构图取景等内容。

一条是后期处理线,详细介绍使用 Snapseed 和 MIX 处理慢门效果的方法,以及使用剪映 App 剪辑延时视频等内容,帮助大家快速掌握手机的后期慢门技术。

一条是经典案例线,详细介绍8大慢门专题的拍摄技巧,包括夜景、人像、车轨、烟花、星空、光绘、丝绢流水和延时视频,帮助读者步步精通手机慢门摄影。

本书适合摄影爱好者和有一定经验的摄影师,尤其是喜欢慢门、延时、夜景摄影的用户阅读,无论是手机摄影读者,还是单反摄影读者,都可以通过本书提升自己的摄影能力。

本书封面贴有清华大学出版社防伪标签,无标签者不得销售。

版权所有,侵权必究。举报:010-62782989,beiqinquan@tup.tsinghua.edu.cn。

图书在版编目 (CIP) 数据

手机慢门摄影与后期从入门到精通:夜景、人像、车轨、烟花、星空、光绘、丝绢流水、延时视频全攻略 / 龙飞编著. —北京:清华大学出版社,2021.6(2023.10重印)
 ISBN 978-7-302-58174-1

Ⅰ. ①手… Ⅱ. ①龙… Ⅲ. ①移动电话机—摄影技术 ②视频编辑软件 Ⅳ. ① J41 ② TN929.53 ③ TN94

中国版本图书馆 CIP 数据核字 (2021) 第 098809 号

责任编辑:李 磊
封面设计:王 晨
版式设计:孔祥峰
责任校对:马遥遥
责任印制:沈 露

出版发行:清华大学出版社
 网 址:http://www.tup.com.cn, http://www.wqbook.com
 地 址:北京清华大学学研大厦A座 邮 编:100084
 社 总 机:010-83470000 邮 购:010-62786544
 投稿与读者服务:010-62776969, c-service@tup.tsinghua.edu.cn
 质 量 反 馈:010-62772015, zhiliang@tup.tsinghua.edu.cn
印 装 者:小森印刷霸州有限公司
经 销:全国新华书店
开 本:170mm×240mm 印 张:15.75 字 数:336千字
版 次:2021年8月第1版 印 次:2023年10月第 2 次印刷
定 价:128.00元

产品编号:090581-02

序言｜不是辛苦，而是幸福

慢门摄影，是每一个深度爱好摄影者的一道必须要跨越的门槛。

与深度爱好者不同，浅度爱好者无论拍什么对象，都是用摄影的默认模式来拍。

根据笔者学习摄影十多年的经历，慢门摄影对于手机摄影深度爱好者，借用诗人王国维《人间词话》的总结，有以下三种境界。

第一种境界：昨夜西风凋碧树，独上西楼，望尽天涯路。

第二种境界：为伊消得人憔悴，衣带渐宽终不悔。

第三种境界：众里寻他千百度，蓦然回首，那人却在灯火阑珊处。

对应学习慢门，有以下三个阶段。

第一个阶段：想学好慢门，但比较迷惘，总是一个人钻研学习，但看不到尽头，不知道怎么学好，也不知道什么时候能够学好。

第二个阶段：静下心来，勤奋、刻苦，深入学习慢门的各项参数，如快门时长、感光度、光圈等。一项一项地试，然后三项参数组合多拍，试图找出它们之间的规律和关系。

第三个阶段：通过对快门、感光度、光圈成百上千次的实拍演练，渐渐不用再靠脑袋去想怎么拍，基本上可以信手拍来，这和练习五笔打字的人一样，开始要背诵口诀，到熟练后完全不记得口诀，但手在键盘上能自如地打出字来，这是因为产生了量变到质变的飞跃。回首总结，技能已熟烂于胸，尽在心中。

在此，笔者列举几段慢门学习经历，大家看看是否有熟悉的感觉，如果说慢门的精通以攀登 10 层楼来比喻，那么分别对应如下。

第一段经历：不再用手机的默认模式拍摄，开始尝试用手机独立的"夜景"模式、"大光圈"模式，来拍摄夜景的充足曝光效果，以及背景虚化效果。这在慢门摄影的第 2 楼。

第二段经历：更进一步，针对不同的对象，开始用专门的智能模式来拍，如拍车轨用"车水马龙"模式、拍流水用"丝绢流水"模式，以及还有"绚丽星轨"模式、"光绘涂鸦"模式等。这个阶段开始感受到慢门的魅力，感受到手机默认模式拍不出的效果。这到了慢门摄影的第 4 楼。

第三段经历：用"专业"模式来拍，自己尝试设置测光的模式、感光度数值、快门的时长、对焦的方式、白平衡的模式等。对于这些参数，既可以单独地摸熟、玩透，也可以组合起来应用自如。这到了慢门摄影的第 6 楼。

第四段经历：掌握了通用的慢门技术，开始对专项对象进行慢门练习，有意识地强化训练。如专门拿几个晚上练习拍摄车轨，对车轨的细节有更深的慢门拍摄感悟；再如拍摄流水，用不同的慢门拍出雾状、丝状，可以做到控制精准。这到了慢门摄影的第 8 楼。

第五段经历：慢门参数的应用已设置自如，专题对象的拍摄也得心应手，这个时候开始注重于构图、颜色、光影的综合考虑，并且从后期的角度考虑如何前期拍出佳片，以及后期再修出更加完美的慢门照片。这到了慢门摄影的第 9 楼。

第六段经历：前面 9 层楼的攀登，都是基于自身的提高和超越的目的，因为第 10 楼是最高的一层，自然需要站得更高、看得更远，这时就要跳出自身的局限，向更厉害的高手、大咖们学习，观摩他们的慢门作品，找出自己的差距，特别是他们用单反拍出的慢门级大片，自己如何用手机尽可能地去实现、达成，拍出他们单反级的效果，这便是第 10 楼的攀登之旅。

对于学习慢门摄影的新人来说，这一步几乎是可望而不可即的，他们看到别人拍得好的片子，最常见的一句话就是：这不可能是手机拍的，但是通过年复一年的努力、成千上万次的实战拍摄，以及精湛的后期技能，是可以达到的。

从 1 楼的楼底，抬头仰望第 10 楼的楼顶，这个高度其实就是我们的追求之旅、蜕变之旅，摄影对于大多数人来讲，都是兴趣爱好，因此这也是一场快乐之旅、成长之旅，以学习的心态，轻装上阵，这一路的经历就不再是辛苦，而是幸福。

如果在学习慢门摄影的过程中遇到有不懂的问题，欢迎交流，可以关注笔者的公众号"手机摄影构图大全"，或加微信 (2633228153) 交流。

感谢赵高翔、徐必文、黄建波、罗健飞、陆鑫东、余航 (鱼头 YUTOU)、王甜康等摄影师提供了部分素材。

本书附赠手机摄影、短视频、Vlog、抖音、剪映学习资源，请扫描下方的二维码，然后将内容推送到自己的邮箱中，即可下载获取相应的资源。

抖音案例拍摄教学视频 1

抖音案例拍摄教学视频 2

短视频拍摄与 Vlog 运镜技巧

剪映热门后期教学视频 1

剪映热门后期教学视频 2

手机摄影构图大师炼成术

编者

目 录
CONTENTS

第1章　手机慢门，快速入门　001

1.1 创作思路：了解慢门摄影的特点 002
- 1.1.1 思路1：慢门摄影让物体充满运动感 002
- 1.1.2 思路2：完整记录下物体的运动轨迹 003
- 1.1.3 思路3：拍出平常肉眼看不到的景物 004
- 1.1.4 思路4：用慢速度来拍摄出迷人景致 005
- 1.1.5 思路5：长曝光给观者带来更多惊喜 005

1.2 手机相机：了解拍照的基本功能 006
- 1.2.1 快门：长曝光拍摄的防抖技巧 006
- 1.2.2 对焦：拍出更清晰的画面主体 009
- 1.2.3 构图线：获得更加完美的比例 009

1.3 专业器材：慢门摄影的常用配件 010
- 1.3.1 三脚架：保持手机拍摄慢门的稳定性 010
- 1.3.2 八爪鱼：集妖性、弹性和灵性于一体 011
- 1.3.3 手持稳定器：防止画面抖动造成模糊 012
- 1.3.4 减光镜：将光线压暗实现长曝光 012
- 1.3.5 外接镜头：增强智能手机的拍摄性能 013

1.4 手机慢门：长时间曝光的3种方式 015
- 1.4.1 方式1：运用夜景模式进行长曝光拍摄 015
- 1.4.2 方式2：运用专业模式进行长曝光拍摄 016
- 1.4.3 方式3：运用慢门模式进行长曝光拍摄 017

第2章　快速出片，一键智能　019

2.1 华为手机：流光快门 020
- 2.1.1 车水马龙：拍摄夜晚城市的车灯运动轨迹 020
- 2.1.2 光绘涂鸦：拍摄光源移动轨迹、光绘效果 021
- 2.1.3 丝绢流水：可以把水流拍出丝般顺滑效果 022
- 2.1.4 绚丽星轨：拍摄银河或者星星的运行轨迹 023

2.2 苹果手机：实况模式 025
- 2.2.1 第1步：使用"实况"模式拍摄慢门 025
- 2.2.2 第2步：使用"长曝光"呈现慢门效果 025

2.3 努比亚手机：相机家族 — 027
- 2.3.1 光绘模式：留住精彩的光影瞬间 — 027
- 2.3.2 电子光圈：单反级大片成像效果 — 028
- 2.3.3 慢门模式：超长曝光的别样魅力 — 030
- 2.3.4 星轨模式：拍下灿烂的星河印记 — 032
- 2.3.5 运动轨迹：捕捉匆匆流逝的身影 — 034

第3章 专业参数，单反大片 — 035

3.1 设置要点：精准控制手机的曝光参数 — 036
- 3.1.1 了解专业模式 — 036
- 3.1.2 设置测光模式 — 036
- 3.1.3 设置光圈参数 — 038
- 3.1.4 设置快门速度 — 039
- 3.1.5 设置 ISO 参数 — 040
- 3.1.6 设置曝光补偿 — 041
- 3.1.7 设置焦距参数 — 042
- 3.1.8 设置饱和度参数 — 043
- 3.1.9 设置对比度参数 — 044
- 3.1.10 设置白平衡参数 — 045

3.2 长曝光拍摄：捕捉时间流逝的动态美 — 048
- 3.2.1 长时间曝光的作用 — 048
- 3.2.2 在手机中设置长曝光 — 048
- 3.2.3 原生相机追焦拍摄 — 050

第4章 慢门相机，轻松拍摄 — 051

4.1 Slow Shutter Cam：专门的慢门拍摄软件 — 052
- 4.1.1 动态模糊：适合拍摄高速运动的物体 — 053
- 4.1.2 灯光轨迹：适合拍摄光源移动的轨迹 — 054
- 4.1.3 低光模式：适合弱光下拍摄静态夜景 — 054

4.2 Camera FV-5：功能强大的慢门摄影 App — 055
- 4.2.1 快门设置：精准地控制曝光时间 — 056
- 4.2.2 自动定时器：更稳定的快门方式 — 058
- 4.2.3 慢门流程：体验手机拍摄的乐趣 — 058

4.3 其他慢门 App：手机即可轻松拍慢门 — 059
- 4.3.1 ProCam6：拍夜景、车轨、流水的利器 — 059
- 4.3.2 Night Cap 相机：iPhone 上的"慢门之王" — 060

4.3.3　Camera+：轻松实现手机慢门作品的拍摄 ··· 063

第5章　经典构图，增强美感　065

5.1　平面构图：拍出画面的"简洁之美" ·· 066
5.1.1　水平线构图，让照片立刻上档次 ·· 066
5.1.2　三分线构图，让画面效果更加美观 ·· 068
5.1.3　九宫格构图，赋予画面新的生命 ·· 070
5.1.4　斜线构图，使画面充满动感与活力 ·· 070
5.1.5　黄金分割构图，构图的经典定律 ·· 072

5.2　空间构图：拍出立体感十足的效果 ·· 073
5.2.1　透视构图，给画面带来强烈的纵深感 ·· 073
5.2.2　框式构图，透过"窗"看看外面的好风景 ·· 075
5.2.3　对称构图，打破常规，让照片更加出彩 ·· 075
5.2.4　倒影构图，得到别具一格的画面效果 ·· 076
5.2.5　明暗构图，增加纵深感，空间瞬间大了 ·· 078
5.2.6　几何形态构图，让作品更具形式美感 ·· 079

第6章　基础后期，完善画面　081

6.1　裁剪照片：进行二次构图 ·· 082
6.1.1　长宽比：裁剪成竖幅短视频尺寸 ·· 082
6.1.2　水平：校正照片中倾斜的水平线 ·· 084
6.1.3　旋转：快速 90°旋转照片的角度 ·· 086
6.1.4　透视：轻松校准画面的透视扭曲度 ·· 086
6.1.5　拉伸：恢复长宽比例错误的照片 ·· 087

6.2　创意后期：打造文艺风美照 ·· 089
6.2.1　网红色调：提升慢门作品格调 ·· 089
6.2.2　一键换天：轻松模拟慢门星空 ·· 092
6.2.3　色彩平衡：改变照片整体色调 ·· 093
6.2.4　添加纹理：释放无限后期创意 ·· 096
6.2.5　局部修整：制作小星球的特效 ·· 097
6.2.6　照片海报：制作文字边框效果 ·· 098

第7章　高阶后期，效果更美　100

7.1　常用工具：轻松调出视觉系大片 ·· 101
7.1.1　晕影工具：给照片添加暗角效果 ·· 101

7.1.2	调整图片：增加曝光度和对比度	103
7.1.3	镜头模糊：制作浅景深慢门美照	105
7.1.4	局部工具：精准控制局部的光影	107
7.1.5	突出细节：增加慢门作品清晰度	110

7.2 高级修图：让照片瞬间变得更精彩 112

7.2.1	玩转曲线：控制好照片的光线影调	112
7.2.2	画笔工具：选择性地精修照片局部	113
7.2.3	照片修复：去除照片中的多余杂物	115
7.2.4	魅力光晕：打造梦幻朦胧的画面感	116
7.2.5	双重曝光：轻松混合两张照片素材	118

第8章 夜景拍摄，注意要点　　123

8.1 前期准备：认真对待才不容易出纰漏 124

8.1.1	准备1：拍摄前的构思	124
8.1.2	准备2：选择拍摄地点	125
8.1.3	准备3：拍摄时的器材	126
8.1.4	准备4：选择拍摄时间	127

8.2 拍摄技巧：拍出清晰的慢门夜景照片 129

8.2.1	技巧1：拍摄前首先确定好构图方式	129
8.2.2	技巧2：用星光镜拍出星光璀璨画面	130
8.2.3	技巧3：用柔光镜拍出朦胧美感画面	132
8.2.4	技巧4：倾斜拍摄使画面更具深邃感	133
8.2.5	技巧5：拍摄多张照片进行堆栈合成	135

8.3 超级夜景：拍出令人惊艳的夜景大片 136

8.3.1	打开功能：开启超级夜景模式	136
8.3.2	选择前景：装饰画面增加层次	138
8.3.3	使用滤镜：让画面色彩更鲜艳	139

第9章 慢门人像，唯美梦幻　　140

9.1 慢门拍摄：拍出与众不同的人像 141

9.1.1	效果：利用慢门实现虚实结合	141
9.1.2	地点：选择人流量大的拍摄环境	141
9.1.3	时间：选择合适拍摄时机和机位	143
9.1.4	参数：设置较低的快门速度值	143
9.1.5	人物：注意模特主体固定不动	144

9.2 拍摄场景：慢门人像的拍摄题材 146

- 9.2.1 场景1：慢门车轨人像 ············ 146
- 9.2.2 场景2：慢门人流幻影 ············ 149
- 9.2.3 场景3：慢门星空人像 ············ 149

第10章 车轨拍摄，精彩出奇　　154

10.1 拍摄要点：车轨拍摄的前期准备 ············ 155
- 10.1.1 原理：车流灯轨的拍摄原理 ············ 155
- 10.1.2 稳定：固定好手机保持稳定 ············ 156
- 10.1.3 地点：在车流多的地方拍摄 ············ 156
- 10.1.4 方向：选择合适的行车方向 ············ 156
- 10.1.5 构图：学会预测画面和构图 ············ 158
- 10.1.6 注意：拍摄车轨的错误方式 ············ 159

10.2 光线控制：设置车轨的拍摄参数 ············ 159
- 10.2.1 设置1：测光模式 ············ 159
- 10.2.2 设置2：光圈和感光度 ············ 160
- 10.2.3 设置3：对焦模式 ············ 160
- 10.2.4 设置4：白平衡 ············ 161
- 10.2.5 设置5：快门速度 ············ 162

10.3 拍摄场景：车流灯轨的常见题材 ············ 162
- 10.3.1 场景1：在人行天桥上俯视拍摄 ············ 162
- 10.3.2 场景2：在城市高楼平拍或俯拍 ············ 162
- 10.3.3 场景3：在道路的两侧平视拍摄 ············ 164
- 10.3.4 场景4：在道路中央低角度拍摄 ············ 165
- 10.3.5 场景5：选择拐弯处来拍摄车轨 ············ 165

第11章 烟花拍摄，闪耀全城　　167

11.1 拍摄技巧：拍好慢门烟花的要点 ············ 168
- 11.1.1 慢门：记录烟花光点移动轨迹 ············ 168
- 11.1.2 取景：不要拍摄太多烟花元素 ············ 169
- 11.1.3 黑卡：拍摄多个烟花绽放画面 ············ 170

11.2 拍摄步骤：慢门烟花的拍摄流程 ············ 171
- 11.2.1 器材：拍摄烟花的常用器材 ············ 171
- 11.2.2 地点：选择开阔的拍摄场景 ············ 172
- 11.2.3 天气：注意拍摄位置的风向 ············ 173
- 11.2.4 对焦：用手动对焦模式拍摄 ············ 174
- 11.2.5 测光：用参考光源进行测光 ············ 174

11.2.6 曝光：使用曝光锁定的功能 …… 175
11.2.7 光圈：根据现场情况来调整 …… 176
11.2.8 ISO：用低感光度提升画质 …… 178
11.2.9 快门：设置合理的曝光时间 …… 178

第12章 星空拍摄，天旋地转 181

12.1 注意事项：提前做好拍摄规划 …… 182
12.1.1 天气：选择合适的天气出行 …… 182
12.1.2 方向：寻找星系银河的位置 …… 182
12.1.3 光线：避开城市光源的污染 …… 184
12.1.4 构图：选择恰当的前景对象 …… 184

12.2 拍摄步骤：使用手机拍摄星星银河 …… 184
12.2.1 步骤1：找到合适拍摄位置 …… 184
12.2.2 步骤2：设置感光度参数 …… 185
12.2.3 步骤3：设置快门速度 …… 186
12.2.4 步骤4：设置对焦模式 …… 186
12.2.5 步骤5：多次尝试拍摄星空 …… 187

12.3 拍摄场景：手机拍摄星空常见题材 …… 187
12.3.1 场景1：指星画面 …… 187
12.3.2 场景2：工作照片 …… 189
12.3.3 场景3：普通银河 …… 189
12.3.4 场景4：银河拱桥 …… 191
12.3.5 场景5：绚丽星轨 …… 192

第13章 光绘摄影，创意无限 194

13.1 准备工作：认识光绘摄影 …… 195
13.1.1 拍摄原理：用慢速快门记录光轨 …… 195
13.1.2 暗色背景：选择适合光绘的场地 …… 196
13.1.3 移动光源：准备光绘摄影的器材 …… 197

13.2 参数设置：满足光绘需求 …… 198
13.2.1 设置1：选择拍摄模式 …… 198
13.2.2 设置2：设置曝光参数 …… 198
13.2.3 设置3：使用手动对焦 …… 199

13.3 拍摄场景：光绘拍摄题材 …… 199
13.3.1 场景1：钢丝棉光绘 …… 199
13.3.2 场景2：光绘写字 …… 202

13.3.3	场景3：临摹人物形状	203
13.3.4	场景4：光绘汽车	204
13.3.5	场景5：光绘人像	205

第14章　丝绢流水，雾状细腻　　207

14.1 拍摄技巧：将流水拍出拉丝雾状效果 208
- 14.1.1 技巧1：在较弱的光线下拍摄 208
- 14.1.2 技巧2：调整快门速度、感光度 210
- 14.1.3 技巧3：用三脚架和耳机线拍摄 212

14.2 拍摄场景：丝绢流水的常用拍摄题材 213
- 14.3.1 场景1：拍摄海水慢门效果 213
- 14.3.2 场景2：拍摄江河慢门效果 215
- 14.3.3 场景3：拍摄瀑布慢门效果 218
- 14.3.4 场景4：拍摄溪流慢门效果 219
- 14.3.5 场景5：拍摄喷泉慢门效果 222

第15章　延时视频，压缩时间　　226

15.1 准备工作：手机拍摄延时视频的要点 227
- 15.1.1 要点1：保证手机的电量充足 227
- 15.1.2 要点2：将手机固定在三脚架上 227
- 15.1.3 要点3：将手机设置为飞行模式 228

15.2 实战拍摄：手机拍摄延时视频的两种方法 228
- 15.2.1 直接拍摄：一次得到延时视频成品 228
- 15.2.2 后期变速：普通视频进行加速处理 230

15.3 后期处理：使用剪映App编辑视频 232
- 15.3.1 导入：添加多段需要处理的视频 232
- 15.3.2 剪辑：删除视频中不需要的部分 233
- 15.3.3 降噪：一键消除延时视频的噪声 234
- 15.3.4 变速：对视频画面进行加速处理 235
- 15.3.5 调色：调整延时视频的色彩影调 236
- 15.3.6 输出：给视频添加字幕和音乐效果 237

第1章
手机慢门，快速入门

学前提示

慢门是慢速快门的简称，其中的慢速就是指曝光时间较长的快门速度。快门是一个控制曝光时间长短的机械装置，慢门摄影主要通过快门这个装置来实现，核心在于曝光时间较长。本章主要介绍手机慢门摄影的创作思路和常用配件，以及手机相机的基本拍摄功能和长曝光拍摄技巧。

1.1 创作思路：了解慢门摄影的特点

每一位摄影师都应该明白，不管拍什么题材的作品，第一步就得有创作思路，让照片有主题，那么拍摄慢门摄影有哪些主题思路呢？

1.1.1 思路1：慢门摄影让物体充满运动感

慢门摄影不一定需要非常慢的快门速度，只要快门的速度低于物体移动的速度也是可以的。我们通常拍摄运动题材照片时，创作思路都是想将那一瞬间定格下来，但慢门摄影的创作思路则不同。

如图1-1所示，使用高速快门将奔跑的汽车定格了下来，但画面缺少了一些动感，看上去比较呆板。

图1-1 使用高速快门拍摄的画面

使用慢速快门拍摄则可以让主体显得十分动感。如图1-2所示，使用慢速快门拍摄运动中的汽车，画面更具动感，马路上流动的灯轨，使大家第一眼看到这幅作品时，就会很自然地联想到动感、快速和极速等关键词。

需要注意的是，在拍摄此类题材时，不能将快门速度放得太慢，否则照片容易出现曝光过度，或拍摄主体在图中模糊成影，看不清楚。

第 1 章 手机慢门，快速入门

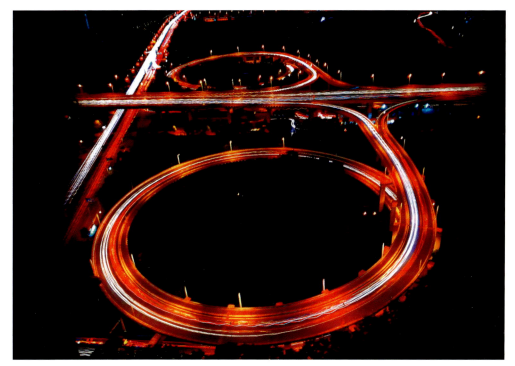

图 1-2 使用慢速快门拍摄的画面

1.1.2 思路 2：完整记录下物体的运动轨迹

常规的静态摄影，能让我们看到在夜里飞奔的汽车与街景中的霓虹灯搭配出非常有感觉的照片。但慢门摄影能让你看到，在夜里飞奔的汽车车灯，会在街道上画出一道道绚丽的光影，如图 1-3 所示。

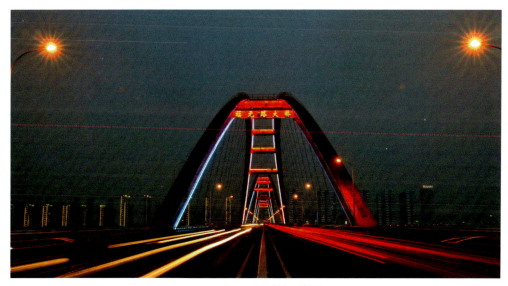

图 1-3 记录车灯的运动轨迹

因此，记录物体的运动轨迹，是慢门摄影的一个重要亮点。图 1-4 为使用慢门拍摄的烟花，能够将烟花绽放的全部过程都记录下来。

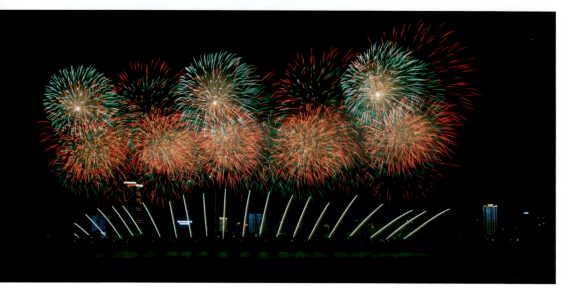

图 1-4　记录烟花的绽放过程

1.1.3　思路 3：拍出平常肉眼看不到的景物

在喧嚣的街头拍摄时，是否有想过将"多余的路人"全部移除呢？在拍摄雄伟的瀑布时，是否有想过将其拍摄得如丝绸般绵柔呢？像这些景象我们肉眼是无法观察到的，但我们可以借助慢门摄影来将这一幕幕画面细腻地描绘出来。

图 1-5 为使用慢门拍摄的城市夜景和水面倒影，水面犹如一面镜子，得到和肉眼观察完全不同的视觉感受。

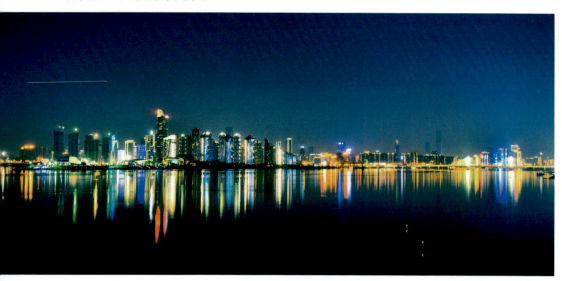

图 1-5　城市夜景和水面倒影

1.1.4 思路4：用慢速度来拍摄出迷人景致

慢门摄影强调的是慢，让手机不再是用来记录瞬间的工具，而是可以用来记录一个时间段的变化。图1-6为采用慢门的方式拍摄的闪电，曝光时间建议设置为5～10秒，可以让延伸的闪电光线被慢门记录下来。

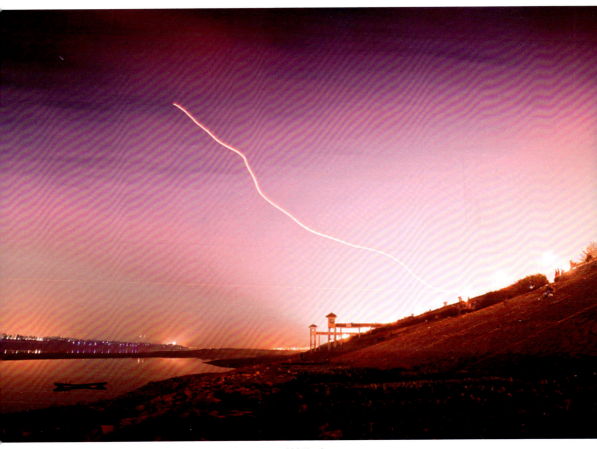

图1-6 拍摄闪电

慢门摄影其实也是一种摄影态度、一种生活态度，在喧嚣的城市中压力总是让我们喘不过气来，在生活中缺少惊喜。而在拍摄慢门作品时，却能放松我们紧绷的心，当设置好拍摄参数，在快门落下的瞬间，所有烦心事全部被抛到了脑后，脑海中则在描绘将要呈现出来的慢门摄影作品，心中满是惊喜与期待，这恐怕是其他摄影方式不能带来的感受。

1.1.5 思路5：长曝光给观者带来更多惊喜

相比平常的瞬时摄影来说，慢门摄影拍摄的画质要好于前者，原因就在于长曝光时间的运用，能让画质得到极大的提升，因此慢门绝对是一个能够给观者带来惊喜的摄影方法。如图1-7所示，拍摄的是星空银河的画面，曝光时间通常在30秒以内，否则太长的曝光时间会导致星星出现拖尾现象，星点会变成星轨。

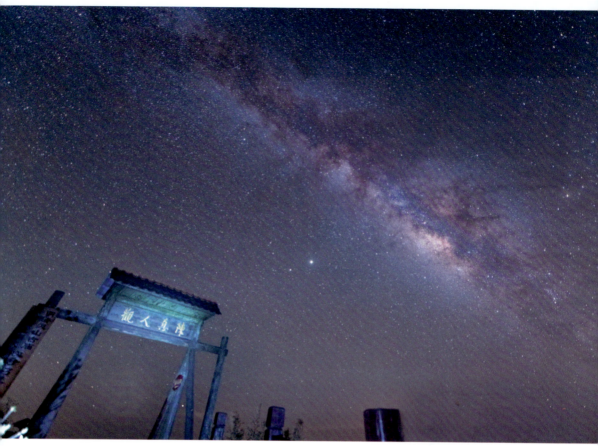

图 1-7 拍摄星空银河

通常用手机拍摄夜景是一件棘手的事情，暗淡的光线对手机是极大的考验，而慢门摄影却能轻松驾驭，更好地突出主体。慢门摄影不仅能增加照片的亮点，让照片看起来更加与众不同，而且还能够陶冶情操，让摄影作品更具有深意。

1.2 手机相机：了解拍照的基本功能

手机虽然不及传统相机的那种庄重感和仪式感，但正是因为手机消解了这种仪式感，才有了更多的可能和发现。手机也能拍摄出精美的慢门作品，这个时代一定会产生一些手机慢门摄影大咖。当然，要达到慢门摄影大咖的水平，首先要掌握手机相机的基本拍照功能。

1.2.1 快门：长曝光拍摄的防抖技巧

手机的快门方式比较"傻瓜"，通常只需要点击屏幕上的快门按钮即可。用手机长曝光拍摄慢门作品，最大的忌讳就是直接点击手机屏幕上的快门按钮，通常是"十拍九

虚",下面笔者介绍几个好用的点击手机快门的技巧。

1. 设置声控拍照,代替手按快门拍照

打开手机相机,❶点击右上角的设置按钮⚙,进入"设置"界面;❷然后选择"声控拍照"选项;❸打开"声控拍照"右边的开关按钮即可,如图1-8所示。

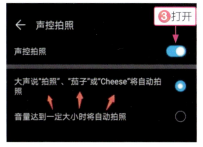

图 1-8 打开"声控拍照"功能

在拍照时说"拍照"或者"茄子",手机就会自动拍照,非常好用。这样拍照时就无须用手指去点击快门按钮,从而解决了容易造成画面模糊的问题。这一招在自拍时也特别适用,有时你自拍会将手伸得长长的,不太好再点击快门按钮,此时用声控拍照功能说一句"拍照"就解决了。

2. 设置定时拍照,减少手的触动

在"声控拍照"功能的上方,有一个"定时拍照"功能。点击进去后,可以设置定时拍照的时间,如这里选择为5秒,意思是用手指点击快门按钮后,手机相机会倒计时5秒,5秒后再进行拍照,如图1-9所示。这5秒的倒计时,就规避掉了手指对手机造成的触动,让手机更加稳定,拍出清晰的画面。

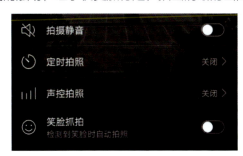
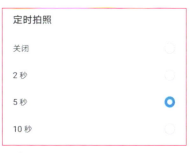

图 1-9 设置"定时拍照"功能

"定时拍照"功能还有一个特别实用的地方,就是用户可以选择将自己拍进去,因为你有 5 秒或 10 秒的等待时间,足够你走进手机镜头的取景画面,并摆好 POSE。

3. 用耳机线作为快门线,减少手机的触动

其实,手机的耳机线,是可以作为快门线的,只要按耳机线上的按钮,就可以拍照,这样也可以减少手指对手机的触动,具体使用方法后面会详细介绍。图 1-10 为使用手机耳机线控制快门拍摄的慢门瀑布照片。

图 1-10　使用耳机线拍摄慢门照片

4. 用蓝牙遥控器,减少手机的触动

在网上买自拍杆或八爪鱼时,一般都会赠送一个蓝牙遥控器,轻轻一按,即可拍照,同样可以减少手指对手机的触动,如图 1-11 所示。

图 1-11　蓝牙遥控器

第 1 章 手机慢门，快速入门

1.2.2 对焦：拍出更清晰的画面主体

一张照片是否清晰，对焦是最关键的一步。手机主要采用触摸屏幕的对焦方式，就是在手机相机取景屏幕上用手指点击你想要对焦的地方，点击的地方就会变得更加清晰，而越远的地方则虚化效果越明显，如图 1-12 所示。

另外，很多手机还具有曝光调节功能，在对焦框的下方可以拖曳太阳图标，来调整对焦点的曝光，如图 1-13 所示。

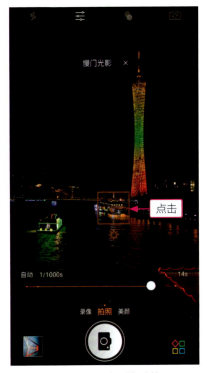

图 1-12　手机对焦功能

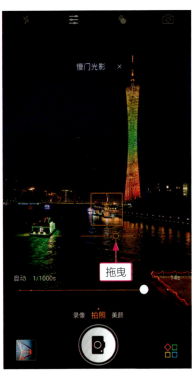

图 1-13　手机曝光调整功能

如今，市场上大部分的智能手机都采用双摄像头甚至四摄像头，拍照功能有很大的提升，用户可以先拍照，然后再去选择照片的焦点及光圈，从而实现类似光场相机的效果。双摄像头对焦的主要优势为：两个摄像头同时工作，其中一个负责拍摄固定的景深效果，而另外一个则完成对焦工作。另外，两个摄像头的曝光时间也不相同，可以得到更加生动的画面效果。

1.2.3 构图线：获得更加完美的比例

手机照片的整体构图基本就决定了这张照片的好坏与否。在同样的色彩、影调和清晰度下，构图更好的慢门作品其美感也会更高。

因此，我们在使用手机进行慢门摄影时，可以充分利用相机内的构图线功能，帮助我们更好地进行构图，获得更完美的比例。通常，大部分的智能手机在设置中打开构图线即可，操作方法比较简单，然后再打开慢门模式拍摄，如图 1-14 所示。

手机慢门摄影与后期从入门到精通：夜景、人像、车轨、烟花、星空、光绘、丝绸流水、延时视频全攻略

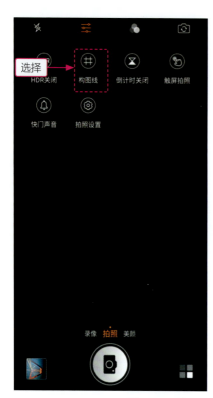

图 1-14　使用构图线辅助拍摄慢门作品

1.3　专业器材：慢门摄影的常用配件

相比专业的单反相机来说，智能手机的拍摄效果还有很大的提升空间，例如通过加装各种手机摄影配件就是一种不错的提升方法。本节主要介绍慢门摄影的一些常用摄影配件，如三脚架、手持稳定器和减光镜等，让用户用手机也可以轻松拍出精彩的慢门摄影作品。

1.3.1　三脚架：保持手机拍摄慢门的稳定性

三脚架因三条"腿"而得名，是用于拍摄慢门照片时的稳定器材，支撑手机的辅助设备。很多接触过摄影摄像的人都知道三脚架，但是很多人却并没有意识到三脚架的强大功能。

三脚架的最大优势就是稳定，这在拍摄延时摄影、流水或者流云等运动性的物体时，三脚架就能很好地保持手机的稳定，从而取得更优的画质效果。

在用手机拍摄慢门作品的过程中，除非特殊需要，否则都不希望画面晃动。所以，用户如果想要保证画面的稳定，首先得保证手机的稳定，而手机三脚架就能够很好地保证手机拍摄时的稳定性，如图 1-15 所示。

第 1 章 手机慢门，快速入门

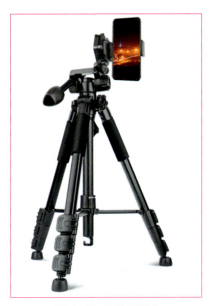

图 1-15 手机三脚架

> **专家提醒**
>
> 大部分的手机三脚架都具有蓝牙和无线遥控功能，可以"解放"拍摄者的双手，远距离也能实时操控快门。同时，手机三脚架还可以自由伸缩高度，满足一定区间内不同高度环境的拍摄需求。

1.3.2 八爪鱼：集妖性、弹性和灵性于一体

三脚架的优点一是稳定，二是能伸缩，但三脚架也有缺点，就是摆放时需要相对比较平的地面，而八爪鱼刚好能弥补三脚架的缺点，因为它有"妖性"。

八爪鱼能伸能屈，能弯能直，有弹性能变形，三脚架干不了的事，它能干。关键是八爪鱼携带方便，不占地方，利用身材矮小的优势，在室内、室外都能大展拳脚，助你拍出平常拍不出的大片、好片，如图 1-16 所示。

图 1-16 八爪鱼支架设备

1.3.3 手持稳定器：防止画面抖动造成模糊

手持稳定器的主要功能是稳定拍摄设备，防止画面抖动造成的模糊，适合拍摄车流灯轨和烟花等慢门作品，如图 1-17 所示。

图 1-17 手持稳定器

所谓稳固手机，就是指将手机固定或者让手机处于一个十分平稳的状态。手机是否稳定，能够在很大程度上决定拍摄画面的稳定性。如果手机不稳，就会导致拍摄画面也跟着摇晃，从而使拍摄出来的画面变得十分模糊。如果手机被固定好，那么在慢门作品的拍摄过程中就会十分平稳，拍摄出来的画面也会非常清晰。

手持稳定器就是将云台的自动稳定系统放置在手机照片拍摄上来，它能自动根据用户的运动方向或拍摄角度来调整手机镜头的方向，使手机一直保持在一个平稳的状态。无论用户在拍摄期间如何运动，手持稳定器都能保证拍摄的稳定。

手持稳定器一般来说重量较轻，女生也能轻松驾驭，而且还具有自动追踪和蓝牙功能，能够实现即拍即传。部分手持稳定器还具有自动变焦和照片滤镜切换等功能，对于拍摄慢门作品来说，是一个很棒的选择。

1.3.4 减光镜：将光线压暗实现长曝光

使用慢速快门拍摄时，快门时间通常要拉长到零点几秒以上，甚至到几十秒，如果是在白天拍摄，会导致照片过曝，拍出来的照片会变成全白的画面，因此我们需要使用一些设备将光线压暗。

此时，减光镜 (Neutral Density Filter，又称 ND 滤镜或中性灰度镜) 就是一个必不可缺的设备。手机通常使用的是夹式减光镜，如图 1-18 所示。

图 1-18 夹式减光镜

在手机上安装了减光镜后，我们可以通过旋转减光镜外侧的调节旋钮，然后根据拍摄环境的光线状况来调整明暗度，从而更好地搭配手机的快门时间，进行慢门摄影创作。手机搭配减光镜，可以在日光下使用长曝光拍摄流水，如图 1-19 所示。

图 1-19 流水慢门作品

1.3.5 外接镜头：增强智能手机的拍摄性能

手机摄影具有很强的扩展性，用户可以在手机上安装各种外接镜头，如广角镜头、

微距镜头、鱼眼镜头、变焦镜头、手机望远镜、偏振镜头、星光镜、荧光镜以及渐变滤镜等，能够增强手机的拍摄性能，解决一些特殊的拍摄需求或问题。

例如，手机广角镜头的焦距通常都比较短、视角较宽，而且其景深很深，对于拍摄建筑和风景等较大场景的照片非常适合，如图 1-20 所示。

图 1-20　手机广角镜头

图 1-21 为采用手机广角镜头拍摄的立交桥上的车流灯轨慢门作品，不仅可以增加画面的宽广度，拍摄到更多的车流灯轨，而且能够将远景的建筑群拍下来，展现出灯火辉煌的璀璨城市夜景画面。

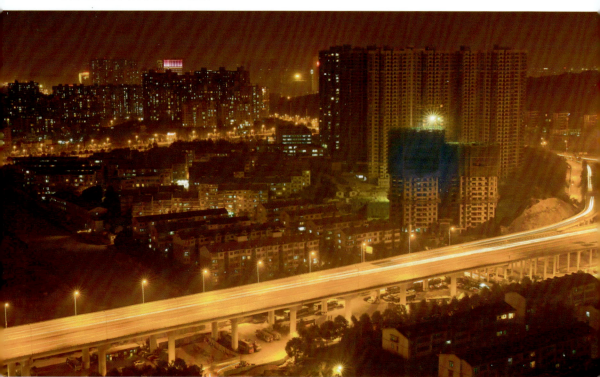

图 1-21　城市夜景慢门作品

1.4 手机慢门：长时间曝光的3种方式

前面掌握了很多拍照防止手机抖动的方式，本节我们继续往后学习，更上一层楼，来看看手机慢门的具体拍摄方法。慢门是指将手机相机的快门速度放慢，将曝光时间拉长，因此也称为长曝光，快门速度通常慢于 1/30 秒以下。本节主要以华为手机为例，介绍手机长时间曝光拍摄的 3 种方式。

1.4.1 方式 1：运用夜景模式进行长曝光拍摄

打开手机相机，切换到"夜景"模式，如图 1-22 所示。一般系统会自动根据夜景的光线，设定一个拍照时间，通常在 1 ~ 10 秒，初学者可以直接点击快门按钮，等时间充分曝光完成，即可拍出比默认模式更好的画质效果。

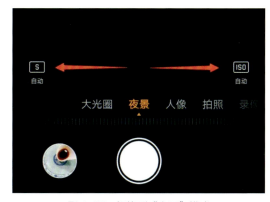

图 1-22 切换到"夜景"模式

注意，在"夜景"模式中，调整右边的 ISO 值可以设置感光度，调整左边的 S 值可以设置快门的曝光时间。建议先设置感光度，值越低越好，如 100，不需要选自动；再设置曝光时间，夜景模式下最长曝光时长为 32 秒，如图 1-23 所示。

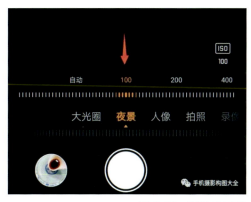 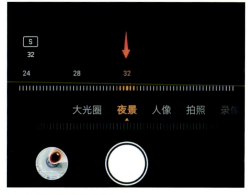

图 1-23 设置"夜景"模式的感光度和曝光时间

设置好"夜景"模式的各个参数后，即可拍摄夜景长曝光作品，效果如图 1-24 所示。

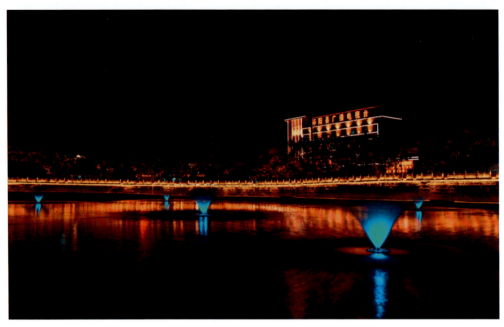

图 1-24 夜景长曝光作品

1.4.2 方式 2：运用专业模式进行长曝光拍摄

如果你还想更上一层楼，可以这样操作：在手机相机的"专业"模式中，调整好合适的感光度、快门速度和对焦方式等，如图 1-25 所示。"专业"模式的具体操作方法，在本书第 3 章会进行具体介绍，此处不再赘述。

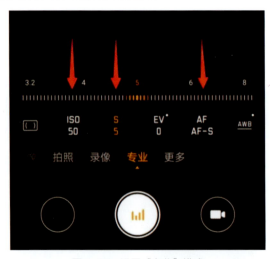

图 1-25 设置"专业"模式

然后通过声控快门的方式，说一声"拍照"或"茄子"，即可拍出更加迷人的夜景长曝光作品，如图 1-26 所示。

第 1 章 手机慢门，快速入门

图 1-26 夜景长曝光作品

1.4.3 方式 3：运用慢门模式进行长曝光拍摄

最后一种方式是比较傻瓜的操作方法，那就是用手机相机中的慢门模式，如华为手机的"流光快门"，具体拍摄方法会在第 2 章进行介绍。例如，遇上有水面的夜景，即可使用"流光快门"模式中的"丝绢流水"功能，如图 1-27 所示。

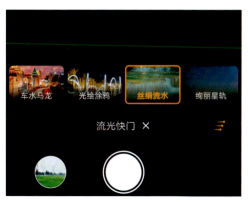

图 1-27 选择"丝绢流水"功能

然后使用声控快门拍摄，拍到你觉得效果满意时即可停止，可以让水面显得更加粘稠，如图 1-28 所示。拍车水马龙、光绘涂鸦、绚丽星轨的操作也一样，大家可以自行发挥创意。

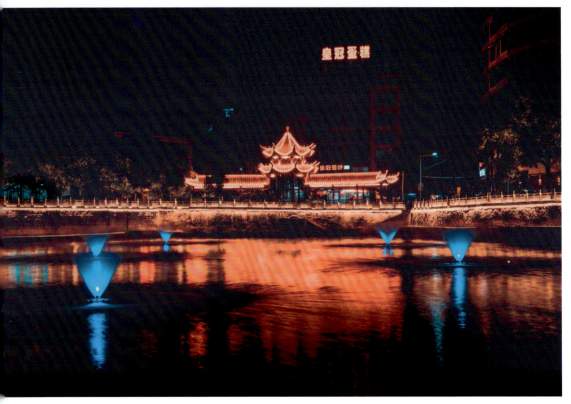

图 1-28 水景长曝光作品

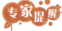

下面总结一下手机慢门摄影的相关技巧。

- 使用八爪鱼或三脚架固定相机，能得到更清晰稳定的画质。
- 使用声控拍照或定时拍照，或耳机当快门线来遥控式拍照。
- 使用专门的手机"夜景"模式来拍照，同时还可以调整快门速度与感光度参数。
- 使用手机"专业"模式，自定义设置对焦方式、快门速度、感光度以及白平衡等参数。
- 使用专门的"流光快门"模式，如"丝绢流水"或"车水马龙"等。

第 2 章

快速出片，一键智能

 如今，很多智能手机品牌都推出了慢门摄影功能，如华为、努比亚、魅族和 360 等。另外，苹果手机也推出了实况模式功能，来实现长曝光的拍摄需求。本章主要以华为、苹果和努比亚 3 个品牌的手机为例，介绍一键智能出片的慢门摄影技巧。

2.1 华为手机：流光快门

"流光快门"是华为手机的一种慢门摄影模式，其中包括"车水马龙""光绘涂鸦""丝绢流水"以及"绚丽星轨"4 种不同类型的慢门模式，通过相机的"更多"界面进入"流光快门"模式 ，如图 2-1 所示。

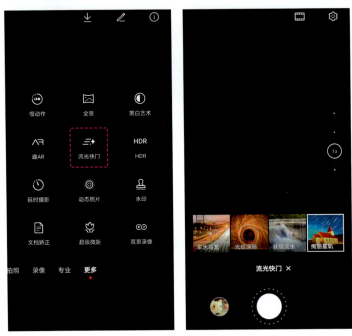

图 2-1 进入"流光快门"模式

> **专家提醒**
>
> 使用"流光快门"模式拍摄照片时，一定要使用三脚架或者手机支架，将手机固定好，不能有任何抖动，否则拍摄出来的画面可能会模糊不清。

2.1.1 车水马龙：拍摄夜晚城市的车灯运动轨迹

"车水马龙"模式可以拍摄出夜晚道路上的车灯慢门效果，如果取景角度够好的话，就可以拍出绚丽的车流灯轨效果。进入手机相机的"流光快门"模式，在下方选择"车水马龙"模式，即可拍摄车流的慢门特效，如图 2-2 所示。

如图 2-3 所示，这张在大桥中央拍摄的车流照片，视角十分独特，将三脚架放置在马路的中央，利用地面上的引导线来将画面分割成垂直对称构图，同时左边的车流光影为白色的车头灯，右边的车流光影为红色的车尾灯，色彩对比十分强烈。另外，地面线条由于透视作用汇聚到了一个点，让照片的纵深感更强烈。

第 2 章 快速出片,一键智能

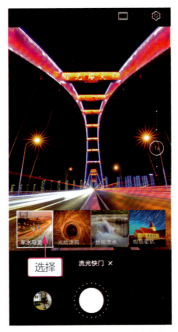

图 2-2 选择"车水马龙"模式

图 2-3 车流灯轨照片

2.1.2 光绘涂鸦:拍摄光源移动轨迹、光绘效果

光绘摄影也是一种常见的慢门夜景拍摄题材,拍摄方法和拍摄车轨的原理差不多。

在华为手机的"流光快门"模式中,选择"光绘涂鸦"模式,点击快门按钮,即可开始拍摄光绘照片。

图 2-4 就是笔者在岳麓山上与同行小伙伴拍摄的光绘涂鸦照片效果,将手机架在三脚架上,选择"光绘涂鸦"模式,点击快门按钮拍摄,待拍摄出满意的光绘效果后,点击结束按钮停止拍摄即可。

图 2-4 光绘效果

这种弱光下的慢门夜景 + 光绘拍摄,有以下几个要注意的细节。

(1) 光绘的材料可以是钢丝棉火花,也可以是彩色灯管,效果都非常出彩。

(2) 安全第一,不要穿容易着火的棉或丝质衣服,女孩子如果有一头长发的话,最好戴个帽子或扎起来。

(3) 选择的场地尽量宽敞,后面没有太杂的背景,最好前景可以安放人。

(4) 华为手机自带"光绘涂鸦"功能,可以边拍边观察,直到得到想要的结果。

(5) 拍摄光绘不难,难在前景人物的拍摄,如果前期拍不好,就只有后期合成了,这也是一种常见的办法。

(6) 光绘摄影很简单,但要拍好不简单,前期、中期、后期都要规划好细节。

2.1.3 丝绸流水:可以把水流拍出丝般顺滑效果

"丝绸流水"慢门模式可以拍出丝滑水面的效果,给人一种"煮水"的视觉感。在华为手机的"流光快门"模式中,选择"丝绸流水"慢门模式,点击快门按钮,即可开始拍摄。图 2-5 为使用"丝绸流水"慢门模式拍摄的城市水景照片,曝光时间长达 6 秒,

水流变得如丝绸一般顺滑。

图 2-5 城市水景照片

如图 2-6 所示，这张油画般的照片，就是使用华为手机的"丝绢流水"慢门模式拍摄的，可以令溪水变成拉丝状，给照片带来一份诗意般的画面感。

图 2-6 小溪流慢门效果

2.1.4 绚丽星轨：拍摄银河或者星星的运行轨迹

拍摄星轨的时间可以根据画面的拍摄效果来定，有 30 分钟、40 分钟和 60 分钟，

使用手机中的"绚丽星轨"功能进行拍摄，最大的方便就是不用设定拍摄参数，也不用设定拍摄时长，直接打开功能进行拍摄即可。

在拍摄星轨照片时，如果觉得拍摄的效果差不多了，就可以结束拍摄；如果觉得星轨的路径还不够长、不够亮，就可以根据需要继续拍摄，这个时间都可以由自己来自由控制，十分方便。

图 2-7 为笔者使用手机拍摄了 1 分 19 秒左右的星轨效果，只看得到星星点点，还看不到星轨效果。

图 2-7　拍摄 1 分 19 秒左右的星轨效果

图 2-8 为笔者拍摄了 40 分钟的星轨成品效果。

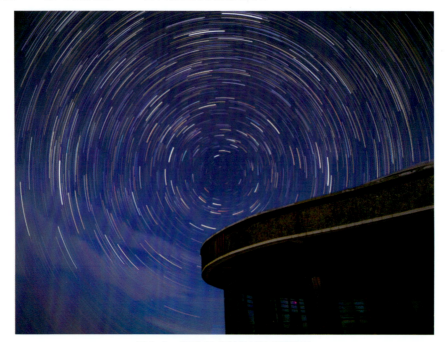

图 2-8　拍摄 40 分钟的星轨成品效果

2.2 苹果手机：实况模式

在 iPhone 6S 以后的手机相机中，可以发现一个"实况"模式拍摄功能，该功能能够实现长曝光的拍摄，本节介绍具体的拍摄方法。

2.2.1 第 1 步：使用"实况"模式拍摄慢门

首先要打开"实况"模式拍摄功能，在 iPhone 的手机相机中，进入"照片"模式，点击上方的"实况"模式按钮，如图 2-9 所示。执行操作后，"实况"模式按钮的图标颜色由白色变为黄色，表示已开启"实况"模式拍摄功能，此时即可开始拍摄慢门效果，如图 2-10 所示。

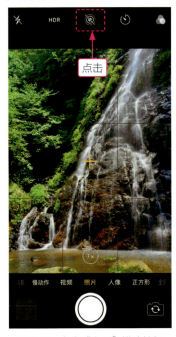
图 2-9　点击"实况"模式按钮

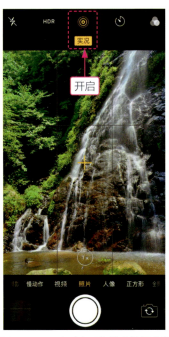
图 2-10　开启"实况"模式拍摄功能

使用"实况"模式拍摄时，手机相机会自动记录用户按下快门前后 1.5 秒的所有画面和声音，同时手机也会自动被调为静音，从而将快门声音去除。

2.2.2 第 2 步：使用"长曝光"呈现慢门效果

使用"实况"模式拍摄好照片后，用户可以打开"照片"App，在其中选择所拍摄的照片，然后用手指按住照片并向上滑动，如图 2-11 所示。在弹出的"效果"菜单中选择"长曝光"选项，如图 2-12 所示。

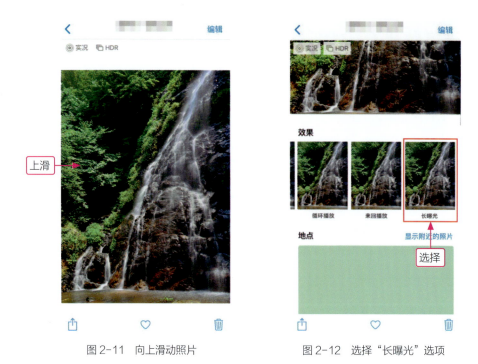

图 2-11　向上滑动照片　　　　　　　　图 2-12　选择"长曝光"选项

执行操作后，即可呈现"长曝光"的画面效果，如图 2-13 所示。转换后的慢门效果如图 2-14 所示。

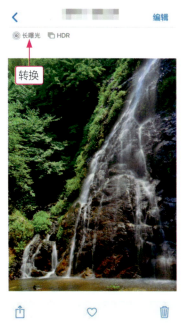 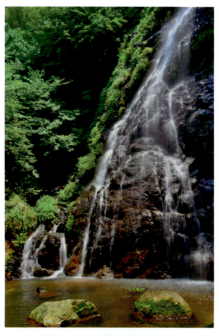

图 2-13　呈现"长曝光"的画面效果　　　　　图 2-14　转换后的慢门效果

2.3 努比亚手机：相机家族

努比亚手机引以为傲的就是其强大的拍照功能，其"相机家族"中内置了很多专业摄影模式，其中不乏长曝光功能，如"光绘"模式、"电子光圈"模式、"慢门"模式、"星轨"模式以及"运动轨迹"模式等，如图 2-15 所示。通过这些丰富的摄影模式，能够帮助用户快速拍摄出媲美单反的慢门大片。

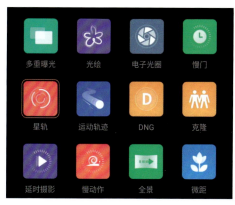

图 2-15　努比亚手机的"相机家族"功能

2.3.1 光绘模式：留住精彩的光影瞬间

"光绘"模式可以用来实时拍摄移动光源的运动轨迹，下面介绍具体拍法。

步骤 01　打开手机相机，切换至"相机家族"拍摄功能，选择"光绘"模式，如图 2-16 所示。

图 2-16　选择"光绘"模式

步骤 02　进入"光绘"模式拍摄界面，用户可以根据拍摄环境的光线来调整"背景亮度"参数，如图 2-17 所示。

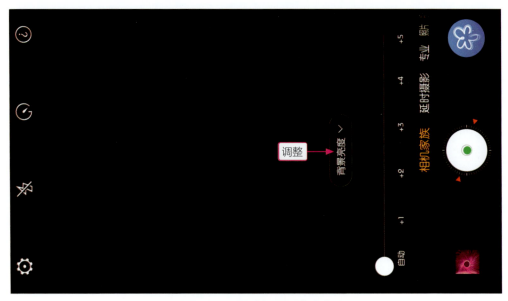

图 2-17 调整"背景亮度"参数

步骤 03 点击快门按钮即可开始拍摄,拍摄完成后再次点击快门按钮,即可结束拍摄,同时得到一张光轨图和一个光轨视频,效果如图 2-18 所示。

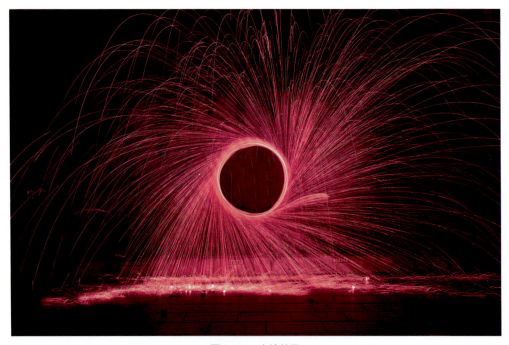

图 2-18 光绘效果

2.3.2 电子光圈:单反级大片成像效果

"电子光圈"是努比亚创造的一种专业慢门模式,用户可以通过调整手机相机的光

圈 (F/2.8~F/44)，来模拟真实光圈的拍摄效果。同时，"电子光圈"模式还可以降低快门速度，实现丝绢流水、丝状流云、街道夜景、人山人海以及车流灯轨等慢门效果。

"电子光圈"模式相当于单反相机的"光圈优先自动曝光"模式（即 Av 档），用户只需手动选择"电子光圈"值进行拍摄，即可进行长时间曝光，拍出极具动感的画面效果，其拍摄界面如图 2-19 所示。

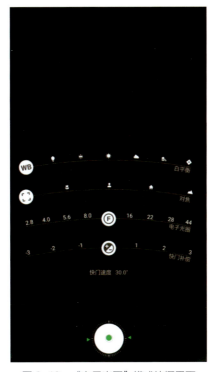

图 2-19　"电子光圈"模式拍摄界面

> **专家提醒**
>
> 　　光圈是一个用来控制光线透过镜头进入机身内感光面光量的装置。打开光圈时，可以让大量光线进入传感器；缩小光圈时，则可以限制进入传感器的光线量。光圈具有两个功能，分别为调节光量和调整合焦范围。
>
> 　　光圈叶片的打开比例通常用 F 数值来表示，也就是我们所说的光圈值。光圈值越小，光圈越大，进光量则越大；光圈值越大，光圈越小，进光量也就越小。
>
> 　　智能手机由于镜头体积的限制，很难在硬件上做到光圈的调整，因此大部分的手机光圈值都是固定的。努比亚的"电子光圈"模式，则可以帮助用户轻松模拟真实光圈的调整效果。

图 2-20 为使用"电子光圈"模式拍摄的流水照片，"电子光圈"值为 F/29、白平衡为自动、对焦为自动、曝光时间为 1 秒，画面极具流动感。

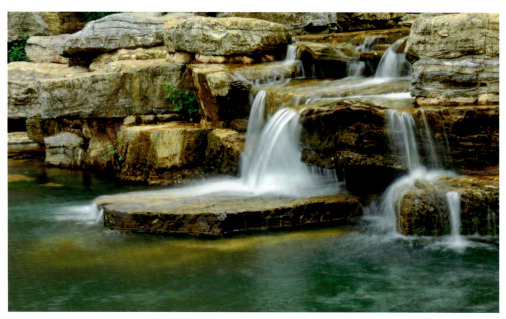

图 2-20 流水效果

2.3.3 慢门模式：超长曝光的别样魅力

如果说"电子光圈"模式相当于单反相机的 Av 档，那么"慢门"模式就相当于单反相机的 S 档或 Tv 档，即"快门优先自动曝光"模式，用户可以直接调节快门时间进行拍摄。

在努比亚手机的"慢门"模式下，曝光时间可以长达 21 分钟，只要镜头中有光，都可以拍出来，甚至能够进行星空的长时间曝光拍摄，如图 2-21 所示。

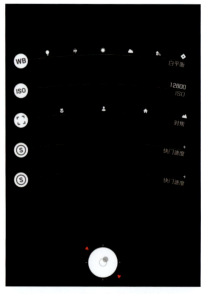

图 2-21 "慢门"模式拍摄界面

需要注意的是，部分努比亚的机型取消了"慢门"模式。图 2-22 为努比亚 X 的"相机家族"功能，其中可以看到"慢门"模式；图 2-23 为努比亚 Z20 的"相机家族"功能，其中就缺了"慢门"模式。

图 2-22　努比亚 X 的"相机家族"功能　　　图 2-23　努比亚 Z20 的"相机家族"功能

如果"相机家族"功能中没有"慢门"模式，用户也可以选择"专业"模式来代替，只要在其中将快门速度调慢，即可变成"慢门"模式。在"专业"模式中，曝光时间最长可以达到 1 分钟，如图 2-24 所示。

图 2-24　在"专业"模式下调整快门速度

"慢门"模式适用于夜晚等环境光线较弱的场景下拍摄，同时需要借助三脚架等设备来固定手机，可以十分方便地拍摄夜景、星空、星轨和光轨等题材。图 2-25 为使用努比亚手机的"慢门"模式拍摄的车流灯轨照片，快门速度为 20 秒、感光度为 100、对焦为 100（无穷远）、白平衡为自动、EV 值（曝光补偿）为 0，流动的灯轨可以让夜景显得更美。

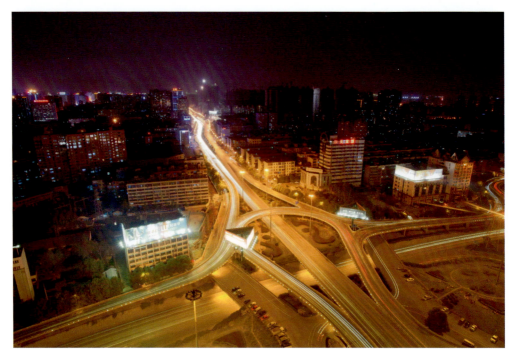

图 2-25　车流灯轨效果

2.3.4　星轨模式：拍下灿烂的星河印记

由于地球的自转，天空中所有的星星都是东起西落。努比亚手机中的"星轨"模式不仅能够拍摄出清晰明亮的星空，而且可以进行长时间曝光拍摄，记录下星光移动的路径轨迹，其拍摄界面如图 2-26 所示。

图 2-26　"星轨"模式拍摄界面

"星轨"模式有两个快门速度选项,分别为分和秒的设置。注意,这里设置的是单张照片的曝光时间,整体曝光时间可以在点击快门按钮后自由决定。

用户可以将手机固定在三脚架上,然后将镜头对准天空,并选择"星轨"模式,点击快门按钮开始拍摄。在拍摄星轨的过程中,可以在手机屏幕上看到星轨呈逆时针方向一点点拉长,当达到满意的形状后,再次点击快门按钮即可结束拍摄。

为了获得更加漂亮、清晰的星轨,努比亚的"星轨"模式在参数方面还做出了一些特殊的调校,如降低 ISO、调整白平衡并适当扩大对焦范围等。图 2-27 为使用"星轨"模式拍摄的星轨照片,呈现出华丽而奇幻的超现实画面效果。

图 2-27 星轨效果

2.3.5 运动轨迹：捕捉匆匆流逝的身影

"运动轨迹"模式能够在长曝光的基础上，自动检测画面中运动的物体，同时保留其运动的轨迹，非常适合记录物体运动时的姿态。例如，用"运动轨迹"模式拍摄人物奔跑的画面，然后选出几张照片，即可合成为一张照片里面有几个同一人物在运动中的不同姿势。

图2-28为使用"运动轨迹"模式拍摄的白鹭飞舞的身影。在努比亚手机的"相机家族"功能中选择"运动轨迹"模式，点击快门按钮后，手机会连续拍摄多张照片，以记录白鹭的运动轨迹。用户则可以从中选择几张，将白鹭的运动轨迹呈现在一张图片上。

图2-28 白鹭飞舞的身影

第 3 章

专业参数，单反大片

　　除了直接使用手机内置的"慢门"模式拍摄慢门作品外，大家还可以通过"专业"模式来拍摄慢门作品。"专业"模式可以实现各种高级参数的调整，如光圈、快门速度、测光模式、感光度、曝光补偿以及焦距等，能够为用户带来单反般的拍摄体验。

3.1 设置要点：精准控制手机的曝光参数

如今，大部分的安卓智能手机都带有"专业"相机模式，可以手动设置感光度、快门、曝光补偿和白平衡等参数，能够使拍摄出来的慢门照片更加符合要求。本节主要介绍各种基本拍摄参数的设置方法。

3.1.1 了解专业模式

"专业"模式是指可以自定义设置曝光参数的模式。例如，在360手机相机的"更多模式"界面中，选择"专业"模式进入其拍摄界面，下面显示了一排可以设置的高级参数，如白平衡、感光度、曝光、快门时间和焦距等，如图3-1所示。

图3-1 "专业"模式拍摄界面

3.1.2 设置测光模式

测光模式是测定被摄对象亮度的功能。根据测光范围不同，测光模式具有多种方法，如360手机相机的"专业"模式中，包括点测光、中央重点测光以及平均测光3种测光模式，如图3-2所示。为了获得正确的画面曝光，摄影朋友们需要了解这些测光模式各自的特征。

（1）中央重点测光：对画面中央的拍摄对象进行准确测光，可以让此部分的曝光更加精准，同时兼顾画面两侧的亮度。

（2）点测光：只对很小的区域或某一个对象进行准确测光，精度很高。

（3）平均测光：手机在拍摄时将画面纵横等分64或128个区域，将不同区域的曝

光参数进行平均,得到一个平均的曝光值。使用该模式可以快速获得曝光均衡的画面,不会出现局部的高光过曝,整个画面的直方图也比较平衡。

图 3-2　常见的 3 种手机测光模式

在夜晚进行慢门摄影时,由于环境中的光比反差比较大,尤其是暗部部分,通常是一片死黑,此时用户可以根据拍摄题材来选择合适的测光模式。例如,拍摄车流灯轨时,可以选择点测光模式,将画面中的次亮区作为测光区域,如车灯或路灯,来重点突出这些元素,如图 3-3 所示。

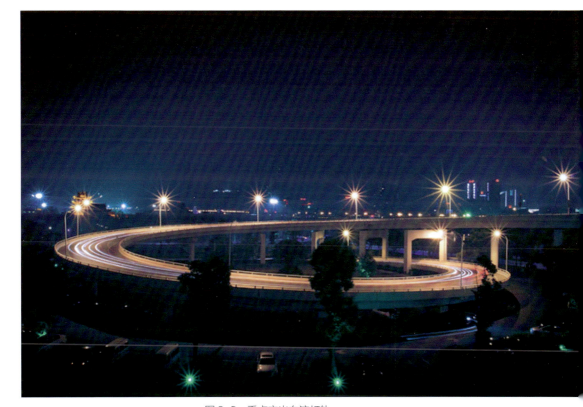

图 3-3　重点突出车流灯轨

再如,用户如果想要同时展现马路周边的建筑夜景,则可以选择平均测光模式,将更多画面元素拍摄出来,如图 3-4 所示。

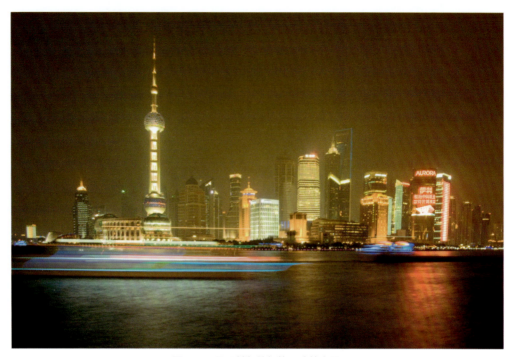

图 3-4 展现轮船的灯轨和建筑夜景

3.1.3 设置光圈参数

光圈可以控制透过镜头的光线数量,手机专业模式虽然无法直接设置光圈参数,但我们可以通过调整快门速度和 ISO 来间接控制合理的光圈参数。例如,华为 P30 手机中提供了大光圈拍摄模式,在其中可以自定义光圈数值,用 f 值表示大小,如 f/2.4、f/2.8 和 f/4 等,如图 3-5 所示。具有大光圈功能的手机,可以让更多光线进入相机,从而增加曝光,让相片变亮,能拍出更清晰的照片。

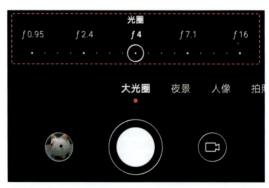

图 3-5 设置光圈参数值

慢门摄影的拍摄场景通常都比较大,需要对较大范围进行合焦并清晰成像,同时在昏暗的弱光环境下拍摄时,则可以适当调大光圈,来获得清晰的画面效果。如图 3-6 所示,这张照片的光圈为 f/11,从而获得正确的画面曝光。

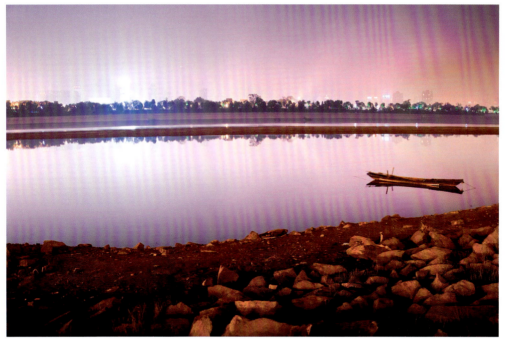

图 3-6 曝光正确的水景作品

3.1.4 设置快门速度

快门是控制照片进光量一个重要的部分，如果把相机曝光拍摄的过程比作用水管给水缸装水的话，快门控制的就是水龙头的开关。水龙头控制装多久的水，而快门则控制光线进入传感器的时间。用好快门速度，能够有效减少废片出现的概率。

例如，在华为手机的"专业"模式中，S 表示快门速度，点击该图标即可设置，左侧为高速快门区，右侧为慢速快门区，如图 3-7 所示。

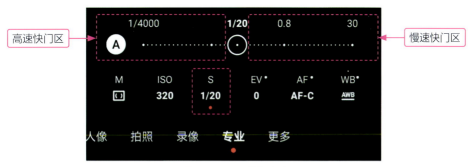

图 3-7 设置快门速度

快门分为高速快门与慢速快门两种，下面进行相关介绍。

(1) 高速快门：顾名思义就是快门在进行高速运动，可以用来记录快速移动的物体，例如汽车、飞机、宠物、人物、水滴和海浪等。

(2) 慢速快门：指快门以一个较低的速度来进行曝光工作。如图 3-8 所示，小溪流

水的雾化效果就是使用慢速快门拍摄出来的，其曝光时间为 1/2 秒。

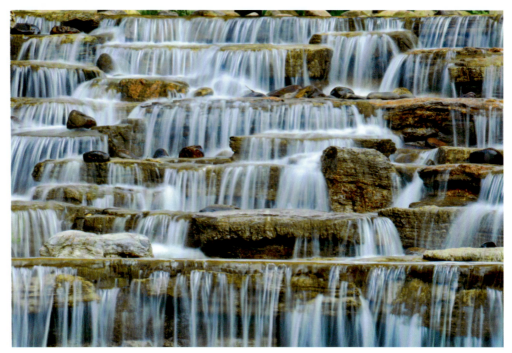

图 3-8　小溪雾化效果

3.1.5　设置 ISO 参数

ISO 我们通常称为感光度，即手机的感光元件对光线的敏感程度，反映了其感光的速度。ISO 的调整规则：感光度数值越高，则对光线越敏感，拍出来的画面就越亮；反之，感光度数值越低，画面就越暗。在华为手机的"专业"模式中，ISO 表示感光度参数，点击该图标即可设置，如图 3-9 所示。

图 3-9　设置 ISO 感光度

高感光度的特点为：噪点多，影响画面的质量；手机相机对光线非常敏感，所以在暗光环境下也能获得充足的光线，使得快门速度提高，便于手持拍摄。

低感光度的特点为：成像质量佳，画面效果更出色；手机相机对光线的敏感程度低，

在光线稍暗的场景中，快门速度则会降低，不利于手持拍摄，这个时候如果使用三脚架来拍摄照片，画面质感会好很多。如图 3-10 所示，拍摄的是烟花绽放的画面，其感光度为 50、曝光时间为 3.1 秒。

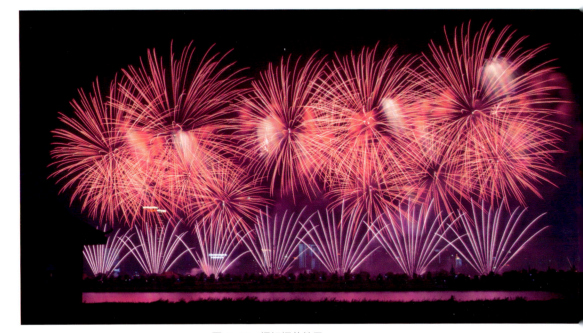

图 3-10　慢门烟花效果

3.1.6 设置曝光补偿

当环境中的光线太暗或太亮的时候，我们就可以手动来增加或减少曝光补偿。调整曝光补偿有两种方式：一是测光对焦，在手机屏幕上点击就可以了，优点是方便操作，缺点是有时会失灵；二是手动调整曝光补偿，以华为手机为例，在"专业"模式中点击 EV 图标即可设置，如图 3-11 所示。

图 3-11　设置曝光补偿

如图 3-12 所示，在拍摄这张照片时，环境中的光线比较复杂，既有车灯和路灯，又有建筑上的霓虹灯，因此拍摄时将曝光补偿设置为 -1.3，并设置曝光时间为 30 秒，拍摄出清晰、动感的城市夜景效果。

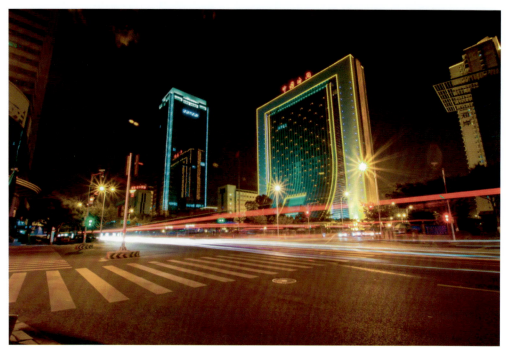

图 3-12 清晰、动感的城市夜景效果

3.1.7 设置焦距参数

　　焦距是指焦点到凸透镜光心的距离，焦距越短，景深越大，视角越大，同时背景元素更多，画面更有空间感；焦距越长，景深越浅，视角越小，同时背景元素更少，画面更有压缩感。图 3-13 为 360 手机相机"专业"模式中的"焦距"调整功能，左右拖曳白色圆形滑块即可改变焦距，最左侧为自动焦距模式 (AUTO)。

图 3-13 "焦距"调整功能

　　如图 3-14 所示，通过手动调整焦距形成虚焦状态，同时调大光圈，来拍摄迷人的星斑照片效果，其焦距为 100 毫米、曝光时间为 1/20 秒。

图 3-14 迷人的星斑照片效果

3.1.8 设置饱和度参数

饱和度是指画面色彩的纯度,饱和度参数越高,色彩就越鲜艳;饱和度参数越低,色彩就越趋近于黑白色。图 3-15 为 360 手机相机"专业"模式中的"饱和度"调整功能。

图 3-15 "饱和度"调整功能

在拍摄慢门作品时,可以适当增加饱和度,让光线的色彩更为明亮和生动,从而增强画面的表现力,如图 3-16 所示。

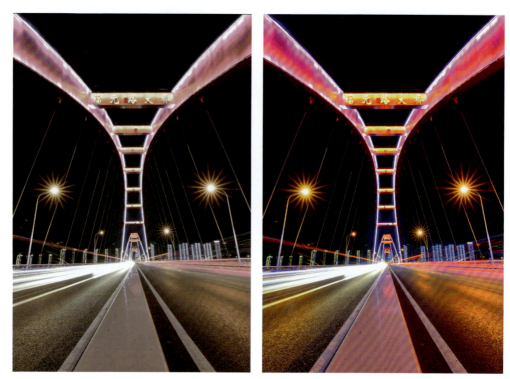

图 3-16 低饱和度（左）和高饱和度（右）的画面效果对比

3.1.9 设置对比度参数

对比度是指画面中的黑与白的比值，对比度越大，画面中亮部与暗部的对比就越明显，反之则明暗对比就越小。图 3-17 为 360 手机相机"专业"模式中的"对比度"调整功能。

图 3-17 "对比度"调整功能

在进行手机慢门摄影时，增加对比度可以看到图像的轮廓会更加明显，不过反差不大的部分损失也就会越多，如图 3-18 所示。

图 3-18 低对比度（左）和高对比度（右）的画面效果对比

3.1.10 设置白平衡参数

白平衡，字面的理解是白色的平衡，但实际核心是色温的变化。不同的场景下，物体颜色会因投射光线颜色而产生改变。手机毕竟只是机器，有时无法准确地判断当时的光线，造成照片偏色，这时则需要利用手机相机"专业"模式中的"白平衡"功能来手动校色，还原景色最原本的颜色。

在拍摄复杂光线的时候，由于环境光线的增加，对手机的测光系统是一个极大的考验。使用自动白平衡时，经常出现白平衡不准确的情况，摄影师将其称为"白平衡漂移"。这时我们就应该打开"白平衡"设置，自行调节白平衡范围。

例如，在华为手机相机的"专业"模式中，点击 WB 图标，即可打开白平衡模式列表，其中包括 6 种模式，即自动、多云、荧光灯、白炽灯、日光、手动模式，如图 3-19 所示。每种模式名称下对应着的是色温值，色温值越高，画面颜色越暖，偏向橙黄色；色温值越低，整体画面颜色则就越冷，偏向蓝色。选择不同的白平衡模式，会产生不一样的画面效果。

（1）自动白平衡模式：显示为 AWB 图标，选择自动白平衡模式后，手机会自动补偿光源的颜色，可以比较准确地还原画面色彩，在拍摄慢门作品时最为常用，照片效果如图 3-20 所示。

图 3-19　设置手机白平衡模式

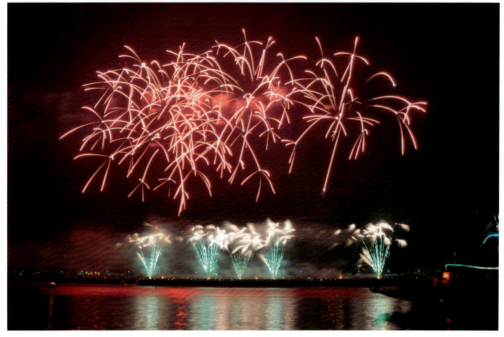

图 3-20　烟花效果

（2）多云白平衡模式：适合在没有太阳的阴天，或者多云的天气下使用，可以使环境光线恢复正常的色温效果，营造出一种泛黄的暖色调效果。

（3）荧光灯白平衡模式：这是对白色荧光灯的色调进行补偿的白平衡模式，可抑制白色荧光灯光线偏绿的特性，营造出冷蓝色的画面效果。

（4）白炽灯白平衡模式：该白平衡模式会对白炽灯的色调进行补偿，能够对白炽灯光线偏红的特性产生抑制作用，营造出一种偏蓝的冷色调画面。

（5）日光白平衡模式：适合在晴天日光条件下使用，可以对室外拍摄场景进行如实显色。

（6）手动白平衡模式：选择该模式后，我们可以先测量现场的光线，拍摄白色或灰色的对象，然后用该数值进行白平衡的补偿设置。图 3-21 为同一场景下使用手动白平衡模式拍摄的不同画面效果。

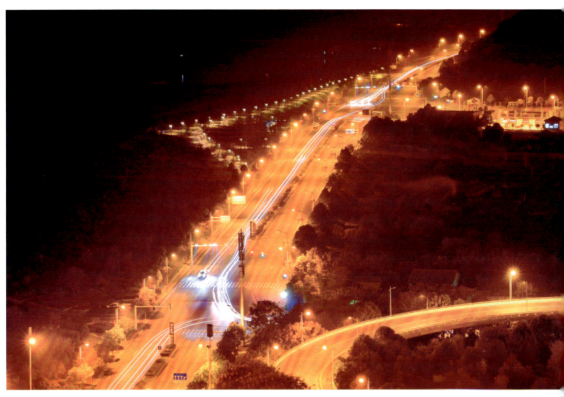

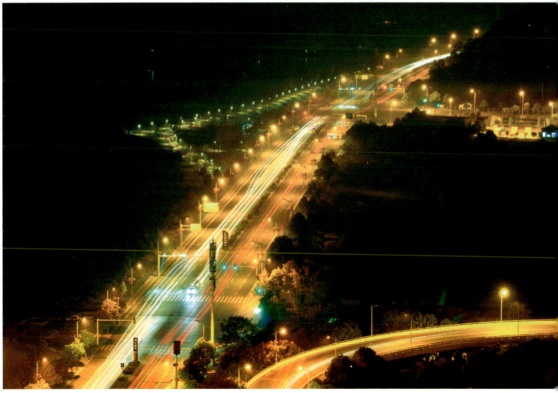

图 3-21 车流灯轨效果

3.2 长曝光拍摄：捕捉时间流逝的动态美

长时间曝光，简称"长曝光"，即使用慢速快门进行拍摄。前面的知识点中介绍过，慢速快门的曝光时间要慢于 1/30 秒，有时候是 10 秒、30 秒、50 秒等，这都属于长曝光。本节主要介绍长曝光的作用，以及在手机中设置长曝光的方法。

3.2.1 长时间曝光的作用

使用手机进行长时间曝光通常有两个作用。

第一，在光线不足的情况下，通过长时间曝光提升画面的亮度，如夜景拍摄。

第二，使用长时间曝光的手法，将画面中较长一段时间内发生变化的景象全部记录下来，得到肉眼不能直观看见的梦幻般的画面。如图 3-22 所示，通过 14 秒的长时间曝光，完整地记录了烟花的燃放过程。使用长曝光不仅可以将烟花拍摄成丝状，还可以拍摄出水面的雾化效果。

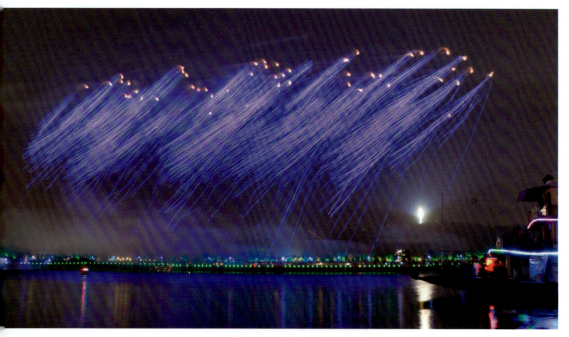

图 3-22　完整记录烟花的燃放过程

3.2.2 在手机中设置长曝光

下面以 360 手机为例，介绍使用长曝光拍摄水面的操作方法。

步骤 01 将手机架在三脚架上稳固好，在手机相机中，打开"专业"模式，选择"快门时间"选项，如图 3-23 所示。

步骤 02 在"快门时间"控制条中，向右拖曳白色圆形滑块，设置曝光时间为 8 秒，表示使用 8 秒的长曝光来拍摄画面，如图 3-24 所示。

第 3 章 专业参数，单反大片

图 3-23 选择"快门时间"选项

图 3-24 设置快门参数

步骤 03 点击下方的快门按钮，即可开始长曝光的拍摄，效果如图 3-25 所示。

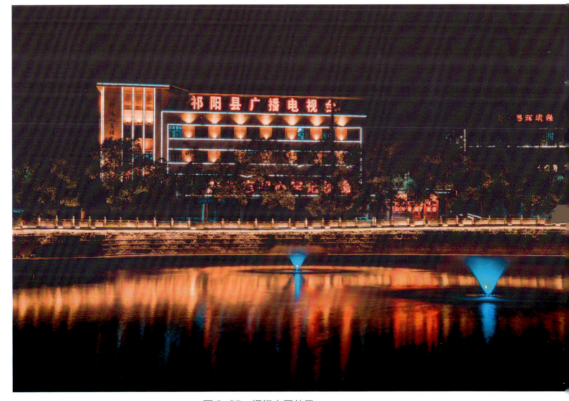

图 3-25 慢门水景效果

3.2.3 原生相机追焦拍摄

在使用手机的原生相机进行慢门拍摄时，除了"专业"模式和预设的"慢门"模式外，还可以通过原生相机追焦拍摄的方式进行慢门摄影。

追焦拍摄是在慢速快门的基础上，同时跟随运动物体保持同样的方向一起运动，从而实现主体清晰、背景模糊的画面效果，体现出画面的流动感和视觉冲击力，如图3-26所示。

图 3-26 追焦拍摄效果

其实，追焦拍摄可以看作是普通慢门摄影的反向操作，只是操作难度要更大，需要多练、多拍。在普通慢门摄影中，通常是主体运动，呈现出模糊状态；使用追焦拍摄时，则刚好相反，运动的主体反而变成了静止对象，在画面中清晰成像，而静止的背景则由于焦点的快速运动变成了运动对象，在画面中显得非常模糊。

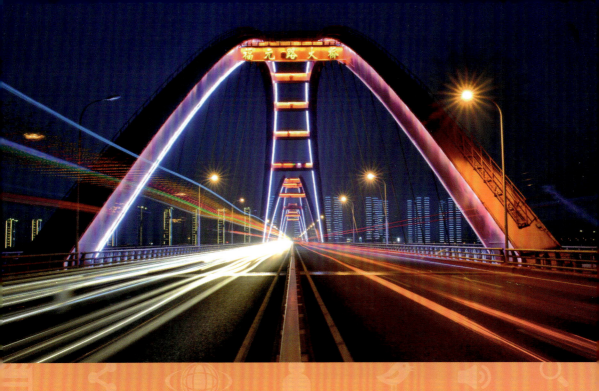

第 4 章

慢门相机，轻松拍摄

前面介绍了很多安卓手机的慢门拍摄方式，那么对于没有慢门功能的苹果手机和其他品牌手机来说，要如何才能进行慢门摄影呢？其实，如果只是一般的慢门摄影爱好者，我们也可以通过在手机上安装一些慢门摄影 App 来实现长曝光的拍摄。本章将介绍一些常用慢门摄影 App 的基本功能和拍摄技巧，帮助大家快速上手。

4.1 Slow Shutter Cam：专门的慢门拍摄软件

Slow Shutter Cam 是苹果手机上常用的慢门摄影 App，是一款付费应用，苹果用户可以在应用商店下载，如图 4-1 所示。在手机上下载并安装 Slow Shutter Cam App 后，打开应用即可进入其拍摄界面，如图 4-2 所示。

图 4-1　Slow Shutter Cam 下载界面

图 4-2　Slow Shutter Cam 拍摄界面

在 Slow Shutter Cam App 的拍摄界面中，各个图标功能如下。

- ⬤：拍照选项按钮，点击可以看到动态模糊、灯光轨迹和低光模式 3 个慢门模式选项。
- ⬤：拍照快门按钮，点击即可开始拍照。
- ⬤：相机设置功能，其中提供了很多设置选项，如自动定时开启拍摄、画面质量设置、工作流程、增强感光度和声效等。
- ⬤ ➕、➖：数码变焦控制条，上下拖曳白色圆圈滑块，实现变焦效果。
- ⬤：曝光控制点，调整曝光点的位置。
- ⬤：对焦控制点，调整对焦点的位置。
- ⬤：闪光灯控制按钮，用于控制闪光灯的开关。
- ⬤：开启或关闭效果预览功能。
- ⬤：开启或关闭自动曝光功能。
- ⬤：开启或关闭自动对焦功能。
- ⬤：反转镜头功能。
- ⬤：在方框中显示效果预览图。

4.1.1 动态模糊：适合拍摄高速运动的物体

在 Slow Shutter Cam App 的拍摄界面中，点击左下角的拍照选项按钮，在弹出的 Capture Mode（拍摄模式）菜单中选择 Motion Blur（动态模糊）选项，如图 4-3 所示。动态模糊拍摄模式下方包括两个参数设置，分别为 Blur Strength（模糊强度）和 Capture Duration（曝光时间）。

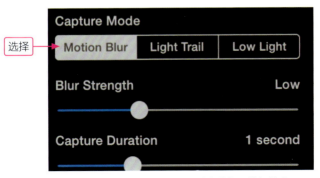

图 4-3 选择 Motion Blur（动态模糊）拍摄模式

动态模糊拍摄模式主要用于拍摄高速运动的物体，如飞奔而过的汽车或火车，以及快速流动的瀑布水流等，可以呈现出运动模糊的画面效果，如图 4-4 所示。

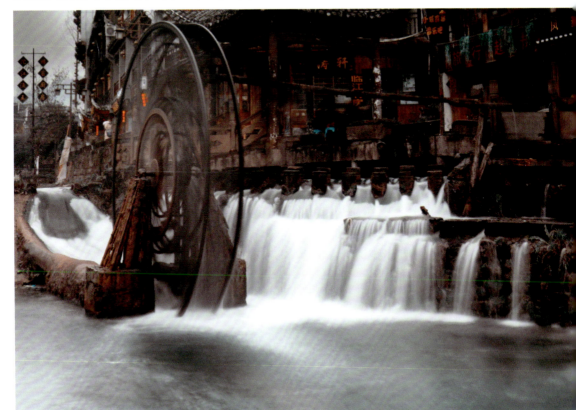

图 4-4 拍摄虚化的水流效果

4.1.2 灯光轨迹：适合拍摄光源移动的轨迹

在 Slow Shutter Cam App 的 Capture Mode（拍摄模式）菜单中选择 Light Trail（灯光轨迹）选项，即可切换至灯光轨迹拍摄模式，如图 4-5 所示。灯光轨迹拍摄模式下方包括两个参数设置，分别为 Light Sensitivity（感光度）和 Capture Duration（曝光时间）。

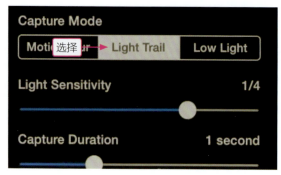

图 4-5 选择 Light Trail（灯光轨迹）拍摄模式

灯光轨迹拍摄模式主要用于在夜晚环境下拍摄移动的光源，如车流灯轨、星轨和光绘摄影等。如图 4-6 所示，使用灯光轨迹模式拍摄马路上飞驰而过的汽车灯光，可以让车灯变成绚丽的彩色线条。

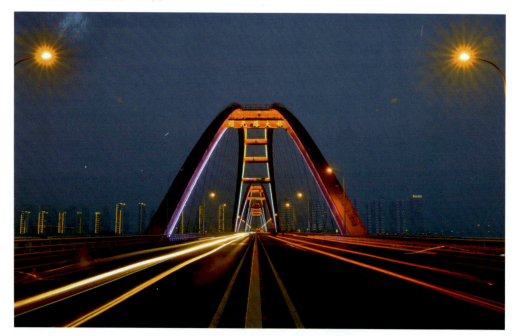

图 4-6 拍摄飞驰而过的汽车灯光效果

4.1.3 低光模式：适合弱光下拍摄静态夜景

在 Slow Shutter Cam App 的 Capture Mode（拍摄模式）菜单中选择 Low Light

(低光模式)选项,即可切换至低光拍摄模式,如图 4-7 所示。低光拍摄模式下方包括两个参数设置,分别为 Exposure Boost(增强曝光)和 Capture Duration(曝光时间),调整 Exposure Boost 还可以实现降噪功能。

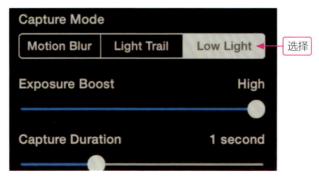

图 4-7　选择 Low Light(低光模式)拍摄模式

低光拍摄模式主要用于提升苹果手机的弱光拍摄性能,能够很好地增加画面的亮度,同时还通过设置曝光时间来模拟慢快门的拍摄效果。如图 4-8 所示,使用低光拍摄模式拍摄的城市霓虹灯,让灯光更加明亮,同时可以很好地抑制画面中的噪点。

图 4-8　拍摄城市霓虹灯效果

4.2　Camera FV-5:功能强大的慢门摄影App

Camera FV-5 是一款功能非常强大的摄影 App,我们可以通过这个 App 调整手机镜头的各种拍摄参数,包括曝光补偿、ISO、测光模式、对焦模式、白平衡和程序模

式等，并且支持类似单反相机取景器的显示效果、完整的包围曝光、内置定时曝光和长时间曝光等功能，如图4-9所示。

图4-9　Camera FV-5 App 的部分功能

本节将重点介绍 Camera FV-5 App 的长时间曝光功能，从而帮助手机实现慢门摄影效果。安装好 Camera FV-5 App 后，打开即可看到其主界面，如图4-10所示。其中，各部分功能包括❶常规设置、❷快门设置、❸拍摄工具、❹闪光灯设置、❺对焦模式、❻白平衡设置、❼测光模式、❽感光度设置、❾曝光补偿。

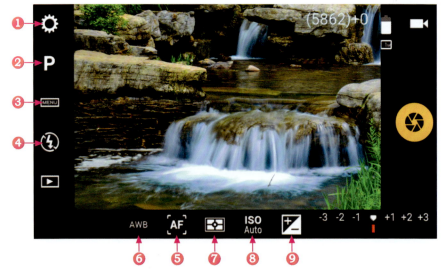

图4-10　Camera FV-5 App 的主界面

4.2.1　快门设置：精准地控制曝光时间

Camera FV-5 App 的长时间曝光功能非常强大，支持的曝光时间可长达60秒，

第 4 章 慢门相机，轻松拍摄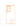

可以帮助用户轻松捕捉光线的运动轨迹，获得美丽的夜景照片。使用 Camera FV-5 App 拍摄慢门作品时，我们首先要进行快门速度设置，它可以控制手机拍摄时的曝光时间。

点击"快门设置"按钮P，弹出"程序模式"设置菜单，如图 4-11 所示。快门设置分为 P 档（全自动）和 S 档（快门优先）两种，点击 S 档后即可设置曝光和快门。

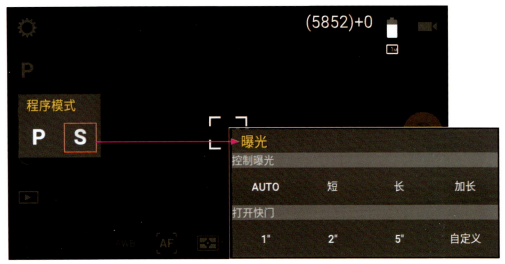

图 4-11 "程序模式"设置菜单

"控制曝光"选项不能进行具体参数调节，但可以应用多种默认参数，能够满足一般的拍摄需求，因此这里用户只需了解一下即可。

(1) Auto：即自动曝光模式，与单反相机中的 P 档类似，App 会根据拍摄者所处的光线环境来自动测算曝光时间，效果与手机自带的原生相机相似。

(2) 短：加快曝光时间，通常比根据环境光计算得出的时间要更快一些。

(3) 长：减慢曝光时间，通常比根据环境光计算得出的时间要更慢一些。

(4) 加长：比"长"选项的曝光时间更长。

"打开快门"选项则可以帮助用户更加精确地控制曝光时间，这也是进行手机慢门摄影时常用到的参数设置。

(1) 1"、2"、5"：选择相应的数字，可以分别设置 1 秒、2 秒、5 秒的曝光时间。例如，选择 5"，表示按下手机快门后相机开始曝光，曝光时间会延续 5 秒才关闭。在这 5 秒内，手机摄像头会记录取景范围内的所有固定光源或移动光源。其中，那些移动的光源就会形成运动轨迹，这也是光绘慢门摄影的原理所在。

(2) 自定义：在拍摄慢门题材时，如果 5 秒的曝光时间还不够用，此时"自定义"选项就可以帮助用户获得更长的曝光时间，如图 4-12 所示。

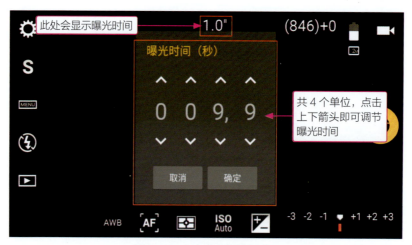

图 4-12　自定义设置曝光时间

4.2.2　自动定时器：更稳定的快门方式

在"拍摄工具"菜单中，包含了很多拍摄模式的设置，如定时和连拍等。其中，"自动定时器"可以设置自动拍摄倒计时的时间，有 2 秒、5 秒和 10 秒 3 个时间段可选择，这是进行手机慢门摄影时经常会用到的一个功能，如图 4-13 所示。

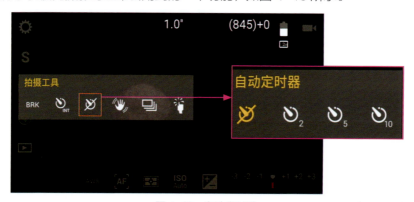

图 4-13　自动定时器

"自动定时器"主要有两个实用的场景，第一个就是手机自拍，另一个就是慢门摄影了。前面说过，慢门摄影获得成功最主要的因素就是稳定，用户尽量不要用手去点击手机屏幕上的快门按钮，避免因手机震动造成画面模糊，而 Camera FV-5 App 暂不支持遥控快门，此时就只能利用"自动定时器"来辅助拍摄了。

4.2.3　慢门流程：体验手机拍摄的乐趣

熟悉了慢门摄影要用到的功能后，接下来我们就可以开始拍摄了，下面介绍使用 Camera FV-5 App 进行慢门创作的拍摄流程。

步骤 01 牢牢固定手机：利用三脚架或手机支架固定好手机。

步骤 02 选择拍摄对象：选择要拍摄的合适场地，如广场、街道或者马路等，将三脚架

尽量放在高一点的地方。

步骤 03 正确构图：在进行构图取景时，注意画面中要有运动物体和静止物体来进行对比。例如，在夜晚的河岸，水中的轮船为运动物体，可以展现出灯轨效果，对岸的路灯和建筑霓虹灯则为静止物体，形成动静对比，同时用水平线构图，展现夜晚的宁静感，如图 4-14 所示。

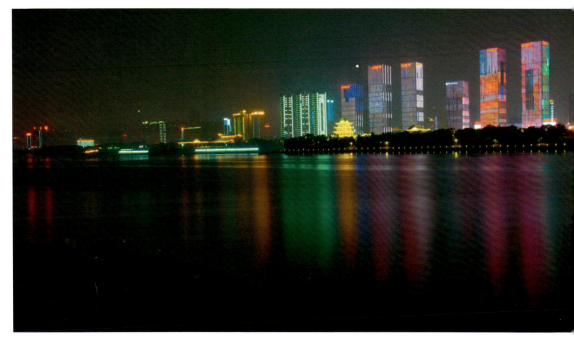

图 4-14 水平线构图效果

步骤 04 设置 App 参数：打开 Camera FV-5 App，首先进入"快门设置"界面设置相应的曝光时间，然后开启"自动定时器"功能，并设置相应的拍摄倒计时时间，用户可以根据实际情况来多次试验，达到想要的效果即可。

4.3 其他慢门App：手机即可轻松拍慢门

如今，随着手机的摄影硬件越来越好，以及手机原生相机的技术算法不断提升，手机也可以轻松拍摄各种慢门大片。同时，用户还可以在手机中下载各种慢门 App，实现更多的拍摄玩法。

4.3.1 ProCam6：拍夜景、车轨、流水的利器

ProCam6 App 支持类似"专业"模式的手动档拍摄功能，用户可以自行调节曝光补偿、感光度、曝光时间、对焦模式以及白平衡等参数，如图 4-15 所示。同时，ProCam6 App 还拥有动态模糊、光轨和低光等慢门模式，能够"一键傻瓜成像"，很好地满足了专业的长曝光拍摄需求，如图 4-16 所示。

手机慢门摄影与后期从入门到精通：夜景、人像、车轨、烟花、星空、光绘、丝绢流水、延时视频全攻略

图 4-15　自行调节拍摄参数

图 4-16　慢门拍摄模式

　　ProCam6 App 可以轻松实现长曝光和延时拍摄，是拍摄夜景、车轨和流水等慢门作品的利器，拍摄效果如图 4-17 所示。另外，ProCam6 App 还可以将照片存储为 RAW 格式，便于用户进行后期处理，获得高质量的成品效果。

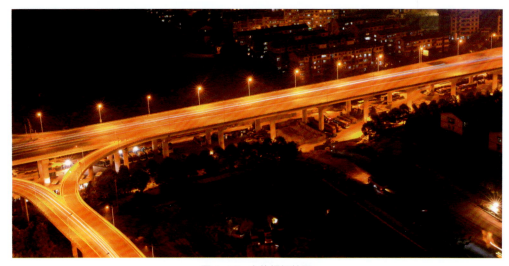

图 4-17　车轨慢门效果

4.3.2　Night Cap 相机：iPhone 上的"慢门之王"

　　跟前面介绍的操作比较"傻瓜"的 Slow Shutter Cam App 相比，"Night Cap 相机"App 的操作方式更加复杂，但其调整功能也更加全面、精细。

在"Night Cap 相机"App 的拍摄界面上，用户不仅能够调整各种参数，如 ISO、曝光时间、对焦点和白平衡等，而且能够设置长曝光模式、亮光轨迹、星拍模式、星迹拍摄模式、ISS 模式以及流星模式等拍摄功能，如图 4-18 所示。

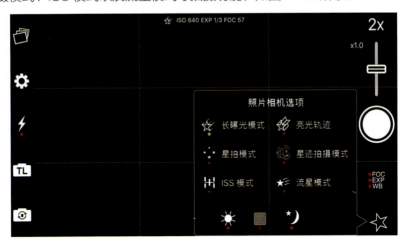

图 4-18　"Night Cap 相机"App 的拍摄功能

例如，长曝光模式可以增加曝光时间，获得跟相机同样的拍摄效果，非常适合拍摄流水等慢门作品，如图 4-19 所示。

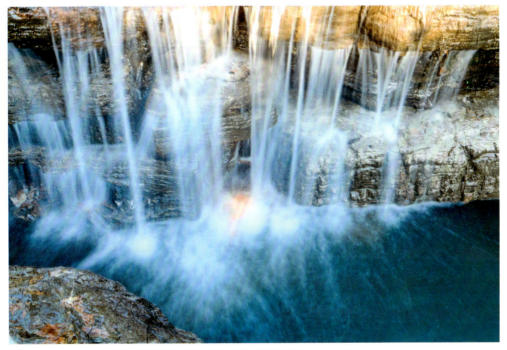

图 4-19　流水效果

再如，亮光轨迹主要是基于画面中有亮度的光线，通过堆栈叠加来实现慢门效果，适合拍摄车灯、光绘和风车等移动且明亮的物体轨迹，如图 4-20 所示。

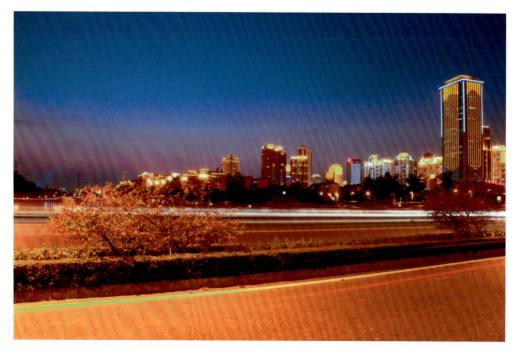

图 4-20 车流灯轨效果

另外，用户还可以尝试流星模式，用手机来拍摄转瞬即逝的流星，效果如图 4-21 所示。选择流星模式后，"Night Cap 相机"App 会自动延长曝光时间，将流星雨划过夜空所留下的星轨拍摄得一清二楚。

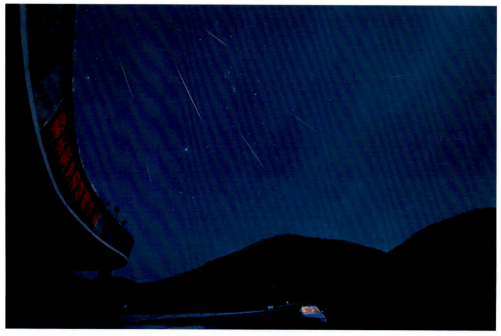

图 4-21 流星效果

4.3.3 Camera+：轻松实现手机慢门作品的拍摄

Camera+ 是一款社交图片分享 App，不仅可以拍照，而且还可以对照片进行简单编辑。Camera+ App 可以手动调整快门速度、感光度、焦距、曝光以及白平衡等参数，同时还可以实现焦光分离（分离曝光和对焦），从而更好地满足各种拍摄场景和拍摄需求，如图 4-22 所示。

图 4-22　Camera+ App 的拍照界面

点击 Camera+ App 拍照界面右下角的 ▤ 按钮，打开"设置"菜单，可以看到 Camera+ App 拥有非常丰富的拍摄功能，如图 4-23 所示。在"设置"菜单中选择"高级控制"选项，进入其界面，在此可以设置手动曝光模式，甚至有能够完全控制快门速度和 ISO 的"全手动"模式，如图 4-24 所示。

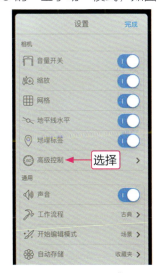

图 4-23　打开"设置"菜单　　　　　图 4-24　"高级控制"设置界面

"全手动"模式适合有经验的拍摄者,而对于新手来说,建议选择"快门优先级"手动曝光模式,这样可以实现更好的曝光效果,如图 4-25 所示。

图 4-25　车流灯轨效果

第 5 章

经典构图，增强美感

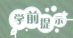

　　简单来说，构图就是一种安排镜头下各个画面元素的技巧，通过将人物和景物等进行合理的布局，从而更好地展现拍摄者要表达的主题，或者使画面看上去更加美观、有艺术感。另外，不同的构图形式，可以形成不同的画面视觉感受，用户在拍摄慢门作品时可以通过适当的构图形式，展现出独特的画面魅力。

5.1 平面构图：拍出画面的"简洁之美"

平面构图法中有很多种不同的类型，但是它们有个共同的特点，那就是以简单的线条和平面为基础来进行构图取景。对于拍摄慢门作品来说，掌握好平面构图技巧，不但可以锻炼用户的大脑思维能力，而且还能拍摄出画面的"简洁之美"。

5.1.1 水平线构图，让照片立刻上档次

平静、舒适是水平线构图呈现出来的视觉效果，同时在面对自然风光等大场面的慢门、夜景类题材时，这种构图形式还可以让景色更加辽阔、浩瀚。

1. 水平线构图1：拍摄大桥夜景

在夜晚拍摄大桥全景时，可以借助桥面或水面作为画面的水平线，可以使画面显得更加宽广，如图5-1所示。

图5-1 大桥夜景

2. 水平线构图2：拍摄城市水景

使用慢门拍摄夜晚的城市水景时，倒影在水流的变化下会显得非常朦胧，同时将水平线放置在画面中央，可以让江水显得非常平静，并且能够表现出江河的宽广，如图5-2所示。

慢门摄影因为长时间曝光，可以运用于水流的拍摄，以获得绸缎般的质感。水平线构图让城市的霓虹灯倒影如画，美不胜收，如图5-3所示。

第 5 章　经典构图，增强美感

图 5-2　城市水景 (1)

图 5-3　城市水景 (2)

5.1.2 三分线构图，让画面效果更加美观

三分线构图，顾名思义，就是将画面从横向或纵向分为三部分，在拍摄时将对象或焦点放在三分线的某一位置上进行构图取景，不仅可以让主体对象更加突出，而且可以让画面效果更加美观。

例如，下面这张照片的天空占了整个画面上方的三分之一，水面和岸边的景物占了整个画面下方的三分之二，形成了上三分线构图，这样不仅突出了重点，而且在视觉上也更加令人愉悦，如图5-4所示。

图 5-4　海岸效果

在进行构图时一定要根据取景对象和拍摄环境，灵活多变，切不可墨守成规。例如，下面这张照片笔者就没有将水平线作为三分线，而是将烟花的爆裂中心点之间的连线，这个成水平规律的主体放在画面上方的三分线上，如图5-5所示。

图 5-5　烟花效果

有时候，主体对象比较大，一条线也许无法很好地展现其全貌，此时也可以结合"三分线+面"的构图形式，将画面划分为三个面积相同的矩形，并将主体对象置于其中一个矩形块内部，这样就形成了横向双三分线构图。

如图5-6所示，将喷泉和建筑主体放置于画面中间的三等分位置处，通过独特的三分线构图可以使画面变得更加生动，富有活力。

图5-6　横向双三分线构图

如图5-7所示，将最高的一幢大楼安排在左三分线上，可以使画面更加紧凑，同时也起到了平衡画面并转移视线至右侧风景的作用，使水面在建筑灯光的照射下显得更加艳丽，为画面增添了美感。

图5-7　左三分线构图

5.1.3 九宫格构图，赋予画面新的生命

九宫格构图又叫井字形构图，是指用横竖各两条直线将画面等分为 9 个空间，不仅可以让画面更加符合人们的视觉习惯，而且还能突出主体、均衡画面。使用九宫格构图，可以将主体放在 4 个交叉点上，也可以将其放在 9 个空间格内，从而使主体非常自然地成为画面的视觉中心。

如图 5-8 所示，将一个海螺安排在九宫格右下方的交叉点上，让大家的焦点一下就集中在了主体上。从视觉习惯上讲，右下角是最后的交叉点，所以这种构图往往可以带来别样的艺术效果。

图 5-8 九宫格右下单点构图

当然，不同的位置有不同的视觉效果，例如在 4 个交叉点中，上面的两个点就比下面的两个点更能呈现变化与动感，因此为画面带来的活力也更强一些。

5.1.4 斜线构图，使画面充满动感与活力

在慢门摄影中，斜线构图是一个使用频率颇高，而且也颇为实用的构图方法。斜线构图是在静止的横线上出现的，具有一种静谧的感觉，同时斜线的纵向延伸可以加强画面深远的透视效果，斜线构图的不稳定性可以使画面富有新意，给人以独特的视觉感受。利用斜线构图还可以使画面产生三维的空间效果，增强画面立体感，使画面充满动感与活力，且富有韵律感和节奏感。

如图 5-9 所示，下面这张照片用慢速快门将路面的车流灯轨完整地记录下来，路面倾斜的直线可以给欣赏者带来流动、失衡、运动的视觉感受，完美地烘托了慢门夜景的画面氛围，强调了汽车奔驰中的画面场景。

第 5 章 经典构图，增强美感

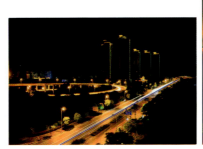
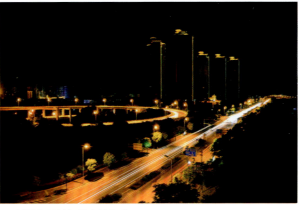

图 5-9 斜线构图拍摄的车流灯轨

如图 5-10 所示，在拍摄慢门烟花题材时，使用斜线构图可以增加画面的延伸性，让画面构图更加精致。

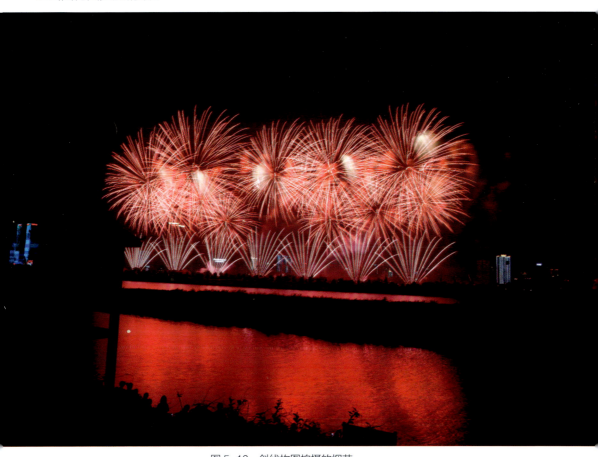

图 5-10 斜线构图拍摄的烟花

使用斜线构图拍摄照片时，转动手机镜头可以让画面的视觉效果更加新鲜。如图 5-11 所示，使用斜线构图拍摄的立交桥，具有很强的视线导向性。

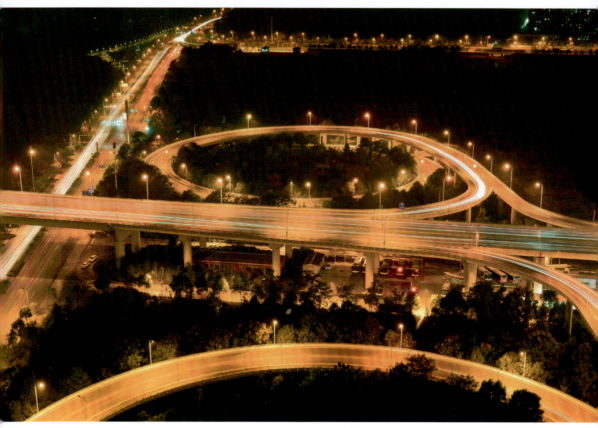

图 5-11　斜线构图拍摄的立交桥

5.1.5 黄金分割构图，构图的经典定律

黄金分割构图是以 1:1.618 这个黄金比例作为基本理论，可以让我们拍摄的慢门照片更自然、舒适、赏心悦目，更能吸引观众的眼球。

黄金分割构图的适用场景为：画面中有主体对象，或主体对象存在某一个特别显眼的亮点。如图 5-12 所示，将画面中最亮的灯光放置在左上角的黄金分割点上，能够吸引更多的注意力，而且还能同时增强画面的层次。

黄金分割线有一种特殊的表达方法，那就是黄金螺旋线，它是根据斐波那契数列画出来的螺旋曲线，是自然界最完美的经典黄金比例。

需要注意的是，使用黄金分割构图拍摄慢门照片时，最好提前将要拍摄的焦点在线与线交汇处校准好，这样才能拍出完美比例的照片。

图 5-12 黄金分割构图

5.2 空间构图：拍出立体感十足的效果

前面介绍了二维平面的一些基本构图技巧，本节主要介绍一些空间感非常强烈的构图形式，如透视构图、框式构图、对称构图、倒影构图、明暗构图以及几何形态构图等。通过在照片中营造空间感，来增强代入感，使欣赏者身临其境，产生情感上的共鸣。空间构图的形式更加灵活，画面效果更加丰富，可以极大地增强用户的创新能力，拍出更美更好的慢门作品。

5.2.1 透视构图，给画面带来强烈的纵深感

近大远小是基本的透视规律，绘图是这样，摄影也是如此，透视构图可以增加画面的立体感。

如图 5-13 所示，隧道建筑上的线条在画面中都呈现出斜线的特征，多根线条与圆环结合在一起，形成了斜线透视构图。可以看到，实际上同样大小的圆环在照片中具有非常明显的"近大远小"的透视效果。

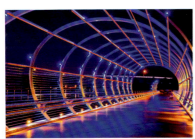
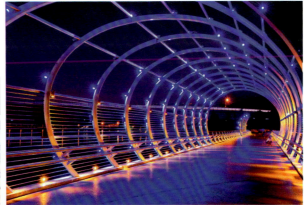

图 5-13 斜线透视构图拍摄的隧道

斜线原本是一种静止的状态，但在透视的影响下，多根斜线的纵向延伸又呈现出一定的运动特性，为画面带来了层次和变化。

如图 5-14 所示，大桥一直从画面左侧从近到远延伸，呈现出非常明显的透视效果，画面左侧的线条宽度比较大，而画面右侧的线条则逐渐聚合到一起。

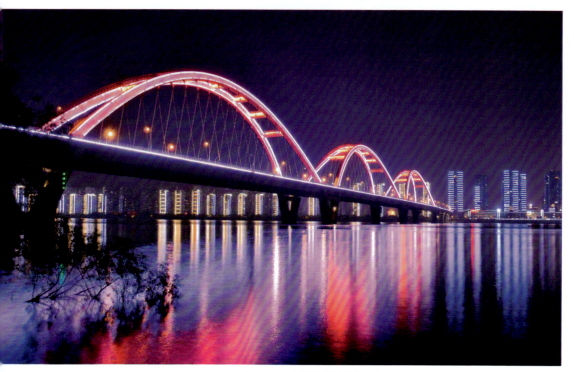

图 5-14 透视构图拍摄的大桥

如图 5-15 所示，使用双边透视构图拍摄隧道走廊，可以让画面更有空间感。

图 5-15 双边透视构图拍摄的隧道走廊

在线条的汇聚过程中，有些直线和平行线都以斜线的方式呈现，这样使画面更有视觉张力，纵深感很强。

5.2.2 框式构图,透过"窗"看看外面的好风景

框式构图也叫框架式构图,也有人称为窗式构图或隧道构图。框式构图的特征是借助某个框式图形来构图。而这个框式图形,可以是规则的,也可以是不规则的,可以是方形的,也可以是圆形的,甚至是多边形的。

框式构图主要是通过门窗等框架作为前景,可以起到突出主体的作用。如图5-16所示,通过后期的合成处理进行二次构图,添加一个椭圆形的鱼缸作为前景框架。照片就像画作一样,透过透明的鱼缸引导欣赏者的视线至被拍摄对象上,使得画面的层次感增强,同时具有更多的趣味性,形成不一样的画面效果。

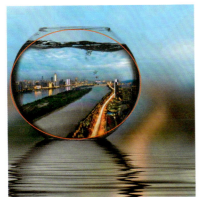
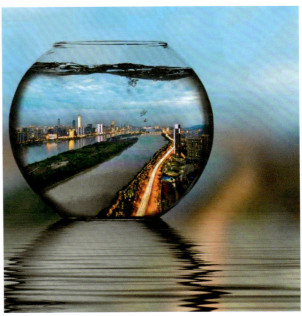

图 5-16 框式构图

> **专家提醒**
>
> 框式构图可以让欣赏者感受到,由框内对象和框外空间所组成的多维空间感。用户还可以将框里框外的多个空间元素组合在一起,这样可以更好地提升空间层次。

5.2.3 对称构图,打破常规,让照片更加出彩

对称构图是指画面中心有一条线把画面分为对称的两份,可以是画面上下,也可以是画面左右,或者是画面斜向,这种对称画面会给人一种平衡、和谐的感觉。中国传统艺术讲究的就是对称,上下对称、左右对称,对称的景物都会让人感到画面稳定。

如图5-17所示,以大桥中央为垂直对称轴,画面左右两侧的建筑和灯光对称排列,拍摄时注意要横平竖直,尽量不要倾斜。

图 5-17 对称构图

> **专家提醒**
>
> 斜面对称构图，是以画面中存在的某条斜线或对象为分界线进行取景构图，而且斜线越是接近对角线，则分隔的画面对称感越强烈。

5.2.4 倒影构图，得到别具一格的画面效果

生活中的倒影无处不在，我们在拍摄慢门作品时，也可以利用各种反光面来创造独特的构图方式，得到别具一格的画面效果。用户可以多留意周边的事物，尤其是那些反光物体，如玻璃镜子、窗户、路面的积水、湖面、江面、地板以及手机屏幕等，这些都可以作为反射面。如果找不到，也可以用矿泉水来制作一个小水滩。

如图 5-18 所示，采用逆光拍摄，在天空还未完全变黑的时候，适用慢速快门拍摄水景，曝光时间为 13 秒，平静的水面将建筑完全清楚地倒映出来，这样更容易拍出不错的倒影画面效果。

拍摄倒影构图的画面时，要尽量将水平线放在画面中央，这样画面会显得更加对称、整齐，如图 5-19 所示。

同时，用户还可以添加一些前景元素，如树木、岩石或者渔船等，让画面意境更高、更具美感。

如图 5-20 所示，在拍摄水边的建筑夜景时，如果拍摄距离比较近，则可以采用竖画幅的取景方式，拍摄出来的倒影效果会更具视觉冲击力。

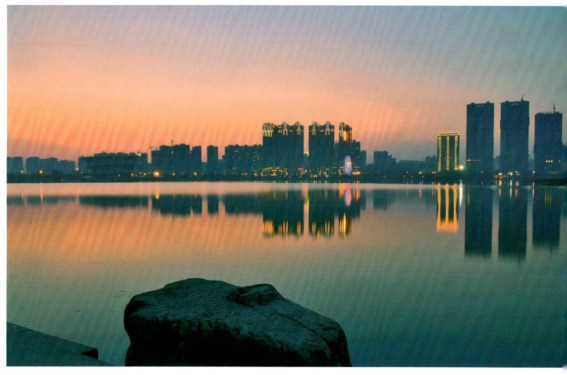

图 5-18　倒影构图

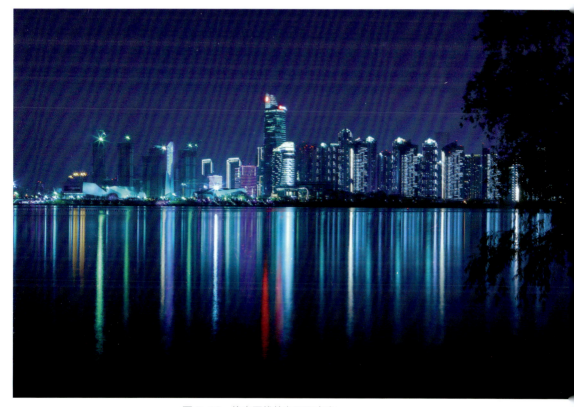

图 5-19　将水平线放在画面中央

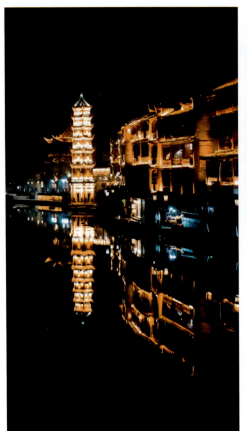

图 5-20 竖画幅 + 倒影构图

在拍照时可以从不同角度去拍摄同一个场景或者对象，如横拍、竖拍或者斜拍等，尽可能地配合不同的构图形式去多拍一些照片，可以给人带来不同的视觉感受。

5.2.5 明暗构图，增加纵深感，空间瞬间大了

明暗构图，顾名思义，就是通过明与暗的对比来取景构图和布局画面，从色彩角度让画面具有不一样的美感。明暗构图的关键在于，看拍摄者如何根据主体和主题进行搭配和取舍，以表达画面的立体感、层次感和轻重感等。

如图 5-21 所示，图中通过暗色的天空和地面，来烘托明亮的主体建筑以及水中的霓虹彩灯。这是一种以暗衬明的明暗构图手法，即以暗的背景或环境衬托出主体的明亮。

图 5-21 明暗构图

5.2.6 几何形态构图，让作品更具形式美感

几何形态构图主要是利用主体对象组合成一些几何形状，如矩形、三角形、方形和圆形等，让慢门作品更具形式美感。

1. 圆形

圆形构图主要是利用拍摄环境中的正圆形、椭圆形或不规则圆形等物体来取景，可以给观众带来旋转、运动、团结一致和收缩的视觉美感，同时还能够产生强烈的向心力。

如图 5-22 所示，采用立交桥的圆形结构进行构图，非常适合拍摄这种充满动感的慢门车轨作品，能够让画面看上去更加优美、柔和。另外，用户也可以截取局部圆形，从而起到引导观众视线的作用。

2. 三角形

三角形构图主要是指画面中有 3 个视觉中心，或者用 3 个点来安排景物构成一个三角形，这样拍摄的画面极具稳定性。三角形构图包括正三角形（坚强、踏实）、斜三角形（安定、均衡、灵活性）或倒三角形（明快、紧张感、有张力）等不同形式。

手机慢门摄影与后期从入门到精通：夜景、人像、车轨、烟花、星空、光绘、丝绸流水、延时视频全攻略

图 5-22　圆形构图

如图 5-23 所示，通过斜拍取景的方式，使建筑和城墙的透视变形，形成了三角形构图画面，可以让主体元素填满画面，创造平衡感的同时为画面增添更多动感。

图 5-23　三角形构图

> **专家提醒**
>
> 需要注意的是，这种三角形构图法一定要自然而然，仿佛构图和照片融为一体，而不是刻意为之。

第 6 章
基础后期，完善画面

 慢门照片拍摄完成后，用户可以使用手机原生相机自带的修片功能，来快速处理照片，同时还可以安装一些热门的手机后期 App，如 MIX App 和 Snapseed App 等，实现更多的后期调整功能。本章主要以 MIX App 为例，介绍通过手机对慢门照片进行二次构图和调色处理的技巧，让你的照片构图更合理、色彩更漂亮。

6.1 裁剪照片：进行二次构图

在慢门摄影中，构图是"因人而异"的，每个人都有自己的独特想法和独到眼光，当然你也可以在后期去完善构图。通过 MIX App 调整慢门照片的构图，可以使自己拍摄的照片更美观、更具视觉冲击力，并突出主题，表达出准确的含义。

6.1.1 长宽比：裁剪成竖幅短视频尺寸

通过 MIX App 的"长宽比"功能，我们可以快速将照片裁剪成自己想要的画幅，也可以选择 App 中内置的长宽比尺寸，做出符合各种新媒体或短视频平台要求的尺寸。例如，抖音平台上发布的图片尺寸大小通常为 9 : 16。下面介绍使用 MIX App 将慢门照片裁剪成竖幅抖音短视频尺寸的操作方法。

步骤 01 打开 MIX App，在主界面点击"编辑"按钮，如图 6-1 所示。

步骤 02 进入"编辑"界面，在手机相册中选择要处理的慢门照片素材，如图 6-2 所示。

图 6-1　点击"编辑"按钮　　　　　　图 6-2　选择慢门照片素材

步骤 03 执行操作后，即可打开该照片素材，点击左下角的"裁剪"按钮，如图 6-3 所示。

步骤 04 进入"裁剪"界面，选择"长宽比"功能，其中可以看到 Free 和多种预设的裁剪比例，如图 6-4 所示。

步骤 05 默认为 Free 裁剪模式，即自由裁剪模式，用户可以在预览区中按住图片四周的白色边框并拖曳，即可自由调整裁剪区域，如图 6-5 所示。

步骤 06 在"长宽比"功能菜单中选择 16:9 选项，点击两次，即可切换为 9:16 的尺

寸比例,如图 6-6 所示。

图 6-3 点击"裁剪"按钮

图 6-4 选择"长宽比"功能

图 6-5 Free 裁剪模式

图 6-6 切换为 9:16 尺寸比例

步骤 07 在裁剪控制框中按住图片并拖曳,可调整裁剪范围,如图 6-7 所示。

步骤 08 保存并导出照片后,可以在抖音中分享裁剪后的图片,如图 6-8 所示。

图 6-7 调整裁剪范围

图 6-8 在抖音中分享裁剪后的图片

6.1.2 水平：校正照片中倾斜的水平线

当用户拍摄的慢门照片中水平线不小心倾斜时，可以使用 MIX App 中的"水平"功能，对照片进行任意角度的旋转操作，来校正照片中倾斜的水平线。

步骤 01 在 MIX App 中打开要处理的慢门照片素材，如图 6-9 所示。

步骤 02 点击"裁剪"按钮进入其界面，默认选择"水平"功能，如图 6-10 所示。

图 6-9 打开慢门照片素材

图 6-10 选择"水平"功能

步骤 03 用手指按住白色圆圈滑块并向左拖曳,即可逆时针旋转图片,使图片上的水平线与网格参考线平行对齐,如图 6-11 所示。

步骤 04 松开手指后,即可校正图片的水平线,如图 6-12 所示。

图 6-11 旋转图片　　　　　　　　　图 6-12 校正图片的水平线

步骤 05 保存照片后,预览处理后的慢门照片,效果如图 6-13 所示。

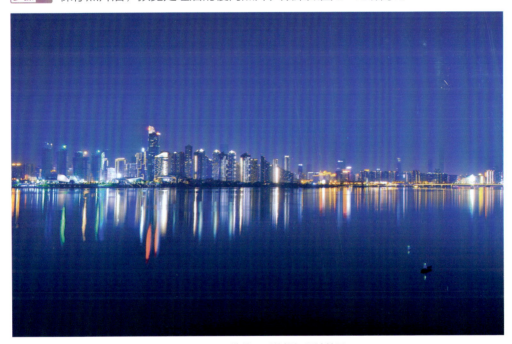

图 6-13 预览处理后的慢门照片效果

6.1.3 旋转：快速90°旋转照片的角度

如果拍摄时由于手机倒置或其他原因，导致照片的预览角度错误，用户可以通过MIX App中的"旋转"功能，快速旋转照片角度，使其恢复为正常预览视角。

步骤 01 在MIX App中打开要处理的慢门照片素材，如图6-14所示。

步骤 02 点击"裁剪"按钮进入其界面，选择"旋转"功能，即可逆时针90°旋转照片，恢复正常的预览视角，如图6-15所示。

图6-14 打开慢门照片素材　　　　图6-15 选择"旋转"功能

6.1.4 透视：轻松校准画面的透视扭曲度

在拍摄一些有建筑的慢门照片，或者使用一些素材时，经常会碰到画面中有空间透视上的扭曲问题，此时用户可以使用MIX App中的"透视"功能，快速完成照片空间透视的校正操作。

> 大部分手机的摄像头都是使用的广角镜头，由于镜头视角非常广，所以很容易产生物体变形或四角畸变等现象，这就需要通过后期来校准画面的透视扭曲。

步骤 01 在MIX App中打开要处理的慢门照片素材，如图6-16所示。

步骤 02 点击"裁剪"按钮进入其界面，选择"纵向透视"功能，如图6-17所示。

步骤 03 向右稍微拖曳白色圆圈滑块，即可校正纵向透视扭曲，如图6-18所示。

步骤 04 保存并导出照片，预览调整后的照片效果，如图6-19所示。

第 6 章　基础后期，完善画面

图 6-16　打开慢门照片素材

图 6-17　选择"纵向透视"功能

图 6-18　校正纵向透视扭曲

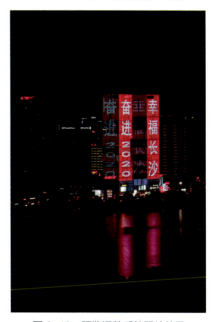

图 6-19　预览调整后的照片效果

6.1.5　拉伸：恢复长宽比例错误的照片

　　用户在对照片进行后期处理时，如果不小心误调了照片的长宽比例，导致画面变得过窄或过宽，此时可以使用 MIX App 中的"拉伸"功能，恢复正常的长宽比例。

步骤 01　在 MIX App 中打开要处理的慢门照片素材，如图 6-20 所示。

步骤 02 点击"裁剪"按钮进入其界面,选择"拉伸"功能,如图 6-21 所示。

图 6-20 打开慢门照片素材

图 6-21 选择"拉伸"功能

步骤 03 向左拖曳白色圆圈滑块,恢复照片的正常长宽比例,如图 6-22 所示。

步骤 04 保存并导出照片,预览调整后的照片效果,如图 6-23 所示。

图 6-22 恢复正常长宽比例　　　　图 6-23 预览调整后的照片效果

6.2 创意后期：打造文艺风美照

MIX App 由 Camera360 推出，内置了 100 多款创意滤镜和 40 多款经典纹理效果，并具有十分完善的专业参数调节工具，可以帮助我们轻松修片，编辑出媲美单反大片的视觉效果，为用户带来创意无限的慢门照片后期体验。

6.2.1 网红色调：提升慢门作品格调

网红色调有非常显著的特点，那就是基本上都是以某一种特殊的色调，或惊艳、或养眼、或耐看而取胜，并受人热追。

使用手机添加网红色调的方法非常简单，用户可以利用 MIX App 的"电影色"滤镜来快速实现，下面介绍具体的操作方法。

步骤 01 在 MIX App 中打开要处理的慢门照片素材，默认进入"滤镜"界面，如图 6-24 所示。

步骤 02 在"滤镜"菜单中选择"电影色"滤镜，展开该滤镜组，如图 6-25 所示。

图 6-24 打开慢门照片素材

图 6-25 展开"电影色"滤镜组

步骤 03 "电影色"滤镜组中的青蓝橙色效果有好几种，有浓有淡，大家根据自己的色感选择即可，如图 6-26 所示。需要注意的是，在调色之前，需要先对照片进行挑选，不是所有的照片都适合进行蓝橙风格的调色。例如，在晴天拍摄的城市夜景照片中，通常有蓝色的夜空和橙色的灯光，就非常适合制作蓝橙色调风格效果。

步骤 04 选择合适的滤镜后，点击右下角的"编辑工具箱"按钮，进入"调整"界面，如图 6-27 所示。

步骤 05 选择"曝光"选项,适当向右拖曳白色圆圈滑块,增加画面的亮度,如图 6-28 所示。

图 6-26　选择相应滤镜进行调色

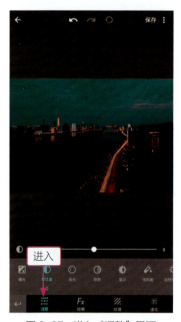

图 6-27　进入"调整"界面

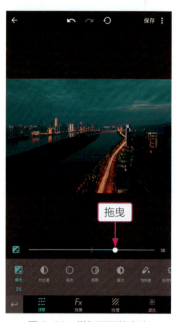

图 6-28　增加画面的亮度

步骤 06 用同样的操作方法,适当调整画面的对比度、高光、阴影、层次、饱和度和锐化等参数,如图 6-29 所示。

步骤 07 在底部工具栏中点击"色相/饱和度"按钮进入其界面,根据需要适当调整红色、青色和蓝色的色相、饱和度和明度参数,如图 6-30 所示。

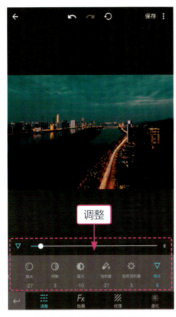
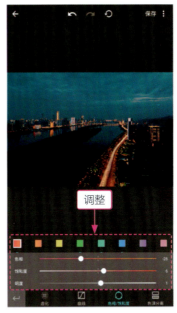

图 6-29 调整其他参数　　　　　图 6-30 调整色相/饱和度参数

步骤 08 保存并导出照片,预览调整后的照片效果,如图 6-31 所示。

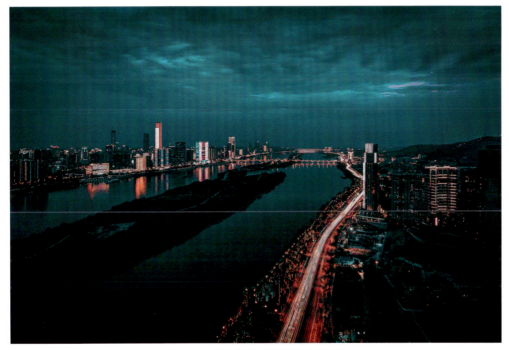

图 6-31 预览蓝橙风格的网红色调效果

用户还可以调出赛博朋克风格的网红色调效果,如图6-32所示。赛博朋克风格主要以青色和洋红色为主,也就是说这两种色调的搭配是画面的整体主基调。

图6-32 预览赛博朋克风格的网红色调效果

6.2.2 一键换天:轻松模拟慢门星空

MIX App的"魔法天空"滤镜可以在画面中的天空部分合成各种特效,瞬间模拟出创意十足的慢门星空、星轨、流星、银河以及极光等天空奇观。

在MIX App中打开照片素材,在"滤镜"菜单中选择"魔法天空"滤镜,展开后在其中选择M211~M216滤镜,即可模拟不同的星空效果,如图6-33所示。

图6-33 选择相应的"魔法天空"滤镜

图 6-34 为添加不同类型的"魔法天空"滤镜后的照片效果。

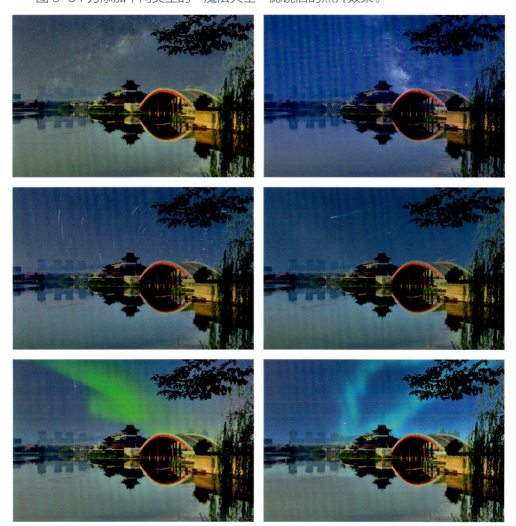

图 6-34 预览不同的"魔法天空"滤镜效果

6.2.3 色彩平衡：改变照片整体色调

MIX App 的"色彩平衡"功能主要通过对处于高光和阴影区域中的指定颜色进行增加或减少，来改变照片的整体色调。

步骤 01 在 MIX App 中打开要处理的慢门照片素材，进入"编辑工具箱"界面，在底部工具栏中点击"色调分离"按钮，如图 6-35 所示。

步骤 02 点击"高光"按钮，并设置相应的色相和饱和度参数值，调整高光部分的色彩，使其偏黄一些，如图 6-36 所示。

图 6-35　点击"色调分离"按钮

图 6-36　调整高光部分的色彩

步骤 03 点击"阴影"按钮，并设置相应的色相和饱和度参数值，调整阴影部分的色彩，使其偏红一些，如图 6-37 所示。

步骤 04 点击"平衡"按钮，并设置相应的参数值，使画面的整体色调偏高光部分的黄色，如图 6-38 所示。

图 6-37　调整阴影部分的色彩

图 6-38　调整平衡参数

步骤 05 保存并导出照片，预览调整后的照片效果，如图 6-39 所示。

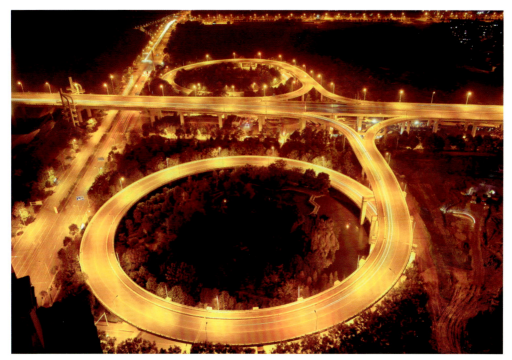

图 6-39 预览调整后的照片效果

用户也可以采用同样的操作方法，改变"色彩平衡"的调整参数，制作出其他的色调效果，如图 6-40 所示。

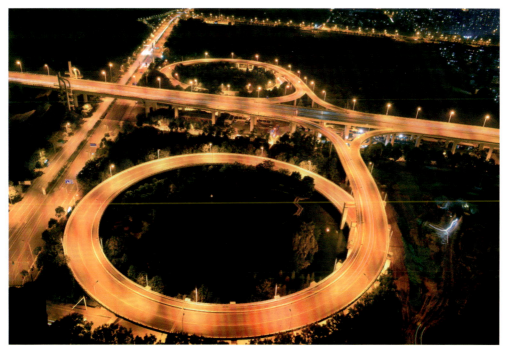

图 6-40 预览其他的色调效果

6.2.4 添加纹理：释放无限后期创意

MIX App 具有丰富的纹理素材，包括炫光、渐变、漏光、颗粒、舞台、雨滴以及天气等不同类型的纹理效果。下面以"舞台"纹理效果为例，介绍具体的操作方法。

步骤 01 在 MIX App 中打开要处理的慢门照片素材，点击右下角的"编辑工具箱"按钮，如图 6-41 所示。

步骤 02 执行操作后，点击"纹理"按钮，如图 6-42 所示。

图 6-41 点击"编辑工具箱"按钮

图 6-42 点击"纹理"按钮

步骤 03 展开"舞台"纹理素材组，选择 S2 选项，如图 6-43 所示。

步骤 04 再次点击该纹理缩略图，调出纹理效果调整菜单，拖曳白色圆圈滑块，适当调整纹理的"程度"选项，如图 6-44 所示。

图 6-43 选择 S2 选项

图 6-44 调整纹理的参数

6.2.5 局部修整：制作小星球的特效

小星球是一种超级酷炫的全景特效，可以将横画幅的照片制作成小星球样式，展示出摄影师的无限后期创意。下面介绍制作小星球特效的操作方法。

步骤 01 在主界面中点击"局部修整"按钮，打开一张照片素材，如图 6-45 所示。
步骤 02 点击"小星球"按钮，显示特效简介，如图 6-46 所示。
步骤 03 点击"开始"按钮，即可自动生成小星球效果，如图 6-47 所示。

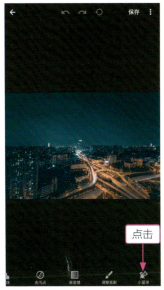
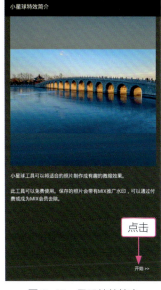
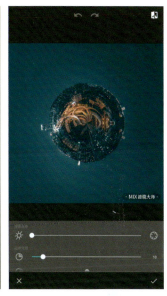

图 6-45　打开慢门照片素材　　图 6-46　显示特效简介　　图 6-47　生成小星球效果

步骤 04 保存照片，预览制作的小星球效果，效果的前后对比如图 6-48 所示。

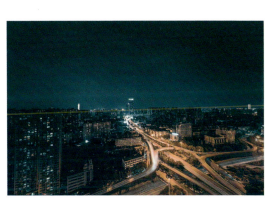

图 6-48　预览小星球效果的前后对比

6.2.6 照片海报：制作文字边框效果

MIX App 的"照片海报"功能可以添加各种边框和文字模板效果，让慢门作品显得更加"高大上"。

下面介绍制作专属照片海报的操作方法。

步骤 01 打开 MIX App，在主界面中点击"照片海报"按钮，选择并打开要处理的慢门照片素材，如图 6-49 所示。

步骤 02 在"模板"选项卡中根据照片风格选择合适的模板，如"风景"模板组，如图 6-50 所示。

图 6-49 打开慢门照片素材

图 6-50 选择"风景"模板组

> **专家提醒**
>
> 通过后期为照片添加文字和边框模板，添加这些元素的意义如下。
> (1) 体现照片的主题，增强作品感，增加思想感。
> (2) 在朋友圈发照片，随便发多张，不如发一张精品，用模板能更显格调。
> (3) 在模板中加文字，有画龙点睛之效，同时还有强大的营销宣传功能。
> 使用模板可以让作品变得与众不同，更上一个台阶：一是模板边框；二是主题提炼；三是文字点睛；四是故事传情。

步骤 03 在"风景"模板组中选择合适的模板效果，如图 6-51 所示。

步骤 04 点击文字可以修改其内容，点击选择不需要的图形元素，点击左上角的 ✕ 按钮，如图 6-52 所示。

第 6 章 基础后期，完善画面

图 6-51 选择模板　　　　　　　　图 6-52 点击相应按钮

步骤 05 执行操作后，即可删除该图形，并添加合适的图形元素。保存并导出照片，预览制作的照片海报效果，如图 6-53 所示。

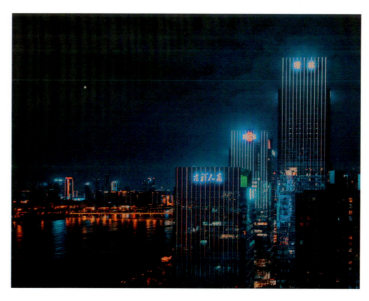

图 6-53 预览制作的照片海报效果

第 7 章

高阶后期，效果更美

> **学前提示**
>
> 　　手机慢门摄影和后期处理看起来很简单，做起来其实并不容易。大家如果想用手机拍出满意的慢门摄影作品，就一定要学会手机摄影的相关技术，以及后期处理的技能，这些都是需要潜心学习和修炼的。本章主要以 Snapseed App 为例，介绍一些高阶后期调整技巧，让大家能够做出效果更美的慢门大片。

第 7 章 高阶后期，效果更美

7.1 常用工具：轻松调出视觉系大片

Snapseed App 是一款优秀的手机数码照片处理软件，可以帮助我们轻松美化和分享照片。通过 Snapseed App，你只需指尖轻触即可轻松调出视觉系慢门大片。

7.1.1 晕影工具：给照片添加暗角效果

在处理照片时，很多处理效果都会给照片加暗角，比如做 Lomo 风格的照片等，加上暗角会使画面更加有感觉。Snapseed App 的"晕影"工具可以为照片添加暗角效果，展现神秘气氛和特殊环境的画面感，同时也可以消除照片中的暗角。

下面介绍使用 Snapseed App 给照片添加暗角效果的操作方法。

步骤 01 在 Snapseed App 中打开一张慢门照片素材，如图 7-1 所示。

图 7-1 打开照片素材

步骤 02 ❶点击"工具"按钮，打开工具菜单；❷选择"晕影"工具，如图 7-2 所示。

图 7-2 选择"晕影"工具

步骤 03 选择该工具后，❶可以调整外部亮度和内部亮度两个参数，这里主要降低了外部亮度，形成暗角效果；❷按住蓝色圆点并将其拖曳到照片中的主要突出部分即可；❸点击按钮确认，如图 7-3 所示。

图 7-3 添加暗角效果

步骤 04 再次打开工具菜单,选择"调整图片"工具,适当增加饱和度参数,如图 7-4 所示。

图 7-4 增加饱和度

> **专家提醒**
>
> 在 Snapseed App 的工具菜单中选择"调整图片"工具,并点击左下角的直方图图标 ,即可查看照片的直方图,显示图片中的色调分布情况。

步骤 05 保存修改后,最终效果如图 7-5 所示。为慢门照片添加暗角效果,不仅可以让拍摄的主体更加突出,而且还能增强照片画面的镜头感。

第 7 章 高阶后期，效果更美

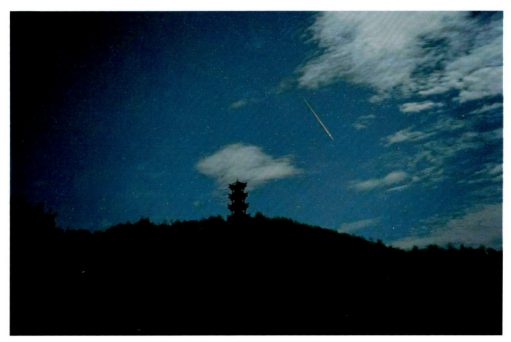

图 7-5 调整后的照片效果

7.1.2 调整图片：增加曝光度和对比度

Snapseed App 的"调整图片"工具中包括了亮度、对比度、饱和度、氛围、高光、阴影以及暖色调等参数选项，可以轻松调整图片的色彩和影调。

下面介绍使用 Snapseed App 增加画面曝光度和对比度的操作方法。

步骤 01 在 Snapseed App 中打开一张慢门照片素材，点击"工具"按钮，如图 7-6 所示。

图 7-6 点击"工具"按钮

步骤 02 打开工具菜单，选择"调整图片"工具，如图 7-7 所示。

图 7-7 选择"调整图片"工具

步骤 03 在图片上垂直滑动选择相应调整选项，选择某个选项后，水平滑动即可精确修片，❶这里主要对该照片的亮度和对比度参数进行调整；❷点击右下角的"确认"按钮 ✓ 应用调整，如图 7-8 所示。

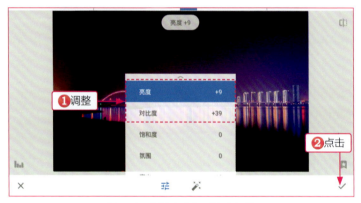

图 7-8 调整亮度和对比度参数

> **专家提醒**
>
> "调整图片"工具中各选项含义如下。
> - 亮度：调整整张照片的亮度，向左调暗，向右则调亮。
> - 对比度：提高或降低照片的整体对比度。
> - 饱和度：对照片的色彩鲜明度进行调整。
> - 氛围：使用照片滤镜调整照片的光平衡。
> - 阴影：单独调整照片中的阴影部分的明暗程度。
> - 高光：单独调整照片中的高光部分的明暗程度。
> - 暖色调：向照片中添加暖色（正值）或冷色（负值）效果。

步骤 04 保存修改后导出照片，最终效果如图 7-9 所示。

第 7 章 高阶后期，效果更美

图 7-9 导出照片效果

7.1.3 镜头模糊：制作浅景深慢门美照

Snapseed App 中的"镜头模糊"工具，最主要的作用就是模拟大光圈镜头的景深效果，用户可以通过设置照片主体对象前后的清晰范围，营造出背景虚化效果，从而实现突出主体的目的。下面介绍制作浅景深慢门照片的具体操作方法。

步骤 01 在 Snapseed App 中打开一张慢门照片素材，点击"工具"按钮，如图 7-10 所示。

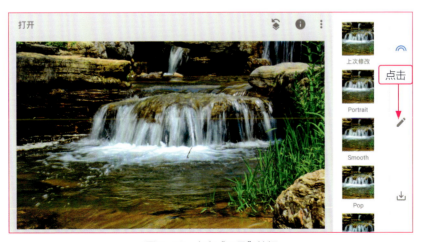

图 7-10 点击"工具"按钮

105

步骤 02 打开工具菜单，选择"镜头模糊"工具，如图 7-11 所示。

图 7-11 选择"镜头模糊"工具

步骤 03 切换为椭圆焦点 ◉，按住中心点并拖曳，调整景深位置，使用双指张合手势可更改椭圆景深圈的大小和形状，控制模糊区域，如图 7-12 所示。

图 7-12 调整焦点

步骤 04 在预览区中垂直滑动图片可以选择编辑菜单，分别设置其中的模糊强度、过渡和晕影强度参数，如图 7-13 所示。

> **专家提醒**
>
> "镜头模糊"工具中的"模糊强度"选项，可以增加或降低模糊效果的程度；"过渡"选项可以设置内焦点和模糊区域之间的淡出距离，使模糊过渡更平滑；"晕影强度"选项用于控制图片边缘的明暗，并在模糊效果中融入晕影。

第 7 章 高阶后期，效果更美

图 7-13 设置参数

步骤 05 保存修改后，最终效果如图 7-14 所示。本实例将雾化的流水作为画面主体，而将其他的画面内容进行虚化处理，运用虚实对比的手法来突出主体。

图 7-14 照片效果

7.1.4 局部工具：精准控制局部的光影

Snapseed App 的"局部"工具可以对慢门照片进行更为精细的局部调整，包括光影、色彩和结构等，下面介绍具体操作方法。

步骤 01 ▶ 在 Snapseed App 中打开一张慢门照片素材，如图 7-15 所示。

图 7-15　打开慢门照片素材

步骤 02 ▶ 打开工具菜单，选择"局部"工具进入其调整界面，❶点击底部的 ⊕ 按钮；❷然后点击图片中的所需区域，放置控制点（控制点为蓝色高亮显示），如图 7-16 所示。

图 7-16　放置控制点

> **专家提醒**
> 长按控制点可以调出放大镜功能，能够对控制点进行更精确的定位。

步骤 03 ▶ 垂直滑动屏幕，可以调整亮度、对比度、饱和度和结构这 4 个参数。这里主要对画面局部的亮度和饱和度参数进行适当调整，具体数值如图 7-17 所示。

第 7 章 高阶后期，效果更美

图 7-17 调整参数值

步骤 04 用同样的方法增加控制点，调整其他局部的影调，如图 7-18 所示。

图 7-18 添加控制点

步骤 05 保存修改后，最终效果如图 7-19 所示。通过后期对大桥上的灯光局部进行调整，可以让金黄色的灯光变得更加亮丽。

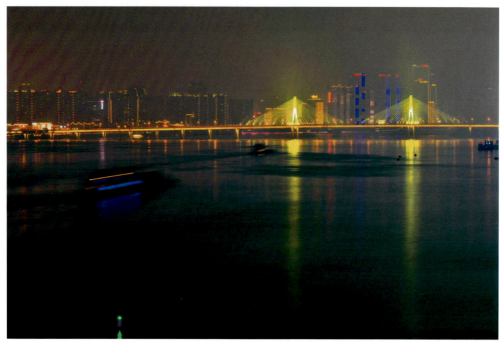

图 7-19　照片效果

7.1.5　突出细节：增加慢门作品清晰度

图像是否足够清晰是评价一张慢门摄影作品画质高低的重要标准。Snapseed App 的"突出细节"工具可以对照片的细节进行处理，同时让主体对象更突出。

步骤 01 在 Snapseed App 中打开一张慢门照片素材，如图 7-20 所示。

图 7-20　打开慢门照片素材

步骤 02 打开工具菜单，选择"突出细节"工具进入其调整界面，垂直滑动屏幕，可以调整结构和锐化参数，具体数值如图 7-21 所示。

第 7 章 高阶后期，效果更美

图 7-21 设置参数值

步骤 03 保存修改后，最终效果如图 7-22 所示。通过"突出细节"工具对慢门照片进行锐化处理，能够弥补前期拍摄不到位而留下的遗憾，从而获得清晰的照片效果。

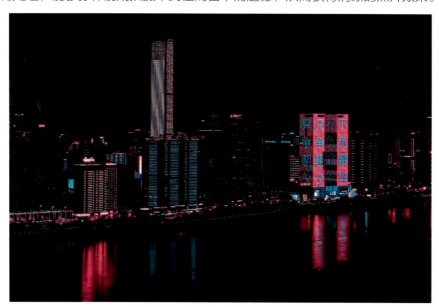

图 7-22 照片效果

"突出细节"工具中各选项含义如下。

○ 结构：增加照片中的细节，将数量参数逐渐向右调整，可以看到图像会越来越清晰，同时可以突出显示照片中对象的纹理，且不影响边缘。

○ 锐化：调整照片细节的锐化程度，来提高图像的清晰度。

111

7.2 高级修图：让照片瞬间变得更精彩

手机慢门摄影与后期处理都不是固定不变的，用户不但要学会慢门的拍摄和后期技巧，而且还要将其"用活"，在照片的前期或后期中更多地注入个人的思想或品味，用自己的观念和角度来重新诠释这些后期功能。

要记住一点，笔者介绍的这些技术只不过是给了你一块基石，绝对没有限制你的想法和创作空间。本节将介绍一些 Snapseed App 的高级修图功能，让我们一起将手机慢门摄影后期升华到一个新的境界。

7.2.1 玩转曲线：控制好照片的光线影调

"曲线"工具可以对图像的影调进行精确调整，用户可以使用各种预设的曲线调整参数，如中性、柔和对比、强烈对比、调亮、调暗以及淡出等，也可以自行调整 RGB、红色、绿色、蓝色以及亮度等曲线形状，从而调出自己想要的影调效果。

步骤 01 在 Snapseed App 中打开一张慢门照片素材，如图 7-23 所示。

步骤 02 打开工具菜单，选择"曲线"工具，如图 7-24 所示。

图 7-23 打开慢门照片素材

图 7-24 选择"曲线"工具

步骤 03 进入"曲线"调整界面，点击曲线，添加控制点，并拖曳控制点的位置，调整照片的光线亮度，如图 7-25 所示。

步骤 04 调整完毕后，保存并导出照片，效果如图 7-26 所示。

第 7 章 高阶后期，效果更美

图 7-25 调整光线亮度

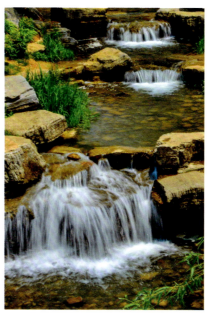

图 7-26 照片调整效果

7.2.2 画笔工具：选择性地精修照片局部

Snapseed App 的"画笔"工具可以有选择性地改变照片的局部效果，比"局部"工具更加精准，其主要功能包括加光减光、曝光、色温和饱和度，如图 7-27 所示。点击右下角的 👁 按钮，还可以显示画笔涂抹的蒙版区域，如图 7-28 所示。

图 7-27 "画笔"工具组

图 7-28 显示蒙版区域

- 加光减光:用于微调照片中所选区域的明暗程度,如图 7-29 所示。
- 曝光:用于增加或降低照片中所选区域的曝光量,如图 7-30 所示。

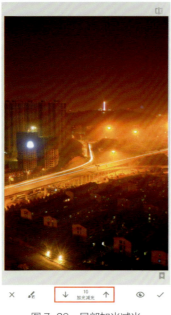

图 7-29　局部加光减光

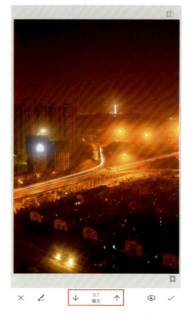

图 7-30　局部曝光调整

- 色温:用于调整照片中所选区域的冷暖色调,如图 7-31 所示。
- 饱和度:用于提高或降低照片中所选区域的色彩鲜明度,如图 7-32 所示。

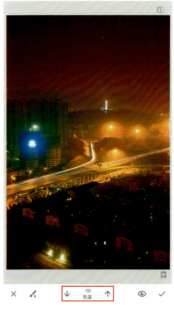

图 7-31　局部色温处理

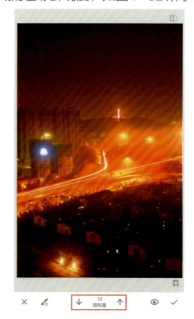

图 7-32　局部饱和度调整

第 7 章 高阶后期，效果更美

7.2.3 照片修复：去除照片中的多余杂物

在拍摄慢门照片时，可能会因为拍摄者的摄影技术不佳或手机的使用问题，使得拍摄出的照片中出现杂物和污点等异常情况，或者拍摄对象本身有一定的瑕疵。此时可以运用 Snapseed App 的"修复"工具来修正照片。

步骤 01 在 Snapseed App 中打开一张慢门照片素材，可以看到画面右下角有一个垃圾桶，如图 7-33 所示。

图 7-33 打开慢门照片素材

步骤 02 打开工具菜单，选择"修复"工具进入其调整界面，用手指在垃圾桶上涂抹，如图 7-34 所示。

图 7-34 涂抹要修复的区域

步骤 03 执行操作后，即可去除垃圾桶，保存修改后，最终效果如图 7-35 所示。

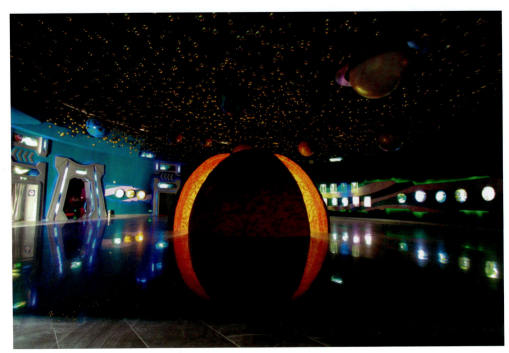

图 7-35　照片修复效果

7.2.4 魅力光晕：打造梦幻朦胧的画面感

Snapseed App 的"魅力光晕"工具主要通过在画面中添加柔和且充满魅力的光晕，让照片效果显得更加梦幻。

步骤 01 在 Snapseed App 中打开一张慢门照片素材，如图 7-36 所示。

图 7-36　打开慢门照片素材

步骤 02 打开工具菜单，选择"魅力光晕"工具进入其调整界面，在底部的预设菜单中选择 3 选项，如图 7-37 所示。

第 7 章 高阶后期，效果更美

图 7-37 选择 3 选项

步骤 03 ❶点击 按钮，调出自定义设置菜单；❷设置相应的饱和度和暖色调参数，如图 7-38 所示。

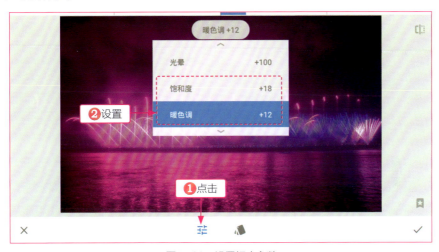

图 7-38 设置相应参数

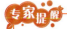

在"魅力光晕"工具的自定义设置菜单中，"光晕"选项可调整画面的柔化程度；"饱和度"选项可调整画面的色彩鲜明程度；"色温"选项可调整暖色或冷色的整体色温。

步骤 04 保存修改后，最终效果如图 7-39 所示。可以看到，效果画面中的烟花烟雾和水面都变得更加朦胧。

图 7-39 照片调整效果

7.2.5 双重曝光：轻松混合两张照片素材

Snapseed App 的"双重曝光"工具可以合成不同的照片，同时还可以结合叠加模式、透明度和图层蒙版等功能，来进行抠图换背景和增添局部元素等后期处理操作。

步骤 01 在 Snapseed App 中打开一张慢门照片素材，如图 7-40 所示。

步骤 02 打开工具菜单，选择"双重曝光"工具，如图 7-41 所示。

图 7-40 打开慢门照片素材

图 7-41 选择"双重曝光"工具

步骤 03 进入"双重曝光"编辑界面，点击底部的"添加"按钮，如图 7-42 所示。

第 7 章　高阶后期，效果更美

步骤 04 进入手机相册，选择需要合成的照片素材，如图 7-43 所示。

图 7-42　点击"添加"按钮

图 7-43　选择照片素材

步骤 05 执行操作后，即可合成两张照片，如图 7-44 所示。
步骤 06 在预览区中，适当调整月亮素材的大小和位置，如图 7-45 所示。

图 7-44　合成两张照片

图 7-45　调整月亮素材

步骤 07 点击底部的"叠加模式"按钮，在弹出的叠加模式菜单中选择"加"选项，如图 7-46 所示。

步骤 08 点击底部的"透明度"按钮，拖曳滑块适当调整叠加后的透明度，让月亮更加凸显，如图 7-47 所示。

119

图 7-46 选择"加"选项　　　　　　图 7-47 调整透明度

步骤 09 点击 ✓ 按钮确认合成处理，返回主界面，点击 按钮，如图 7-48 所示。

步骤 10 在弹出的菜单中选择"查看修改内容"选项，如图 7-49 所示。

图 7-48 点击相应按钮　　　　　　图 7-49 选择"查看修改内容"选项

步骤 11 ❶在修改内容菜单中选择"双重曝光"选项；❷在弹出的菜单中点击"画笔"图标 ，如图 7-50 所示。

步骤 12 使用"图层蒙版"功能，涂抹需要保留的叠加图层区域，把月亮抠选出来，如图 7-51 所示。

第 7 章 高阶后期，效果更美

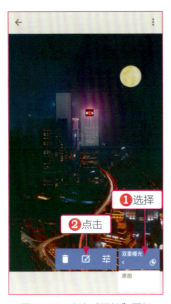

图 7-50 点击"画笔"图标

图 7-51 把月亮抠选出来

步骤 13 保存修改后，使用"局部"工具适当调整月亮区域的亮度和饱和度，效果如图 7-52 所示。

步骤 14 保存修改后，最终效果如图 7-53 所示。

图 7-52 调整月亮局部图像

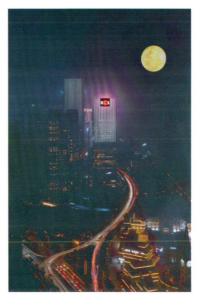

图 7-53 最终效果

用户还可以使用同样的操作方法，为其他夜景慢门作品合成月亮效果，让照片更出彩，效果分别如图 7-54 和图 7-55 所示。

121

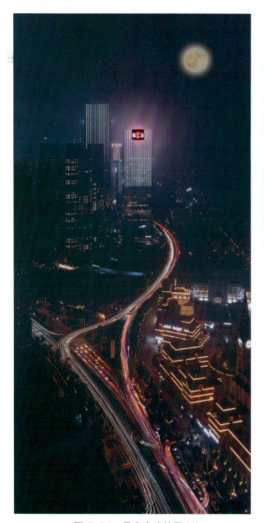
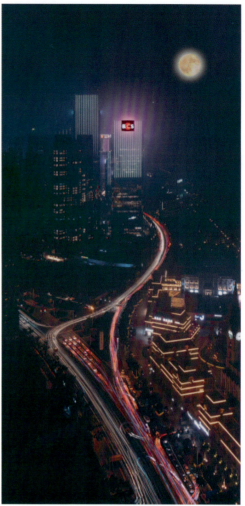

图 7-54　月亮合成效果 (1)　　　　　图 7-55　月亮合成效果 (2)

> **专家提醒**
>
> 　　照片的合成处理是一项有趣且实用的技巧,通过图像处理软件对几张照片进行合成处理,最终达到"偷天换日"的效果。通过 Snapseed App 的"双重曝光"工具可以快速实现简单的照片合成处理,就是将一张照片中的部分图像进行替换或对局部图像进行修饰、增加效果等处理。

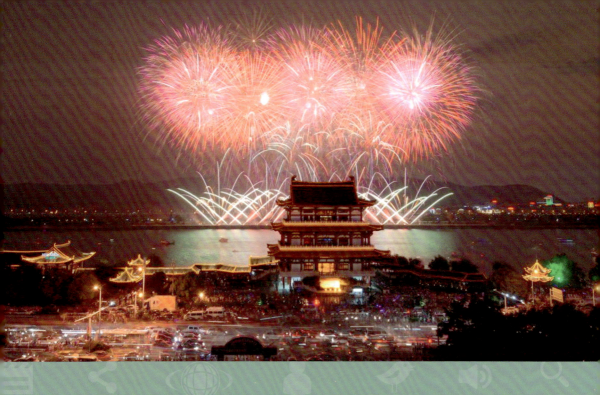

第 8 章

夜景拍摄，注意要点

　　用手机拍摄夜景时，画面很容易变模糊，大家切记带上三脚架或者八爪鱼，必须稳定好手机，才能拍出稳定清晰的画面。另外，用户还需要合理地设置快门速度，让照片更加有专业性，通过增加曝光时间和降低感光度，可以让夜景的画质得到大幅提升。

8.1 前期准备：认真对待才不容易出纰漏

对于慢门夜景来说，前期的准备工作非常重要，需要在出发前进行构思，例如要拍什么、去哪里拍、用什么设备拍，以及什么时间去等。只有做好这些准备，才能快速拍出满意的慢门夜景作品。

8.1.1 准备1：拍摄前的构思

当你决定要拍摄夜景时，脑海中立马会浮现出各种街景、天桥和街灯等场景，其实这些远远不是夜景的全部。好的夜景也不全是著名景点和标志性建筑物，摄影源于生活，只需在一天工作结束后，在回家的路途上用手机记录下你心中的夜景即可。

在拍摄夜景之前，也许你听到过许多关于夜景如何控制曝光的方法，总是说夜景拍摄中很难控制曝光量，拍摄的夜景照片很模糊、看不清楚之类的问题。夜景拍摄确实比较难，但只要掌握好方法，就能从容应对。

在出发拍摄夜景之前，需要问自己一个问题，到底想拍摄一张什么样的照片，是想体现出城市中的霓虹灯？还是想站在高处俯览整座城市？因此，在拍摄夜景前所要做的第一件事情就是确定好拍摄主题。

图8-1为站在一幢大楼的楼顶拍摄的夜景，俯拍高楼林立、灯火辉煌的城市夜景，街道上的车流成"流光状"，远处高楼中的灯光犹如繁星点点，背景的天空则呈现一片漆黑，显得十分寂静，与城市中绚丽的五彩灯光形成了鲜明的对比。

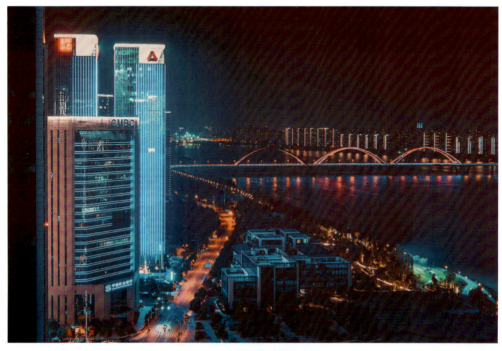

图8-1 在高处俯拍城市夜景

8.1.2 准备2：选择拍摄地点

拍摄夜景时，地点一定不能固定在某一个点，而应当从多角度、多方位进行观察。在用手机拍摄夜景前，可以先简单拍摄，查看取景效果，然后将手机固定好位置，再去拍摄成品。

如图8-2所示，将夜景的拍摄地点选择在一座大桥底下，并使用八爪鱼支架将手机固定在江边的围栏上进行取景。

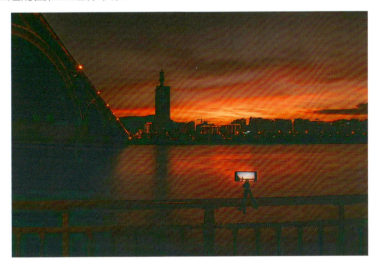

图8-2 确定拍摄地点

大桥横跨江面，在江的对面则是城市的另一端，拍摄时所处的方位刚好可以将对面的城市与大桥拍摄下来，如图8-3所示。

图8-3 拍摄地点的取景角度

另外，我们也可以走到桥的另一侧，更换拍摄地点，拍摄出不一样的画面效果，如图8-4所示。

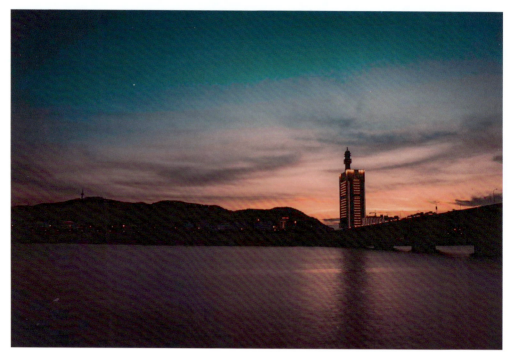

图 8-4　更换拍摄地点

8.1.3　准备 3：拍摄时的器材

准备开始拍摄了，当然不能缺少拍摄器材。拍摄夜景时所需要准备的器材有手机、相机、无人机、八爪鱼、三脚架和手电筒等，如图 8-5 所示。

图 8-5　拍摄夜景的常用器材

同时，我们还需要注意下面这些事项。

(1) 拍摄设备一定要有充足的电量，以免在拍摄时没有电而出现窘境。

(2) 查看内存卡的容量是否充足。

(3) 查看三脚架的部件是否完整，一定要检查快装板，这个部件是最容易丢失的。

三脚架的作用前面已经强调过很多次了，有了三脚架才能更好地稳定手机，让曝光时间更长，画质更好。同时，我们还可以利用手电筒作为照明工具，在晚上查看脚下的路面，保证外出拍摄的安全。

8.1.4 准备4：选择拍摄时间

慢门摄影对当天的拍摄时间有决定性的要求，不同的时间下景色会展现出不同的效果。通常我们认为夜景拍摄需要在晚上才开始，但实际上拍摄夜景的最佳时间为日落黄昏时刻。

如图8-6所示，这张照片的拍摄时间为傍晚7点左右，天空和江面呈现出橙红色的落日余晖，使照片看起来十分大气。画面中可见天空亮度还是很高，城市的霓虹灯光还未完全打开，还不足以体现出夜景的绚丽。

图8-6　拍摄日落场景

随着时间的流逝，太阳完全落下山去，天空也越来越暗，桥上的路灯和建筑里的灯光也相继开启，在暗淡的天空映衬下显得别有韵味，此时也是不错的拍摄时间，如图8-7所示。

可以明显看出，这张照片的效果跟前面日落时的截然不同了。天空的光芒几乎完全消逝，城市中的霓虹灯光也逐渐打开，尤其是桥上的星芒状路灯，显得十分绚丽多彩。同时，深蓝色的天空透出一种夜的寂静感，大大增强了画面效果。

图 8-7 拍摄路灯和建筑灯光

如图 8-8 所示，此时天空已经全黑，对岸的建筑霓虹灯也已经完全亮起，同时水面的灯光倒影也十分好看，此时拍摄的城市夜景又是另一番风味。

图 8-8 拍摄建筑霓虹灯

8.2 拍摄技巧：拍出清晰的慢门夜景照片

夜景拍摄通常伴随着长时间曝光的快门，此时手机稍加抖动就会影响成像质量，造成照片模糊，也就是人们常说的"照片糊啦"。那么，如何拍出清晰的慢门夜景照片呢？本节将介绍 5 个拍摄技巧，帮助大家拍出清晰的慢门夜景照片。

8.2.1 技巧 1：拍摄前首先确定好构图方式

所有类型的摄影都离不开构图，常见的构图方式有许多种，例如九宫格构图、三分线构图、斜线构图、引导线构图、圆形构图和透视构图等，如何掌握并学会使用它们才是关键所在。

如图 8-9 所示，这张照片采用了多种构图方式，有透视构图、冷暖色对比构图和斜线构图。透视构图让整条马路显得十分有纵深感；冷暖色对比构图让画面的分布更均匀、饱满；斜线构图则凸显出了画面中的线条动感。

图 8-9　多种构图方式拍摄的慢门夜景照片

图 8-10 为照片构图的标注。慢门摄影的构图方式第 5 章已经介绍了很多种，此处就不再过多赘述了。想深入学习构图的用户可以阅读《摄影构图从入门到精通》一书，书中采用单点极致的写法将 100 多种细分构图讲深、讲透，含金量极高。

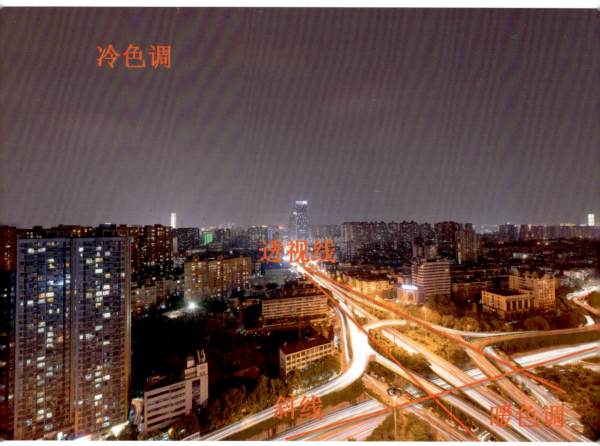

图 8-10　照片构图的标注

另外，我们在拍摄同一场景时，也可以更换横画幅或竖画幅的取景方式。竖画幅就是指将手机竖立拍摄的画面，当碰到有明显垂直特征的对象时，如大树、建筑或者人物等，竖画幅可以更好地表现出拍摄对象高耸和向上延伸的视觉效果。如图 8-11 所示，这种竖画幅构图的方式省去了画面两侧不必要的空白，更好地体现出建筑的高度。

8.2.2　技巧 2：用星光镜拍出星光璀璨画面

星光镜又叫光芒镜或散射镜，是一种比较特殊的滤镜，如图 8-12 所示。星光镜的玻璃上通过蚀刻的方法雕刻出不同类型的纵横线型条纹，在点光源的作用下，可以使拍摄景物中的光亮点产生衍射，从而每个光源点都放射出特定线束的光芒，以达到光芒四射的效果。

在拍摄夜景照片时，大家一定都希望将夜景拍摄得光芒闪烁，此时可以借用星光镜来实现，用来产生不同形状的星光效果，如图 8-13 所示。

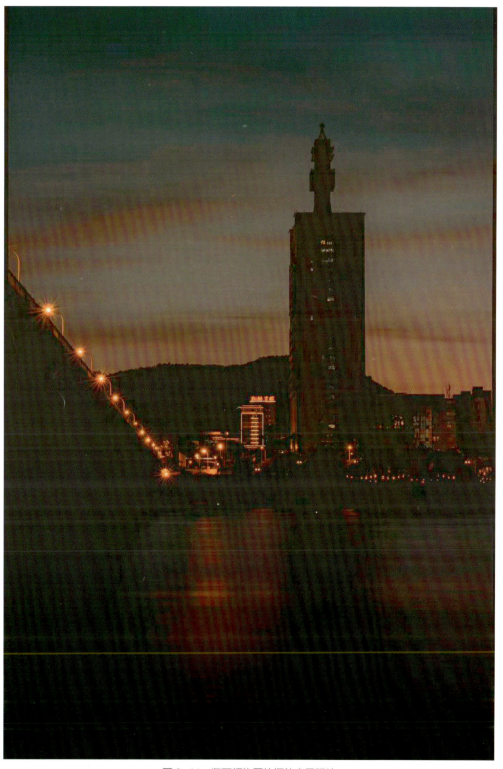

图 8-11 竖画幅构图拍摄的夜景照片

图 8-12　手机星光镜

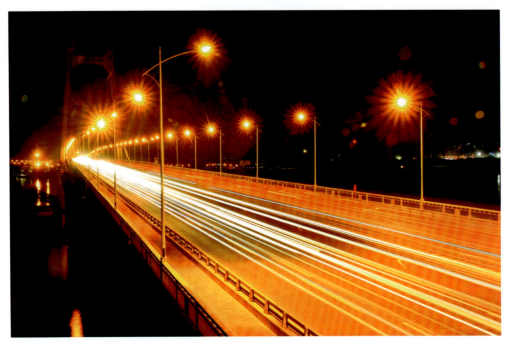

图 8-13　拍摄星光效果

> **专家提醒**
>
> 星光镜分为 4 线、6 线和 8 线，代表着星芒数量。大家可以根据当时的拍摄场景来选择合适的星光镜。光源较多时，可以选择 4 线或 6 线星光镜，能够防止画面过于凌乱；而光源较少时，则可以使用 8 线星光镜，可以增加画面亮点。

8.2.3　技巧 3：用柔光镜拍出朦胧美感画面

柔光镜又称为柔焦镜，它的表面与普通玻璃不同，并不是平面的，而是凹凸不平的，

可以让光线穿过镜片时形成漫反射，使得景物轮廓柔化，并降低反差，达到"柔光效果"，如图 8-14 所示。

图 8-14　手机柔光镜

柔光镜能让夜景中的光源模糊成雾状，为照片营造出柔和的气氛。使用柔光镜拍摄的景物会显得更加朦胧柔和，营造出浪漫温馨的氛围，如图 8-15 所示。

图 8-15　夜景效果

8.2.4　技巧 4：倾斜拍摄使画面更具深邃感

在拍摄夜景建筑时，大胆尝试更多的拍摄角度，总能给我们带来意想不到的惊喜。有时我们不从正面拍摄建筑，倾斜着拍摄更能将建筑物的高度表现得淋漓尽致。

如图 8-16 所示，没有使用正面的拍摄手法，而是将手机倾斜进行仰拍，这种角度更能突出建筑的高度，利用透视效果能够更好地体现建筑的纵深感和立体感。

图 8-17 为采用倾斜方式拍摄的建筑，重点展现建筑的局部。虽不能将整体同步摄

入，但建筑在画面中呈现斜线延伸，利用这种倾斜的拍摄角度，可以将周围环境中的景物同时纳入，很好地传达出摄影师当时的所见所得，画面更具真实性。

图 8-16　倾斜仰拍建筑

图 8-17　倾斜拍摄建筑的局部

8.2.5 技巧 5：拍摄多张照片进行堆栈合成

有时候因为种种原因，我们并不能进行长时间曝光拍摄，这时我们可以用到多张照片合成来模拟慢门摄影，这项技术有个专属名词——堆栈。堆栈是用图层叠加的方式对大量静态照片进行合成处理，最终得到一张照片，用于展示一定时空范围内景物连续的变化。堆栈是一项照片后期处理的技术，摄影师通常将其称为堆栈摄影。

如图 8-18 所示，下面这张照片其实是通过 5 张照片堆栈合成的，这样照片能获得更好的细节、质量、分辨率和宽容度，让画质更细腻、清晰。

图 8-18　由 5 张照片堆栈合成的夜景照片

要拍摄多张同样的照片，用户可以使用手机的连拍功能。以华为手机为例，对准拍摄对象后，长按快门按钮即可连拍照片。松开手指，即可停止连拍。如图 8-19 所示，这是没有堆栈前的原片和堆栈合成后的效果图的局部对比。

图 8-19　堆栈前后的局部效果对比

从上图中可以看到两个细节上的区别：一是效果图的喷泉彩灯颜色更为丰富，因为这是多张照片的颜色堆栈到了一块，类似多张照片的"颜色之和"；二是效果图水面的拉丝雾状效果更为明显，且表现力更为细腻，因为这是多张照片的拉丝水面堆栈到了一块，类似多张照片的雾状水面"效果之和"。

其实，堆栈合成后的照片，还有更多细节方面的表现要更好，如画质更高、文字更清晰，以及池塘边的墙壁更有质感等。因此，笔者总结了一个结论：堆栈处理的目的是为了得到更加细腻的叠加效果，以及通过降噪来获得更清晰的画质。

堆栈的操作步骤其实也很简单，我们可以通过电脑端的 Photoshop 来完成。在 Photoshop 软件中，单击"文件"|"脚本"|"统计"命令，在弹出的"图像统计"对话框中，❶单击"浏览"按钮，载入拍摄的多张照片；❷选择"最大值"堆栈模式；❸单击"确定"按钮即可，如图 8-20 所示。

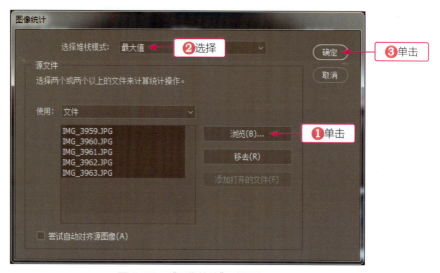

图 8-20 "图像统计"对话框

另外，在手机上也可以安装一些 App 来实现堆栈处理，如 Cortex Cam 和 Superimpose 等，但操作起来比较复杂，建议大家还是使用 Photoshop 比较好。

8.3 超级夜景：拍出令人惊艳的夜景大片

很多智能手机的原生相机都带有"夜景"模式，能够帮助用户轻松拍摄出绚烂夜景照片。本节主要以华为 P30 的"夜景"模式为例，介绍超级夜景的拍摄技巧，希望大家熟练掌握本节内容。

8.3.1 打开功能：开启超级夜景模式

华为 P30 手机自带超级夜景拍摄模式，我们只需要打开手机相机，滑动屏幕选择"夜景"模式即可，如图 8-21 所示。

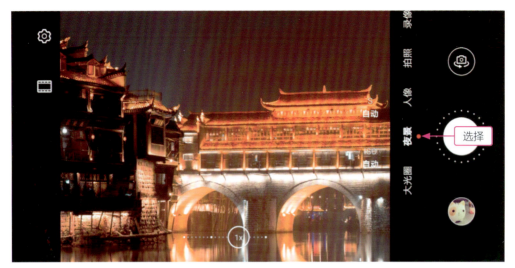

图 8-21 选择"夜景"模式

图 8-22 为笔者在凤凰古城的沱江之上使用华为 P30 拍摄的夜景效果,采用横画幅的构图方式,画面元素以水平对称的构图手法,使倒影与江上的古建筑相互呼应,形成了一幅独具魅力的夜景画面效果。

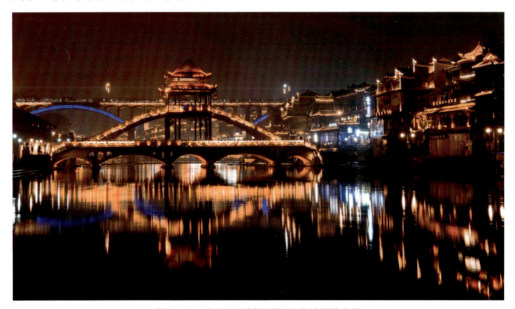

图 8-22 在凤凰古城的沱江之上拍摄的夜景

> **专家提醒**
>
> 夜景是摄影中的一道靓丽风景线,受到很多摄影爱好者的青睐。尤其是城市和古镇的夜景照片,通常都可以通过多彩的灯光来表现。在取景构图时,拍摄者需要注意延长手机的曝光时间,从而获得足够明亮和清晰的夜景画面效果。

8.3.2 选择前景：装饰画面增加层次

在很多优秀的摄影师拍出来的照片中，都有主体，主体就是主题中心，而陪体就是在照片中起到烘托主体作用的元素。在拍摄夜景时，用户可以在主体前面添加一些陪体，作为画面的前景，使用恰当的前景可以起到装饰画面的作用。如图 8-23 所示，笔者以左侧的雕塑和前方的小船作为前景，能够为照片增加空间感。

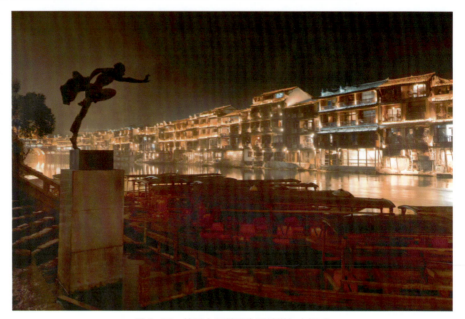

图 8-23 使用大量前景为照片增加空间感

如图 8-24 所示，使用一排笔直的石墩桥作为前景，并将其置于下三分线位置处，不仅可以起到衬托主体的作用，而且还可以使画面的层次更为丰富。

图 8-24 使用前景衬托主体

第 8 章 夜景拍摄，注意要点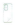

8.3.3 使用滤镜：让画面色彩更鲜艳

夜晚的光线有时候太暗，那么拍摄出来的画面色彩不够鲜艳，会给人一种昏沉的感觉，这个时候可以使用合适的滤镜为画面添彩。以华为 P30 为例，打开相机的"夜景"模式，点击左侧的"滤镜"图标，弹出相应的滤镜菜单，包括徕卡柔和、徕卡鲜艳和徕卡标准 3 种滤镜模式，大家可根据实际需要进行选择，如图 8-25 所示。

图 8-25 华为 P30 的滤镜效果

图 8-26 为使用"徕卡鲜艳"滤镜模式拍摄的画面效果，可以看到画面的色彩非常浓郁，而且对比度也比较高，让古建筑上的灯光呈现出绚烂的光影效果。

图 8-26 绚烂的光影效果

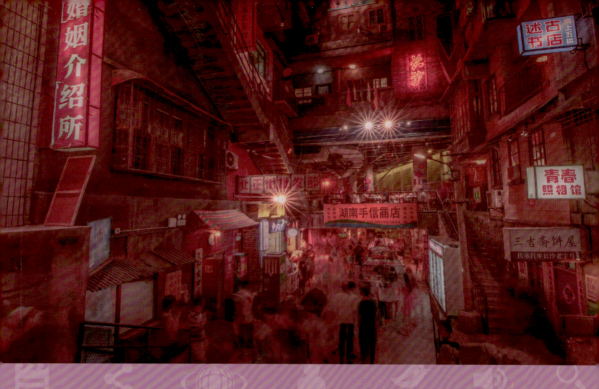

第 9 章

慢门人像，唯美梦幻

在风光摄影中，慢门摄影占据了相当重要的地位，这种摄影方式能够凝固时间，拍摄出肉眼看不到的唯美、梦幻的画面效果。其实，我们也可以将人物放到慢门镜头中，拍出动静结合的慢门人像效果，在虚实之间更能体现出作品的张力。

9.1 慢门拍摄：拍出与众不同的人像

在人像题材中使用慢速快门的拍摄方法，可以获得别有一番风味的画面效果，这也是慢门人像受欢迎的原因所在。本节将介绍一些慢门人像的拍摄技巧，帮助大家用手机拍摄出与众不同的人像作品。

9.1.1 效果：利用慢门实现虚实结合

用慢速快门拍摄人像，能够轻松拍摄出虚实结合的画面效果，可以让照片变得更加精彩。由于手机的光圈基本都是固定不变的，很难通过控制景深的方式去获得虚实结合的画面。因此，我们可以利用手机快门速度的调节功能，来将画面中的动态人物虚化，拍摄出模糊的动态效果，如图 9-1 所示。

图 9-1 拍出虚实结合的画面

9.1.2 地点：选择人流量大的拍摄环境

拍摄慢门人像作品的地点其实都比较普通，最基本的要求就是有一定的人流量，如十字路口、地铁、商场和景区大门等地方都可以。如图 9-2 所示，这张照片拍摄于长沙的网红打卡景点——超级文和友，这里的人流量非常大，很适合拍摄慢门人像。

一般情况下，我们都希望拍摄的作品画面简洁，但超级文和友里面的人实在是太多了，所以笔者干脆使用慢速快门拍摄人物，将人流完全虚化，来衬托环境的热闹。在这种人流量比较大的地方，使用长时间曝光拍摄，能够用手机拍出人群走动轨迹的流动感，画面效果非常新颖。

图 9-2 在人流量大的地方拍摄的慢门人像作品

9.1.3 时间：选择合适拍摄时机和机位

如果拍摄场地的人比较多，画面就会显得很杂乱，如图 9-3 所示。因此，拍摄时必须要选择好的机位，并把握好拍摄时机。如图 9-4 所示，采用较高的机位从上往下俯拍，在人流较多的时候按下快门，可以更好地展现出人群的流动效果。

图 9-3　拍摄场地比较杂乱

图 9-4　拍出人群流动效果

在拍摄人流比较多的慢门人像作品时，我们需要保持耐心，不仅要找到好的拍摄地点和构图角度，还要学会等待时机。我们可以提前固定好手机机位，并设置好合适的快门速度，当人流量足够大的时候，即可按下手机的快门按钮，开始曝光拍摄。

9.1.4 参数：设置较低的快门速度值

想要将人群拍出流动的虚化效果，需要在手机相机的"专业"模式中设置一个合适的曝光时间。需要注意的是，由于人流的速度通常都比较慢，因此快门速度不能太慢，否则人群会被彻底虚化，在画面中会完全看不见人影。

通常情况下，建议快门速度设置为 1/15 ~ 2 秒即可。当然，如果拍摄环境的光线比较暗，我们可以适当地增加 ISO，使曝光时间保持在合理的范围内。

如图 9-5 所示，使用 1/5 秒的快门速度拍摄，可以看到前景的人物已经有了一些虚化效果，但还不太明显。如图 9-6 所示，使用 1 秒的快门速度拍摄，可以看到快速移动的人群已经变成了非常明显的幻影状态。

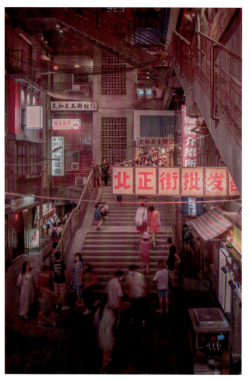

图 9-5　1/5 秒的快门速度拍摄效果　　　　　图 9-6　1 秒的快门速度拍摄效果

　　拍摄人流虚化效果，建议用手机自带的慢门模式，如华为手机的"丝绢流水"模式或者努比亚手机的"电子光圈"模式等，点击快门按钮开始曝光，然后马上再次点击关闭快门即可。

　　如果使用手机相机的"专业"模式拍摄，则曝光时间要尽量控制在 1 秒左右，这个时间内人刚好可以走一两步，能够拍出较深的人影色调。倘若曝光时间过长，人影的颜色就会变成透明状，因此很难在手机镜头中留下他们的身影。

9.1.5　人物：注意模特主体固定不动

　　在拍摄慢门人像时，我们还需要选择一个人物作为主体，否则只拍摄走动的人流，画面难免会显得很凌乱，没有形式感。如图 9-7 所示，模特在画面中保持固定不动，从而拍摄出清晰的主体，同时身后的旋转木马在长时间曝光下变成了一道道光轨，在画面中形成了动静对比，画面有动有静，更容易让人找到视觉兴趣点。

　　如图 9-8 所示，站在人行道中间的人物是静止的，而两边快速移动的车灯则形成了动态的光轨效果，得到一张有动静对比的照片。

第 9 章 慢门人像，唯美梦幻

图 9-7 动静结合的慢门人像效果

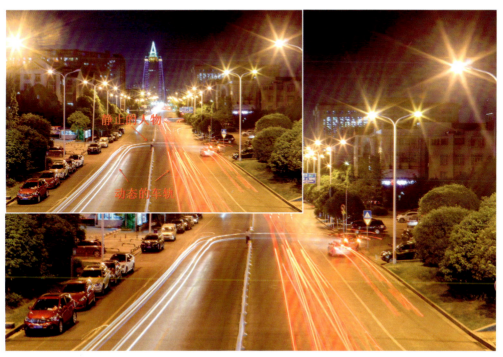

图 9-8 有动静对比的照片

9.2 拍摄场景：慢门人像的拍摄题材

在虚实结合、动静对比之中，可以让慢门人像作品变得更加精彩，更吸引眼球。当然，面对不同的拍摄场景时，我们还需要掌握一些细节技巧，才能让你从容应对各种慢门人像题材。

9.2.1 场景1：慢门车轨人像

在夜晚拍摄人像与车流灯轨结合的画面，光线不足是最大的难点所在，不过我们可以用慢速快门来弥补这个问题。

图9-9为利用慢门拍摄的动静结合的画面效果，动态的车流灯轨和静态的人物形成了鲜明对比。

慢速快门可以延长曝光时间，不仅可以记录车灯轨迹，而且还能够让前景的人物和背景的建筑等元素都能获得正常的曝光效果。

同时，使用较长的曝光时间拍摄，让背景获得充分的曝光，更好地呈现车流灯轨和建筑上的灯光色彩。

除了使用慢速快门和高感光参数外，我们也可以借助路灯、车灯或建筑上的灯光，来保障人物的曝光，同时还可以用慢门让车灯变成美丽的灯轨效果。另外，我们还可以通过后期合成，来制作创意十足的慢门车轨人像作品。

如图9-10所示，拍摄者想拍自己与车轨的合影，在保证安全的情况下，先用长曝光拍摄一张没有人物的车流灯轨空景，等待没车的时候，再单独拍摄人物照片。后期使用蒙版将人物与车轨进行合成处理，得到动静结合的画面效果。

> **专家提醒**
>
> 余航（鱼头YUTOU）是视觉中国签约摄影师、美国Getty image签约摄影师、国家地理供稿摄影师、百度图片入驻摄影师、中国摄影家协会会员，对于风光、建筑、慢门摄影以及相关的后期处理技术都非常精通。
>
> 大家如果想深入学习慢门与建筑摄影的结合技术，可以看看余航（鱼头YUTOU）出版的《城市建筑风光摄影与后期全攻略》，在这本书中详细介绍了城市建筑风光摄影作品的拍摄技法。

第 9 章 慢门人像，唯美梦幻

图 9-9 慢门车轨人像作品效果【摄影师：余航 (鱼头 YUTOU) 】

图9-10 后期合成的慢门车轨人像【摄影师：余航（鱼头YUTOU）】

9.2.2 场景2：慢门人流幻影

要拍摄慢门人流幻影，除了需要具有慢门功能的手机外，我们还需要准备一块减光镜，将光线强度减弱，防止在长曝光时出现画面过曝的情况。

另外，用户也可以在弱光环境下拍摄，通过延长曝光时间不仅能够将人流虚化掉，而且还可以拍摄出星芒效果，如图9-11所示。

图9-12为使用华为手机的"夜景"模式拍出流动的影像效果，不仅底部的人流变成了幻影，而且上面的灯光和招牌也变得更加亮眼。那些走动得比较快的人物虚化得比较厉害，而那些走得慢的人则很好地被记录了移动的轨迹。

9.2.3 场景3：慢门星空人像

星空摄影也属于慢门摄影的一种，是指天黑了以后，用单反相机、手机以及相关摄影设备来记录月亮、星星和行星的运动轨迹，以及记录银河、彗星和流星雨在星空中的移动变化，拍摄出令人震撼和向往的斗转星移场景。

图9-13为使用专业模式拍摄的星空画面，可以拍摄出色彩饱满、层次丰富的夜景效果。

拍摄星空对于时间也有一些要求，一年中的4月~10月，最适合拍摄星空，而7月~8月的银河是最明显的。同时，在一天中晚上11点~1点的星星最亮，而且此时基本没有灯光和云彩，是最适合拍摄星空的时间段。

拍摄星空人像作品，通常要使用手动对焦模式，让天空中的星星能够清晰对焦，同时画面中的人物比例要尽可能地小，这样能够拉近人物与星空的焦平面距离，让人物也能够在画面中清晰成像，如图9-14所示。

拍摄星空人像时，可以使用手机自带的闪光灯给人物进行补光，曝光时间通常为5~8秒，同时调大ISO，以及手动调整白平衡至3000K左右，让画面中的星空色调显得更为幽蓝。

另外，我们还可以发挥自己的创意，对星空人像照片进行一些后期处理，让画面变得更有趣。如图9-15所示，通过对图9-14进行裁剪和镜像合成处理，打造出左右对称构图的效果，给人带来一种沉着、平稳的感觉。

图9-11 在弱光环境下拍摄慢门人流幻影效果

第 9 章 慢门人像，唯美梦幻

图 9-12 慢门人流幻影效果

图 9-13　星空画面

图 9-14　星空人像拍摄效果

图 9-15　星空人像作品的创意后期效果

第 10 章

车轨拍摄,精彩出奇

 在拍摄城市夜景风光时,夜色中的车流灯轨是比较常见的拍摄题材之一。使用长曝光拍摄夜晚城市道路上的车水马龙,能够拍出动感的车灯轨迹效果。
 拍摄车流灯轨的重点在于曝光时间的把握,本章将分享一些简单实用的手机拍摄车轨的技巧,帮助大家拍摄出好看的车流灯轨照片。

10.1 拍摄要点：车轨拍摄的前期准备

其实，用手机拍摄车轨的基本操作还是比较简单的，只需要准备好三脚架，设置好声控快门或遥控快门，选择慢门模式或专业模式，即可用长曝光将车灯的移动轨迹记录到画面中。不过，要想把车轨照片拍好，还需要注意一些拍摄要点。

10.1.1 原理：车流灯轨的拍摄原理

车流灯轨的呈现效果，与普通拍照模式下拍摄的车水马龙画面完全不同，之所以有这种区别，主要在于车流灯轨的拍摄原理要更复杂一些。

车流灯轨的拍摄原理主要在于慢速快门，通过延长曝光时间，在手机镜头中将快速移动的车灯变成一条条光束。尤其是车流越多时，曝光时间越久，画面中记录的光束也就会越多，因此能够产生车流灯轨的效果。

如图 10-1 所示，这张照片就是通过长时间曝光将桥面飞驰的汽车完全虚化，只留下一条条光轨，能够给观赏者带来无限的遐想空间。

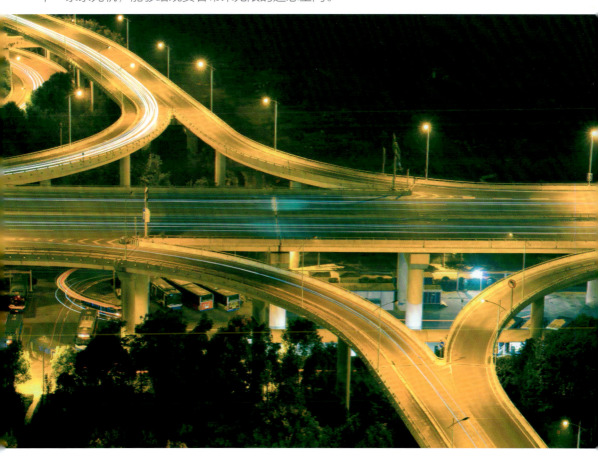

图 10-1 车流灯轨效果

10.1.2 稳定：固定好手机保持稳定

车流灯轨需要慢速快门来拍摄，因此手机是必须要保持稳定的，此时就需要用到三脚架、八爪鱼和蓝牙控制器等稳定器材，如图 10-2 所示。

另外，笔者建议用耳机线来控制手机快门，从而最大限度地保持手机的稳定，避免因抖动造成画面模糊。图 10-3 为使用八爪鱼固定手机，在高楼上拍摄的车流灯轨效果。

图 10-2 将手机固定在八爪鱼上

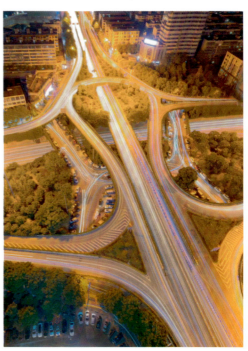
图 10-3 在高楼上拍摄的车流灯轨效果

10.1.3 地点：在车流多的地方拍摄

要拍出车流灯轨的效果，我们还需要选择一个车流较多的地点来拍摄，如人行天桥、城市高楼及山中高地等地点。

同时，用户要注意拍摄地点尽量远离路灯等光源，避免画面过曝。

图 10-4 为站在高楼上拍摄的城市道路车流灯轨效果，路面上形成了大量的车灯轨迹线条。

10.1.4 方向：选择合适的行车方向

车流的方向对于灯轨的效果有很大的影响，车前灯通常是黄色或白色的，车尾灯通常是红色的，拍摄时尽量让两种颜色的灯轨比例一致，这样产生的颜色对比会更强烈，如图 10-5 所示。

第 10 章 车轨拍摄，精彩出奇

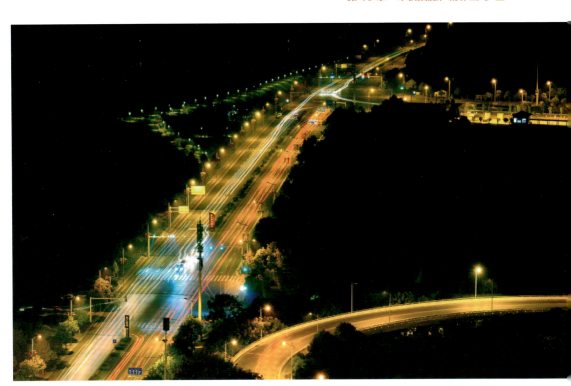

图 10-4　在车流多的道路上拍摄的车流灯轨效果

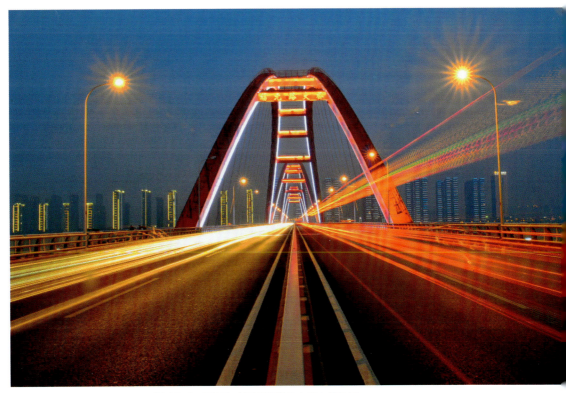

图 10-5　画面左右不同颜色的车灯占比均等

10.1.5 构图：学会预测画面和构图

通常情况下，车前灯的亮度要强于车尾灯，用户在拍摄时可以根据这个差异来选择合适的曝光时间和取景构图角度。如图 10-6 所示，使用斜线构图拍摄的车流灯轨，更能展现画面的动感。

图 10-6　使用斜线构图拍摄车流灯轨

如图 10-7 所示，使用"圆形构图 + 交叉线构图"相结合的方式拍摄的车流灯轨，可以让画面中的车轨线条更丰富，各种曲线和直线使作品更具线性美感。

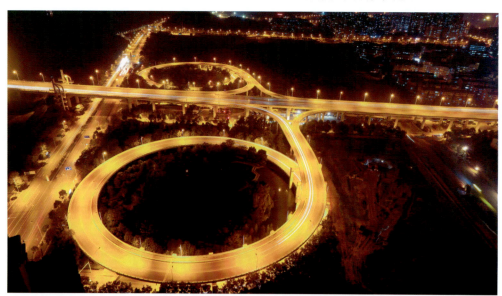

图 10-7　"圆形构图 + 交叉线构图"拍摄车流灯轨

10.1.6 注意:拍摄车轨的错误方式

在拍摄车流灯轨时,还需要避免犯下面这些错误。

(1) 手持拍摄:手部的抖动容易让画面变模糊。

(2) 车轨太小:如果手机距离道路比较远,这样车轨在画面中的比例就会很小,很难突出主体。此时,我们可以靠近主体去拍摄,也可以用好的构图方式来弥补这个缺陷,如对角线构图,能够让画面变得动感十足,如图 10-8 所示。

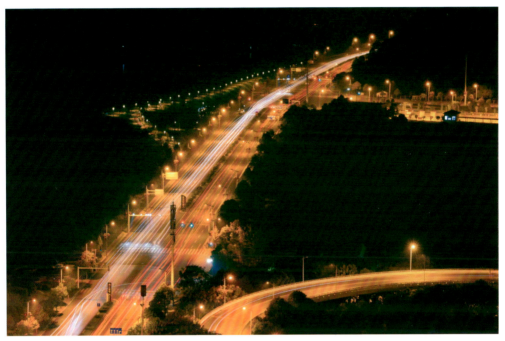

图 10-8　用构图方式弥补取景距离的缺陷

(3) 曝光太久:在设置曝光时间时,要注意适度,并不是越长越好。如果拍摄场景中的车流量非常大,曝光时间太久会让画面中的光线太明显,影响画面观感。

(4) 光源太近:拍摄场地附近的光源过多、过近,曝光时间太久时画面很容易过曝,因此拍摄时要注意避开太亮的光源,或者使用减光镜拍摄。

10.2 光线控制:设置车轨的拍摄参数

在拍摄车流灯轨时,我们需要根据现场的光线情况,多尝试调整测光模式、光圈、白平衡、对焦模式和快门速度等参数,找到合理的参数设置范围。总之,只有不断地进行实践拍摄,才能拍摄出好看的车流灯轨作品。

10.2.1 设置 1:测光模式

拍车流灯轨通常使用点测光模式,对准车灯或画面的偏亮区域进行测光即可,这样

可以让灯轨得到正常曝光。如图 10-9 所示，这张照片的曝光时间为 30 秒、感光度为 200，使用点测光模式对路面上的车灯进行测光，使其曝光正确。

图 10-9　使用点测光模式拍摄的车流灯轨照片

另外，如果拍摄场景的光源或车流较多，就可以适当增加快门速度，同时降低曝光补偿参数。用户在实拍时需要反复调试，来实现相对合理的曝光效果。

10.2.2　设置 2：光圈和感光度

使用手机拍照时，光圈通常是由手机相机自动控制的，会根据不同的快门速度产生相应变化。当然，如果手机能够调整光圈，则可以适当缩小光圈来延长曝光时间，拍摄到更加明显的车灯轨迹效果。感光度的设置范围建议为 100 ～ 400，能够获得不错的降噪效果，让画质更优。如图 10-10 所示，这张照片使用努比亚的"电子光圈"模式拍摄，曝光时间为 4.2 秒、光圈为 F/22、感光度为 200，通过缩小光圈和降低感光度，获得更加清晰的画面效果。

10.2.3　设置 3：对焦模式

车流灯轨通常都是在夜晚拍摄，在这种弱光环境下手机的自动对焦模式很难合焦，因此很容易失效。所以，拍摄车流灯轨时建议使用手动对焦模式，同时可以对着画面中较亮的光源（通常为车灯）进行对焦，可以让主体变得更加清晰。

第 10 章 车轨拍摄,精彩出奇

图 10-10 车流灯轨效果

10.2.4 设置 4:白平衡

对于车流灯轨的白平衡设置,建议用户先用自动白平衡模式拍摄一张样片,然后根据拍摄效果再选择"手动"模式进行调整。

- 若想拍出偏暖黄的画面色调,可以将"色温"调至 500K 或更高,效果如图 10-11 所示。
- 若想拍出偏冷蓝的画面色调,则可以在低于 500K 的范围内调整"色温"参数,效果如图 10-12 所示。

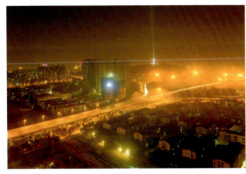

图 10-11 偏暖黄的画面色调

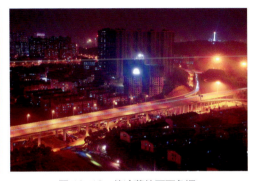

图 10-12 偏冷蓝的画面色调

10.2.5 设置 5：快门速度

用户可以将初始快门速度设置为 1 秒，然后逐步增加曝光时间，这样可以明显看到车轨会变得更长、更粗。用户可以根据车流量的疏密程度来调整快门速度，如果车流量较密集，则可以将快门速度设置为 2 ～ 10 秒；如果车流量较稀疏，则可以将快门速度设置为 10 ～ 30 秒。

如图 10-13 所示，这张照片的曝光时间为 13 秒，车灯的拖影比较细长。如图 10-14 所示，这张照片的曝光时间为 30 秒，可以看到车轨明显要更加"粗壮"。

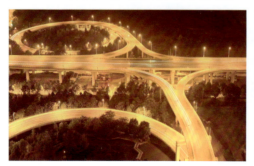
图 10-13　曝光时间为 13 秒的拍摄效果

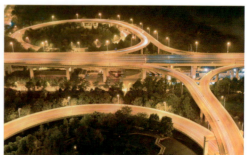
图 10-14　曝光时间为 30 秒的拍摄效果

10.3 拍摄场景：车流灯轨的常见题材

拍摄车流灯轨时，不同的场景和参数会有不一样的视觉效果。本节将介绍一些车流灯轨的常用拍摄场景和角度，让你的夜景车轨照片更具灵动感。

10.3.1 场景 1：在人行天桥上俯视拍摄

城市里的人行天桥是最容易拍摄到车轨的地方，拍摄时尽量找一个道路两边没有太多高楼和明显光源的地方，然后将手机架在天桥的正中间拍摄。

图 10-15 为在人行天桥中间俯拍对向车道的车流灯轨效果，马路两边分别为不同的车灯颜色，一边是白色的车前灯，另一边是红色的车尾灯，对比非常明显。

在拍摄图 10-15 时，由于马路上的车流比较少，因此将曝光时间设置为 30 秒，并将 ISO 设置为 100，让手机自动调小光圈，将路灯的点光源拍出星芒效果。同时，使用点测光模式对道路左侧的车灯进行测光，来加深车轨线条的显示效果。

10.3.2 场景 2：在城市高楼平拍或俯拍

高楼具有天然的视觉优势，平拍可拍摄大气磅礴的远景或全景，俯拍则可拍摄居高临下的车光流影。需要注意的是，到了顶楼，选择位置的基本原则是"安全第一"，地面要既能站稳，同时也能方便拍摄操作。

图 10-16 为在城市高楼上俯拍的车流灯轨效果，使用华为手机的"车水马龙"模式拍摄，曝光时间为 8 秒，可以拍出质感不错且有大量线条的车轨。

第 10 章 车轨拍摄，精彩出奇

图 10-15 在人行天桥上俯拍的车流灯轨效果

图 10-16 在城市高楼上俯拍的车流灯轨效果

在高楼上拍摄车流灯轨时，可以故意晃动一下手机，这样能够让道路产生幻影，同时还能够记录路灯的移动轨迹，拍出更有创意的幻影效果，如图 10-17 所示。

图 10-17 幻影效果

10.3.3 场景 3：在道路的两侧平视拍摄

除了寻找能居高临下的高处俯拍车流灯轨外，也可以在道路两侧进行平拍，能够拍出自带"风感"的车轨效果，如图 10-18 所示。在路边拍摄车轨时首先要注意安全，同时可以选择尾灯较多的一侧拍摄车流，这样画面颜色更为丰富和漂亮。

图 10-18 在路边平拍的车流灯轨效果

10.3.4 场景 4：在道路中央低角度拍摄

在道路中央用低角度拍摄车流灯轨，两侧的车流仿佛靠着手机镜头飘过，可以获得更强烈的空间透视感，从而让观众身临其境地感受车流的动感，如图 10-19 所示。

图 10-19　在道路中央低角度拍摄的车流灯轨效果

10.3.5 场景 5：选择拐弯处来拍摄车轨

在道路的拐弯处拍摄车流灯轨，可以选择立交桥或者山路等场景，能够将车轨的线条美感更好地展现出来。

图 10-20 为在视野开阔的高处俯拍的环形立交桥，曝光时间为 20 秒，能够获得更多的车轨线条，同时弯曲的道路可以更好地表现车轨之美。

图 10-21 为采用近距离的平视角度拍摄的立交桥局部，桥上的车轨呈现字母 C 的形状，具有引导线的效果，能够更加吸引观众的视线。

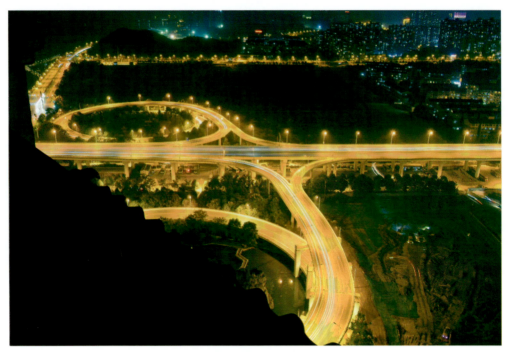

图 10-20　高处俯拍的环形立交桥上的车流灯轨效果

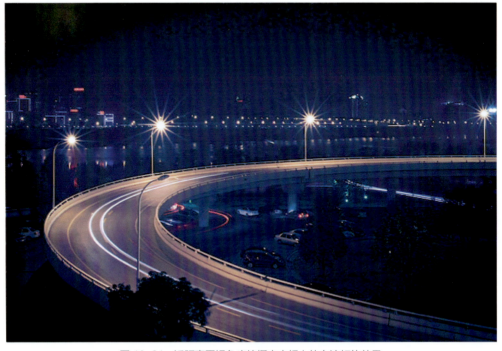

图 10-21　近距离平视角度拍摄立交桥上的车流灯轨效果

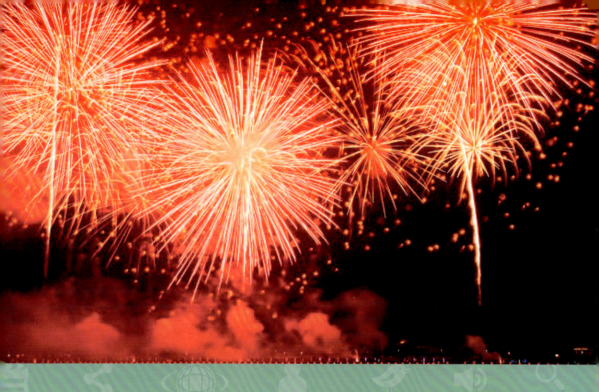

第 11 章

烟花拍摄，闪耀全城

　　在逢年过节或特殊的节庆时期，常常都会燃放烟花来进行庆祝，当烟花在夜空绽放时，画面非常漂亮。不过烟花的美丽是非常短暂的，因此大家都喜欢用照片将烟花绽放的过程记录下来，定格这美丽的瞬间。本章主要介绍使用慢速快门拍摄烟花的相关技巧，帮助大家更好地记录烟花的绚丽之美。

11.1 拍摄技巧：拍好慢门烟花的要点

烟花是慢门摄影的常用拍摄题材之一，本节主要分享拍好烟花的3个要点，包括慢门拍摄、取景构图和黑卡拍摄，希望对大家有帮助。

11.1.1 慢门：记录烟花光点移动轨迹

使用慢速快门拍摄烟花，能够将烟花光点的移动轨迹记录下来，不过需要把握好曝光时间的长短，来捕获更长的烟花轨迹。

如果曝光时间过短，则只能拍摄到烟花的光点，效果如图11-1所示。如果曝光时间适中，则能够拍摄到部分烟花轨迹，不过轨迹长度有限，效果如图11-2所示。

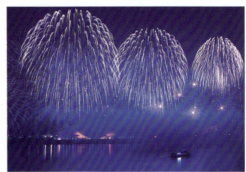

图11-1　曝光时间为1/80秒的拍摄效果　　图11-2　曝光时间为3.7秒的拍摄效果

当使用较长的曝光时间拍摄时，则能够将烟花燃放时的光点轨迹清晰、完整地记录下来，效果如图11-3所示。

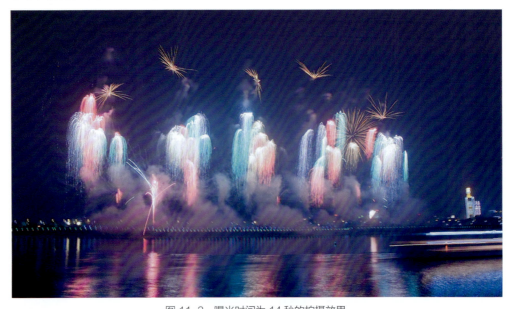

图11-3　曝光时间为14秒的拍摄效果

11.1.2 取景：不要拍摄太多烟花元素

拍摄烟花时，要找到好的拍摄角度，将最漂亮的烟花拍摄下来。因此，我们在取景构图时，切忌贪大求全，否则画面会显得很杂乱。因此可以尽量选择两三朵烟花来拍摄，同时让烟花尽量充满整个画面，这样主体会更突出，如图11-4所示。

图11-4 拍摄时的烟花不要太多

当然，在大部分情况下，烟花燃放的数量并不是我们可以左右的。此时建议大家在构图时可以安排一些前景或背景元素，如街道、建筑、车流和行人等，来丰富画面，提升趣味性，如图11-5所示。

图11-5 增加前景丰富画面效果

11.1.3 黑卡：拍摄多个烟花绽放画面

烟花通常是逐个燃放的，如果要同时拍摄多个烟花，此时可以使用黑卡来实现。在拍摄烟花时，其绽放的时间通常是无法把握的，因此可以使用黑卡来"卡点"。

用户可以在烟花绽放前点击手机的快门按钮，然后用黑卡遮挡镜头，其效果类似于关闭快门，接下来等到烟花绽放的瞬间再拿开黑卡，这样就得到了一次曝光。使用同样的操作，继续用黑卡来拍摄其他烟花的绽放过程即可，效果如图 11-6 所示。

图 11-6 使用黑卡同时拍摄多个烟花绽放的画面

11.2 拍摄步骤：慢门烟花的拍摄流程

拍摄烟花看上去很简单，其实不然，如果你没有做好相关的准备，或者不懂拍摄方法，实际拍摄时就容易手忙脚乱，结果往往拍摄不到精彩的画面效果。本节介绍拍摄烟花的相关步骤和流程，帮助大家用手机轻松拍摄出漂亮的烟花照片。

11.2.1 器材：拍摄烟花的常用设备

拍摄烟花需要提前准备的器材包括三脚架、快门线（可用耳机线代替）、黑卡和手电筒等，同时要保证手机的电量充足，以及有足够的内存空间。

三脚架和快门线主要用来保持手机拍摄时的稳定性，让手机能够在长时间曝光过程中，清晰地记录烟花升空、爆裂和落下的全部光线轨迹，如图11-7所示。如果没有带黑卡，也可以用黑色的钱夹来代替。

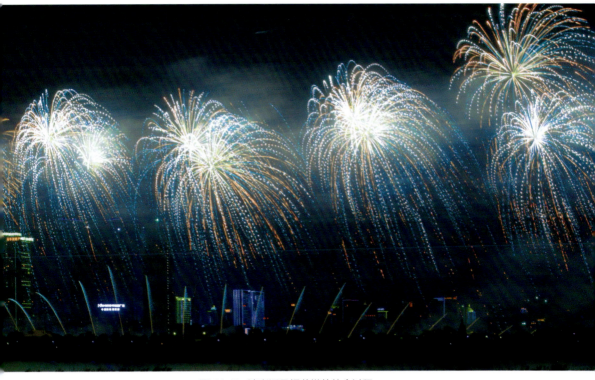

图11-7 清晰记录烟花燃放的全过程

大部分手机都是自带的广角镜头，而且拍摄烟花时通常站得比较远，那么拍出的烟花在画面中会显得很小，而使用手机变焦功能放大画面又会影响画质。

因此，建议大家可以购买一个手机望远镜，在保证画质的同时能够增大画幅，拍摄到烟花燃放时的特写镜头，如图11-8所示。

图 11-8 拍摄烟花特写

11.2.2 地点：选择开阔的拍摄场景

拍摄烟花的取景通常都较为极端，要么直接拍摄整个烟花燃放的大场景，要么利用手机的变焦功能或外接望远镜拍摄烟花特写，如图 11-9 所示。

图 11-9 拍烟花的大场景（左图）和特写（右图）

对于拍摄烟花特写来说，对地点的要求不大。但对于拍摄烟花大场景来说，就需要大家尽量找一个高点和空旷的地点去拍摄，如山顶、高楼或者大桥上等。

同时，用户也可以试着将一些地标建筑作为画面的点缀，增加作品的场景感和纪念价值，如图 11-10 所示。需要注意的是，镜头前尽量不要有杂乱的遮挡物，如电线杆和大树等。

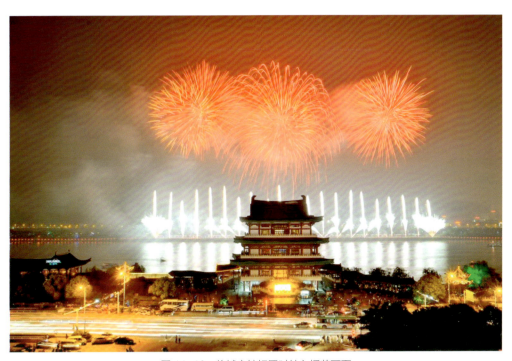

图 11-10 将城市地标同时纳入烟花画面

11.2.3 天气：注意拍摄位置的风向

拍摄烟花对于天气的基本要求是"空气的湿度较大、能见度高"，同时有点微风是最为合适的，可以让烟花的轨迹更加缥缈，如图 11-11 所示。

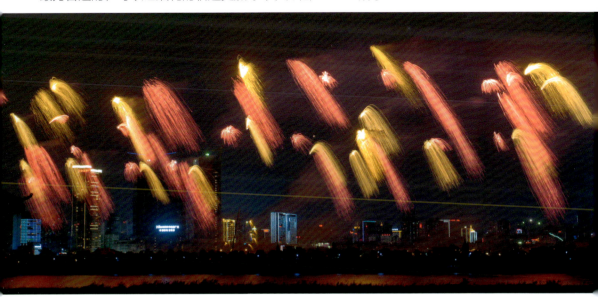

图 11-11 微风可以让烟花都朝向一个方向飘动

另外,风不能太大,否则会将烟花吹乱,拍摄出来的形状就不太美观了。而如果没有风,则烟花燃放后产生的烟雾会长时间在空中停留,这样很难拍摄好后面的照片。

在夜晚拍摄烟花时还要注意,千万不要站在逆风或者顺风的位置上,逆风会让烟花燃放时产生的烟雾都飘向自己,影响视线;顺风则很难拍摄出完整的烟花形状。

11.2.4 对焦:用手动对焦模式拍摄

烟花通常都是在夜晚拍摄,因此环境光线会比较差,此时手机的自动对焦功能就不太好使了。因此,拍摄烟花时我们需要在手机相机中选择手动对焦模式,然后选择烟花燃放的区域进行对焦,即可清晰捕捉转瞬即逝的烟花画面,如图11-12所示。

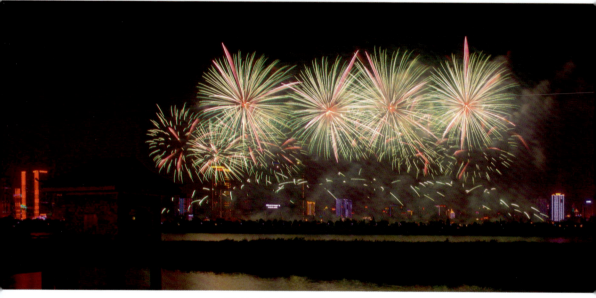

图 11-12 捕捉转瞬即逝的烟花画面

11.2.5 测光:用参考光源进行测光

拍摄烟花时最好选择点测光模式,并对烟花的亮部进行测光,避免画面曝光不足或过曝。另外,用户也可以选择一个与烟花亮度差不多的光源作为测光点,同时将这个参照的光源与烟花一起共同拍摄到画面中,这样更容易拍摄出曝光正常的烟花效果。

图11-13为使用路灯作为测光点进行提前测光,并拍摄的烟花效果。

图11-14为使用建筑霓虹灯作为测光点进行提前测光,并拍摄的烟花效果。

用户在使用手机拍照时,可以使用以下方法调整照片的亮度。

- 点击手机屏幕中的较亮物体进行测光,照片会变得更暗。
- 点击手机屏幕中的较暗物体进行测光,照片会变得更亮。
- 点击手机屏幕中的中性色(通常表现为灰色)进行测光,照片上的明暗关系就比较接近人眼所看到的感觉。

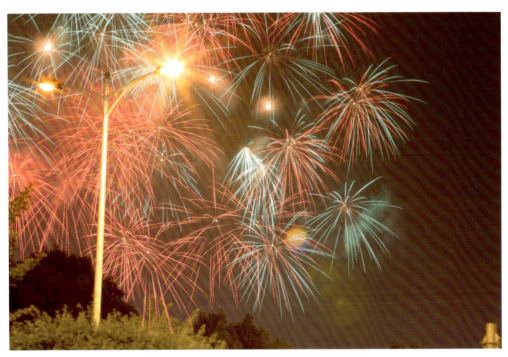

图 11-13　使用路灯作为测光点拍摄的烟花效果

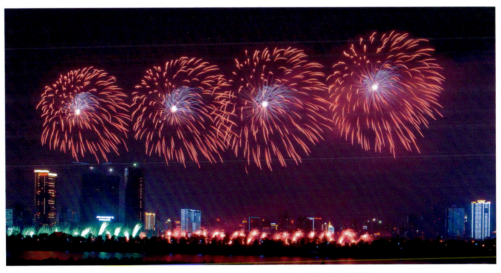

图 11-14　使用建筑霓虹灯作为测光点拍摄的烟花效果

11.2.6　曝光：使用曝光锁定的功能

当获得合适的烟花照片曝光值后，就可以利用手机"曝光锁定"功能锁定曝光点，即可更轻松地拍摄其他烟花照片。

以 iPhone 手机为例，用户可以长按"照片"界面中的黄框区域，即可开启"自动曝光/自动对焦锁定"功能，如图 11-15 所示。

图 11-15 开启"自动曝光/自动对焦锁定"功能

其他具有"曝光锁定"功能的手机操作方法也类似,大家可以自行尝试,例如努比亚全系列手机都有"曝光锁定"和"焦光分离"功能。如图 11-16 所示,拍摄时将测光点对准底部的烟花火焰进行提前测光,然后锁定曝光,并利用手机的"焦光分离"功能,将对焦点放在烟花爆裂的位置处,拍摄出曝光正常且清晰的画面效果。

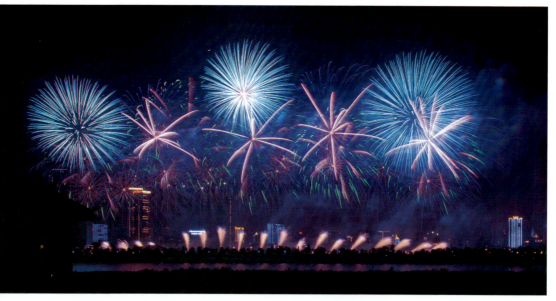

图 11-16 曝光正常且清晰的烟花效果

11.2.7 光圈:根据现场情况来调整

由于拍摄烟花通常都是用的慢速快门,因此光圈都比较小,建议可以设置为 F/8 ~ F/20,来拍摄出清晰、锐利的画面效果。另外,用户可以多进行试拍,并根据现场情况来微调光圈值,从而保证合理的景深效果和正常的曝光量。

如图 11-17 所示,该照片使用努比亚手机的"电子光圈"模式拍摄,光圈为 F/8,烟花的轮廓看上去比较"粗"且"亮",同时可以拍摄出大景深效果,让画面更清晰。

第 11 章 烟花拍摄，闪耀全城

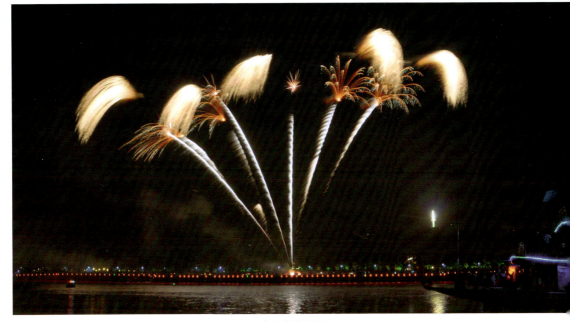

图 11-17　F/8 光圈的拍摄效果

如图 11-18 所示，由于烟花的爆裂范围比较大，因此将光圈增加到 F/11，烟花的轮廓显得更加"细"且"暗"，同时可以保证前景和背景都清晰成像。

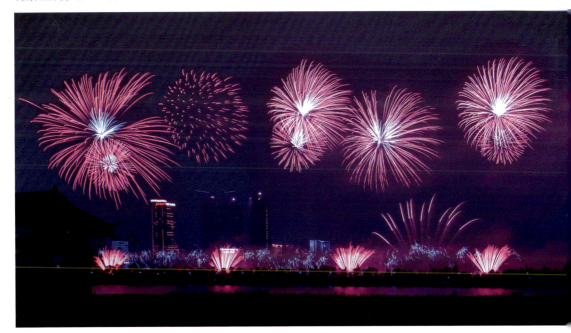

图 11-18　F/11 光圈的拍摄效果

11.2.8 ISO：用低感光度提升画质

拍摄烟花时，ISO 可以设置得稍微低一些，从而避免画面因长时间曝光产生太多的噪点，获得更加细腻的画质效果。

如图 11-19 所示，该照片的曝光时间为 4.7 秒、ISO 为 100，用较长的曝光时间和较低的感光度拍摄，可以看到画面中的烟花轨迹非常长。

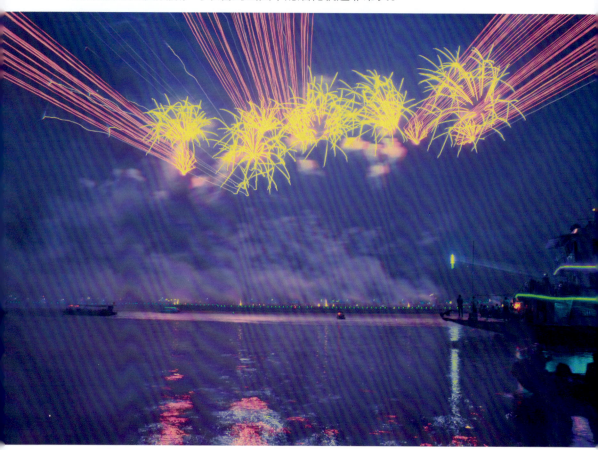

图 11-19　ISO 为 100 的拍摄效果

如图 11-20 所示，该照片的曝光时间为 2.8 秒、ISO 为 200，画面中的烟花数量较多时，可以适当增加感光度，但不要调得过大，要保证画质，减少画面噪点。

11.2.9 快门：设置合理的曝光时间

由于烟花本身就具有很强的亮度，因此我们无须去提升感光度来增加进光量，此时只需要设置好合理的快门速度即可。在设置快门速度时，建议初始值选择 1 秒，然后根据现场光线情况、烟花自身亮度和燃放时间间隔来进行适当调整。

当烟花从地面开始升起的时候，即可点击手机快门按钮进行曝光，然后根据烟花的燃放情况来关闭快门结束曝光，如图 11-21 所示。

第 11 章 烟花拍摄，闪耀全城

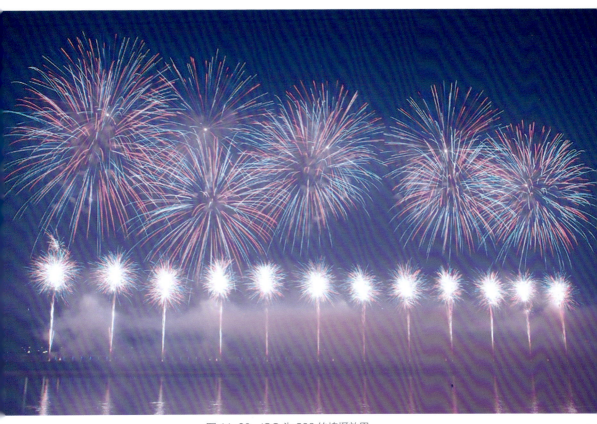

图 11-20　ISO 为 200 的拍摄效果

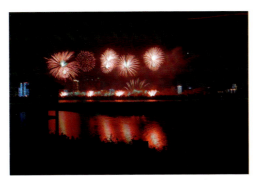 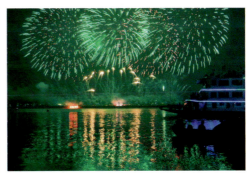

烟花亮度低，延长曝光时间 (5.6 秒)　　　　烟花亮度高，减少曝光时间 (2 秒)

图 11-21　根据烟花的燃放情况调整快门速度

　　图 11-22 为使用华为手机的"专业"模式拍摄的烟花效果，选择 MF（手动对焦模式），并将对焦点设置为无穷远，同时设置曝光时间为 15 秒、ISO 为 200，通过延长曝光时间，将烟花的漂亮轨迹拍摄下来。

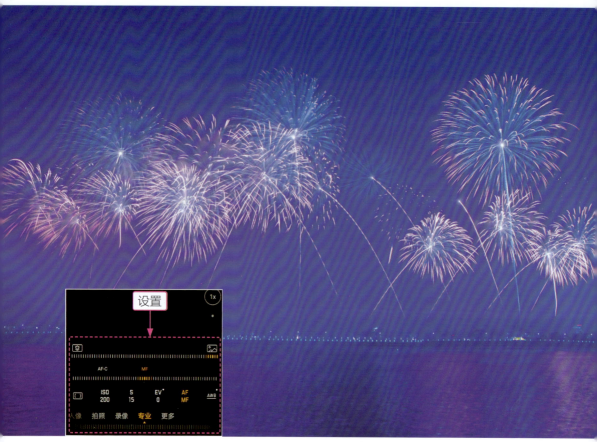

图 11-22 使用 15 秒曝光时间拍摄的烟花轨迹效果

第 12 章

星空拍摄，天旋地转

　　一说到星空摄影，我们都会被满天的繁星美景所震撼、所吸引，但要想拍摄出浩瀚的星空与银河景色，还需要做好大量的准备工作，比如拍摄星空的注意事项、曝光参数的设置及具体的拍摄场景等。本章主要介绍手机拍摄星空的方法，帮助大家轻松拍摄出美美的星空照片。

12.1 注意事项：提前做好拍摄规划

使用手机拍摄星空之前，我们首先要知道拍摄星空有哪些注意事项，提前知晓并做好规划，比如什么样的天气适合拍摄星空、什么样的环境才能拍出星星、银河在哪个方位，以及前景如何选择等。掌握这些注意事项，才能拍摄出理想的星空照片。

12.1.1 天气：选择合适的天气出行

在出门拍摄星空照片之前，我们在规划时间的时候，一定要用手机 App 查看拍摄当天的天气情况，选择天气晴朗的时候出行。

1. 查看天气、云量、雨量情况

我们可以先使用 App 查看出行当天的天气情况，如温度、云量和雨量等信息，可以查看天气的 App 有 Windy、晴天钟和彩云天气等，还有莉景天气小程序。

> **专家提醒**
>
> 天气是瞬息万变的，所以不要完全依赖软件所给出的天气预报，有时候 App 上显示当地是晴天，但到了之后出现多云的天气也是非常常见的事情。所以，越是临近的日期，天气预报才越准确。

2. 一定要避开满月天拍摄星空

农历每月十五、十六，月亮运行到太阳的正对面，日、月相距 180°，此时的地球位于太阳和月亮之间，月亮的整个光亮面对着地球，这个时候就是我们所说的满月。满月天是一种天文现象，表示月亮是满的、圆的，如图 12-1 所示。

> **专家提醒**
>
> 华为 P30 有一个非常强大的功能，就是用手机来拍摄月亮的时候，将焦距设置为 30 倍长焦，相机内置的 AI 模式可以自动识别月亮，这样拍摄出来的月亮又大又清晰。

满月天不适合拍摄星空，因为这个时候的月亮光芒很强，天空中的星星就会显得稀少。所以，我们拍摄星空照片时，一定要避开满月天。

12.1.2 方向：寻找星系银河的位置

当我们挑选好拍摄位置后，接下来打开手机 App，寻找星系银河的位置，我们可以通过巧摄、星空地图、StarWalk（中文名称是"星空漫步"）等 App 来寻找北极星或其他星座的位置。

例如在巧摄 App 中，我们可以使用虚拟现实取景框来查看银河的运动轨迹，以及查看北极星的位置，可以方便我们拍摄星轨时进行构图取景，如图 12-2 所示。

图 12-1　满月天气

图 12-2　寻找北极星的方位

12.1.3 光线：避开城市光源的污染

拍摄星空照片，最重要的一点就是不能有光源污染，因为拍摄时会进行长时间的曝光，手机会不断地吸收星星的亮光，在这个过程中，手机也会不断地吸收画面中其他的光源。所以如果有光污染的话，拍摄出来的整个画面就会产生曝光过度的现象。

12.1.4 构图：选择恰当的前景对象

拍摄星空照片时，一定要选择适当的前景对象作为衬托，如果单纯拍摄天空中的星星，画面感与吸引力都是不够的，一定要地景和前景对象的衬托，才能体现出整个画面的意境。图 12-3 就是以山体的弧度为前景来拍摄的星空照片，还有一块石碑和一辆汽车作为画龙点睛之笔，吸引观众的眼球。

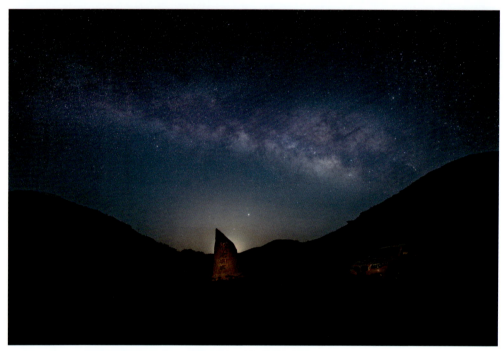

图 12-3　选择恰当的前景

12.2 拍摄步骤：使用手机拍摄星星银河

手机拍摄星空的方法与单反相机类似，只是参数设置界面不同，一个是在相机中设置拍摄参数，一个是在手机中设置拍摄参数。本节主要介绍手机拍摄星空照片的流程与方法。

12.2.1 步骤 1：找到合适拍摄位置

在选择拍摄位置与角度时，注意要选择好星星的方位，一般选星星多的或者某颗最

亮的星星。找好拍摄的位置，前后不要有人，避免拥挤，影响到三脚架的稳定性。

架好三脚架、手机支架或者八爪鱼，注意手机要固定好，不要晃动，否则拍出来的星星会很模糊。如果拍摄当天风很大，就一定要想办法把三脚架稳固好，以免手机摔到地上，产生不必要的损失。

12.2.2 步骤2：设置感光度参数

一般情况下，我们使用低感光度拍摄星空，笔者就使用250的感光度拍摄过星空，如果当前环境太暗，也可以将感光度调至3200来拍摄。

以华为P30手机的"专业"模式为例，点击ISO选项，弹出ISO参数设置条，最左边的A是自动模式，然后参数从小到大依次排列，如图12-4所示。向左或向右拖曳白色圆环滑块，选择3200选项，如图12-5所示。执行操作后，即可完成ISO参数的设置。华为P30手机最大的感光度可以设置为204800。

图12-4 弹出ISO参数设置条

图12-5 选择3200选项

用手机拍的星空，当曝光时间设置为30秒、对焦模式设置为无穷远的时候，尽量用低感光度去拍摄星空，这样拍摄出来的画面噪点少，照片质量高。因为高感光度带来的是高噪点，不便于照片的后期处理。另外，华为P30手机可以拍RAW的格式，方便对照片进行后期处理。

另外，在拍摄星空照片的时候，尽量带一个地灯，主要用来给前景补光，这样可以避免拍摄出来的星空照片黑乎乎的。如果我们要拍摄人像星空的话，也可以用地灯来给人像前景补光，这是一个非常实用的工具。

12.2.3 步骤3：设置快门速度

以华为P30手机的"专业"模式为例，快门速度的设置也是在"专业"模式中进行的，点击S选项，弹出快门参数设置条，最左边的A是自动模式，然后参数从小到大依次排列，如图12-6所示。向右拖曳白色圆环滑块选择最右侧的30选项，这是手机相机曝光时间最长的快门参数值，表示30秒长曝光，如图12-7所示。执行操作后，即可完成快门参数的设置。

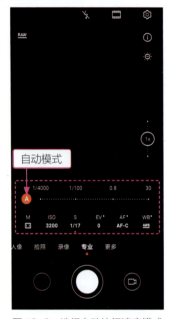 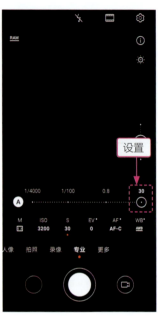

图12-6　选择自动快门速度模式　　　　　图12-7　设置30秒曝光时间

12.2.4 步骤4：设置对焦模式

使用手机拍摄星空照片，一定要将手机的对焦点设置为无穷远▲。在华为P30手机的"专业"模式中，选择AF选项，然后选择MF(手动对焦模式)选项，并通过拖曳白色圆环滑块来调整对焦点，如图12-8所示，直至调到画面清晰为止。需要多拍摄几张照片，才能看出不同对焦效果的区别。

图12-8　设置手机对焦模式

12.2.5 步骤 5：多次尝试拍摄星空

当我们在手机中设置好拍摄参数后，接下来需要大家多次尝试拍摄星空照片，点击手机相机的快门按钮，即可拍摄星空照片。图 12-9 为笔者使用华为 P30 手机拍摄的星空效果。

图 12-9　星空效果

在拍摄星空时，因为选择的角度不一样、构图不一样、光线不一样，拍摄出来的最终效果也会不一样。因此，我们需要在不断的摸索和实践中，找到最好的构图与光线角度，拍摄出理想的星空大片。

12.3　拍摄场景：手机拍摄星空常见题材

其实，我们每天拿在手里的手机，就能拍出"高大上"的星空大片，很多用户都不太熟悉自己的手机，也不知道原来手机中的相机功能这么强大。本节主要介绍使用手机拍摄各种星空题材的方法，帮助大家拍摄出绚丽的星空作品。

12.3.1　场景 1：指星画面

笔者经常拍摄"指星"的画面，这是因为仰望星空是笔者小时候的愿望。如图 12-10 所示，用一个头灯照向最亮的那颗星的方向，然后拍摄即可，核心是在曝光的 N 秒期间，人物和灯光一定要静止不动，等拍摄完再动，否则拍摄出来的画面就是模糊的。

还有一个关键点，就是头灯照射的时间，比如手机曝光 30 秒拍一张，灯光只要开 3 秒左右就要关闭，千万不能开 30 秒的头灯，否则画面会曝光成白色的。

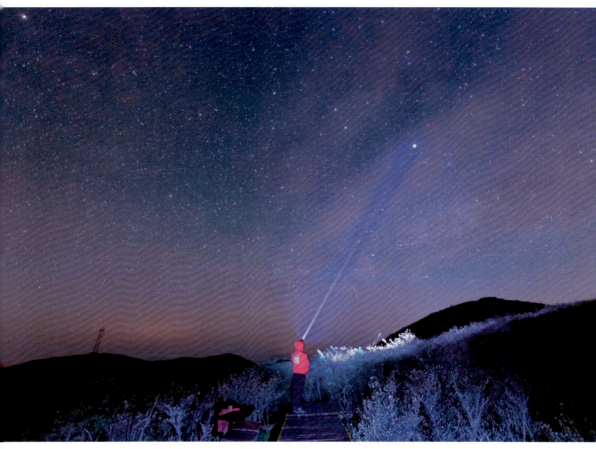

图 12-10 "指星"画面的拍摄效果

其实，拍摄这类照片的操作很简单，只要手机能够设置感光度和曝光时间，就都能拍摄出来。例如，在华为手机的"专业"模式下，设置 ISO 为 3200、曝光时间为 30 秒、对焦点为无穷远，即可拍摄"指星"的照片，如图 12-11 所示。

图 12-11 使用华为手机设置相应参数

目前，市场上只要超过 2000 元的新机型，基本上都能设置这些参数，所以都能拍摄一些简单的星空照片，但要让星星更亮更明显，就需要后期锐化和加强处理。

12.3.2 场景 2：工作照片

"工作照片"即将自己拍摄星星时的过程画面,用手机拍下来,如图 12-12 所示。需要注意的是,拍摄"工作照片"需要布局好相机、人物和星空的关系,同时地景的小亭子也不能挡住,人物身上还需要补光,可以用头灯来打光。

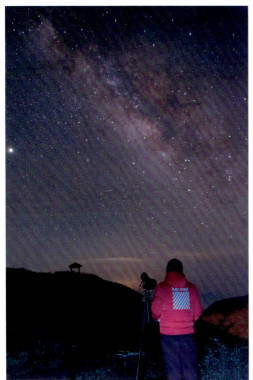 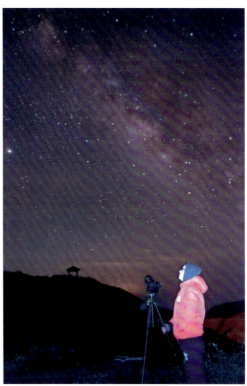

图 12-12 拍摄"工作照片"画面

12.3.3 场景 3：普通银河

手机能拍银河,例如华为和努比亚等品牌的新机型,以及其他专门针对拍摄星空的手机。图 12-13 为一张银河已经升得比较高的照片,曝光时间为 15 秒、感光度为 1000。

笔者曾尝试用华为 P20、P30 以及 P40 拍摄银河,但是手机拍摄出来的效果没有那么强烈,只能靠后期处理,效果如图 12-14 所示。

图 12-13 和图 12-14 主要用了两种构图：前景构图,拍星空一定要选择有特点的地景；斜线构图,整个银河呈斜线形状,非常具有动感。如图 12-15 所示,这两张银河照片采用了竖画幅构图,将亭子分别置于右下角和左下角进行构图取景。

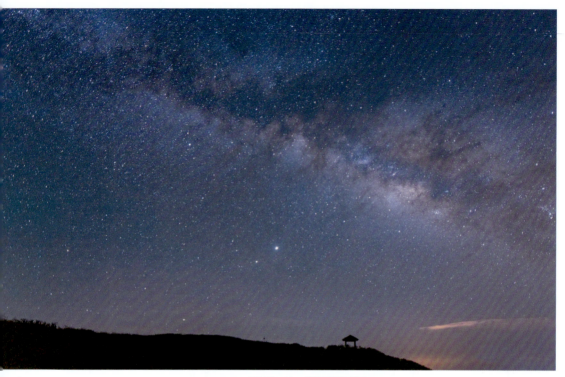

图 12-13 银河照片效果

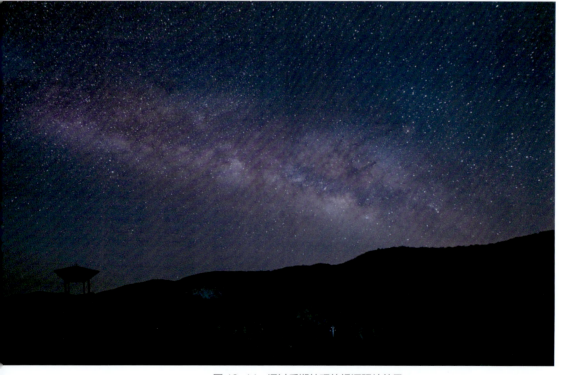

图 12-14 通过后期处理的银河照片效果

第 12 章 星空拍摄，天旋地转

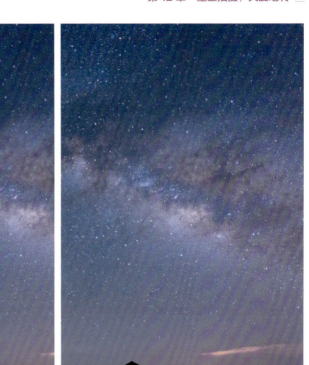

图 12-15 竖画幅构图拍摄的银河照片效果

12.3.4 场景 4：银河拱桥

如图 12-16 所示，下面这张银河拱桥照片，笔者给它取名"拥抱"。这种银河拱桥的拍摄难度非常大，比上面拍摄普通银河场景要难很多。

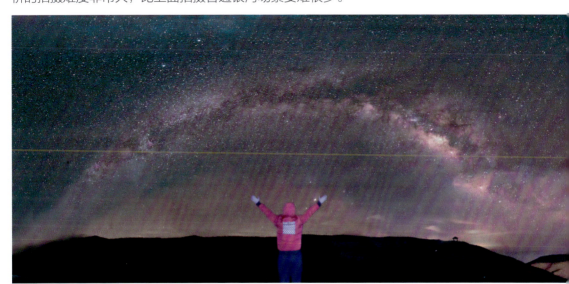

图 12-16 "拥抱"银河拱桥作品效果

191

上图为使用华为手机的"专业"模式,横向水平或竖向垂直移动手机,拍摄了多张照片进行后期拼接并合成为一个全景画面,拍摄时设置ISO为3200、曝光时间为30秒、对焦点为无穷远。同时,每张照片的重叠度为50%。

下面这张照片是180°的全景图,笔者从左到右、从上到下一共拍摄了18张照片,平均一排是6张,共拍了3排,然后在后期通过Snapseed App进行二次曝光合成完成接片,或者使用PTGui或Photoshop等软件进行拼接,效果如图12-17所示。

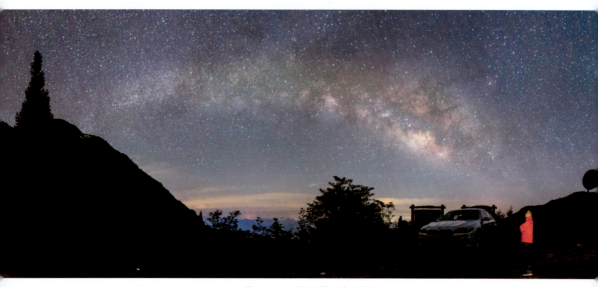

图12-17 银河拱桥全景效果

12.3.5 场景5:绚丽星轨

拍星轨最重要的还是前景要找好,同时用三脚架固定好手机,在曝光的时候绝对不能晃动手机。图12-18为使用华为手机的"绚丽星轨"模式拍摄的星轨效果,拍摄星轨时可以观看实时的星轨效果,只要你觉得合适了,就可以停止拍摄。曝光时间越久,星轨的线条会越多。

在图12-18中,细心的读者可以发现,左边的星轨线条圆心在左上角,右边的星轨线条圆心在右下角的画面外部,这是因为这张照片既体现了北极星方向的星轨(左边),又兼顾了偏南极星方向的星轨(右边)。

注意,要在画面中拍出两极线条,大家可以使用星空地图App来寻找合适的取景位置,最好以北极星和南极星的中间点来取景。另外,用户还需要在画面中安排一些前景元素,使画面层次更丰富。

第 12 章 星空拍摄，天旋地转

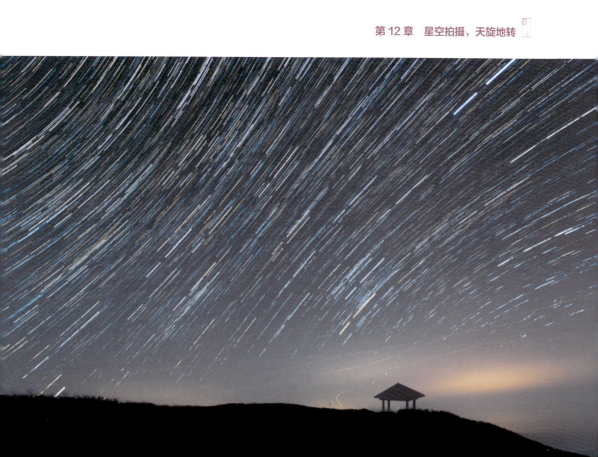

图 12-18 星轨效果

第 13 章
光绘摄影,创意无限

　　光绘摄影,顾名思义,就是利用光线来进行"绘画",从而创造出非常酷炫的画面效果。光绘摄影的拍摄关键点在于暗色背景、曝光时间和移动光源,只有把握好这三点才能创造出华丽的光绘效果。本章主要介绍光绘摄影的拍摄技巧和相关案例,让大家也能够轻松拍出充满高级创意感的光绘作品。

第13章 光绘摄影，创意无限

13.1 准备工作：认识光绘摄影

光绘摄影主要是利用长时间曝光功能，来记录光源的移动轨迹，在画面中呈现出光轨图案，从而获得"光的绘画"效果。如今，很多手机都有"光绘摄影"模式和"专业"模式，因此光绘摄影已经不再是相机的专利，手机也可以轻松实现。

13.1.1 拍摄原理：用慢速快门记录光轨

在拍摄夜景时，如果用慢速快门拍摄镜头前的汽车，就会看到车灯在画面中形成了一条条的红色、蓝色或白色轨迹线，如图 13-1 所示。

图 13-1　慢速快门拍摄的车灯轨迹线

其实，光绘摄影的原理与车灯的光轨是一样的，都是在慢速快门的前提下，用不同类型的光源来"作画"。不同之处在于，车灯的轨迹线利用的是汽车灯光，是我们无法控制的光源，因此其形状跟汽车的移动轨迹一致，通常都是直线；而光绘摄影中用到的光源，通常是我们可以手动控制移动轨迹的，因此能够拍出各种形状的光轨。

当然，想要拍出好看的光绘摄影作品，还需要拍摄者具备一些"作画"的能力，以及拥有不同色彩的光源。图 13-2 为影像极客创始人、光绘吉尼斯纪录创造者、国内顶尖光绘艺术家陆鑫东拍摄的光绘作品，这张照片使用华为 P40 手机拍摄，用光画出"一

个妇女背着孩子",地上还跟着一只"狗",画面非常有创意。

图 13-2 创意十足的光绘摄影作品（摄影师：陆鑫东）

> **专家提醒**
>
> 陆鑫东是一位有名的光绘摄影师，他不仅是 8K RAW 签约摄影师、视觉中国签约摄影师，而且他的团队制作的内容还在各大平台获得了超百万的订阅用户，播放量也已经过亿。大家如果想深入学习光绘摄影技术，可以看看陆鑫东出版的《光绘摄影与后期技巧大全》，在这本书中详细介绍了光绘摄影作品的拍摄技法。

13.1.2 暗色背景：选择适合光绘的场地

光绘摄影对于拍摄场地的要求比较高，首先要找一个有暗色背景的拍摄场地，例如夜晚中的广场、海边、树林、公园、无人的道路或空地等宽敞的场地，以及关了灯和窗户的室内，这些都是比较合适的拍摄场景。

通常情况下，拍摄场地的光线越暗，越容易实现长时间曝光拍摄，如图 13-3 所示。如果拍摄背景不是暗色，不仅背景看上去很杂乱，而且还会由于过多的光源，导致无法突出光绘主体。

第 13 章 光绘摄影，创意无限

图 13-3 在空旷的暗色背景下拍摄光绘作品

13.1.3 移动光源：准备光绘摄影的器材

在拍摄器材方面，除了支持 B 门、M 档（全手动模式）和 S 档等模式的相机外，支持调整快门速度的手机也可以拍摄光绘摄影作品。另外，三脚架和遥控快门也是必备的拍摄器材。

当然，拍摄光绘作品最为关键的器材还是轻便的移动光源道具，如钢丝棉、荧光棒、手机闪光灯、彩色灯管、手电筒、摄影灯箱、激光灯、拇指灯、光刀、光刷和光绘棒等，如图 13-4 所示。

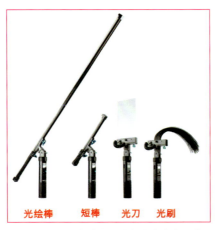

图 13-4 拍摄光绘常用的部分移动光源道具

13.2 参数设置：满足光绘需求

用手机进行光绘摄影，在拍摄参数的设置上其实也比较简单，用户只需要选择合适的拍摄模式，以及设置好曝光参数和对焦方式，即可尽情地在手机镜头前进行光绘创作。

13.2.1 设置 1：选择拍摄模式

华为或努比亚等品牌的大部分机型都带有光绘模式，因此只需在手机中打开相应的拍摄模式即可。其他品牌的安卓手机可以选择"专业"模式，iPhone 手机则可以借助具有长曝光功能的专业软件来实现光绘摄影。

例如，小米旗舰机型基本都支持长曝光功能。图 13-5 为小米手机的"手动"模式，同样可以拍摄光绘摄影作品。

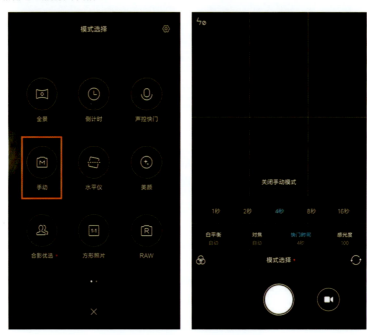

图 13-5 小米手机的"手动"模式

13.2.2 设置 2：设置曝光参数

在使用手机相机的"专业"模式拍摄光绘摄影作品时，用户可以手动调节快门速度、光圈和感光度等参数，使画面的曝光达到理想值。

（1）快门速度：一般情况下建议设置为 4～10 秒，同时还需要根据光绘创作需要的具体时间来进行调整。

（2）光圈：对于支持光圈调节功能的手机来说，例如努比亚手机，可以直接将光圈调至最大。另外，用户也可以根据环境光线的亮度来调整光圈，如果拍摄场景较暗时，就可以采用"低 ISO + 稍大光圈"来获得合适的快门时间；如果拍摄场景较亮时，就

可以采用"低 ISO +稍小光圈"来延长曝光时间。

（3）感光度：ISO 可设置为 50 ~ 200，或者直接选择最小值，让手机镜头的进光量降低，从而获得更长的曝光时间，提升画质表现。

13.2.3 设置 3：使用手动对焦

由于光绘摄影通常都是在弱光或全黑的环境下拍摄，如果使用手机相机的自动对焦模式，不仅难以操作，而且还很容易出现对焦错误。因此，用户需要选择手动对焦模式。

在对焦时，用户可以在光源进入镜头画面时利用手动对焦对主体进行对焦，从而拍摄到清晰的主体和光源轨迹。图 13-6 为在华为手机的"专业"模式下切换至 MF 手动对焦模式。

图 13-6　华为手机的 MF 手动对焦模式

> **专家提醒**
>
> 华为手机的原生相机支持 3 种对焦方式：AF-S（单次自动对焦）、AF-C（连续自动对焦）和 MF（手动对焦）。

13.3　拍摄场景：光绘拍摄题材

了解了光绘摄影的准备工作和参数设置技巧后，接下来就可以找一些场景来进行实际拍摄了。那么，光绘摄影有哪些可以拍摄的题材呢？本节将通过案例讲解的方式，介绍光绘摄影的常见拍摄题材。

13.3.1 场景 1：钢丝棉光绘

钢丝棉是拍摄光绘作品时最为常用的移动光源道具之一。当然，用钢丝棉拍摄光绘作品具有一定的危险性，因此用户还需要准备一些辅助工具，如棉手套、护目镜、铁链、钢丝绳、铁夹或打蛋器等，如图 13-7 所示。

图 13-7 用钢丝棉拍光绘的常用辅助工具

下面介绍拍摄钢丝棉光绘作品的具体步骤。

步骤 01 准备好工具后，戴上棉手套，取出钢丝棉。注意不要直接用手撕扯钢丝棉，否则很容易割伤手。

步骤 02 将钢丝棉拉散，长度大约在 15～30cm，同时可以叠加 1～3 层，这样钢丝棉会更容易接触到空气，燃烧时产生的火花也更多。叠加层数较多时，甩动钢丝棉时的燃烧时间也可以更久一些。

步骤 03 使用铁夹或打蛋器固定钢丝棉，然后将其系在铁链或钢丝绳上。使用铁夹时，注意一定要夹紧钢丝棉，同时钢丝棉不能放太多，如图 13-8 所示。使用打蛋器时，可以直接将剪好的钢丝棉塞入打蛋器内。

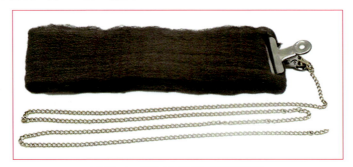

图 13-8 用铁夹和铁链固定好钢丝棉

步骤 04 用三脚架固定好手机，防止抖动，将快门速度设置为 8 秒或更长，同时结合感光度来控制合适的曝光时间。

步骤 05 戴上护目镜，将钢丝棉的末端点燃，然后甩动钢丝棉，同时还可以前后移动，让钢丝绵和飞溅的火星形成"无敌风火轮"形态的光轨效果，如图 13-9 所示。

第 13 章　光绘摄影，创意无限

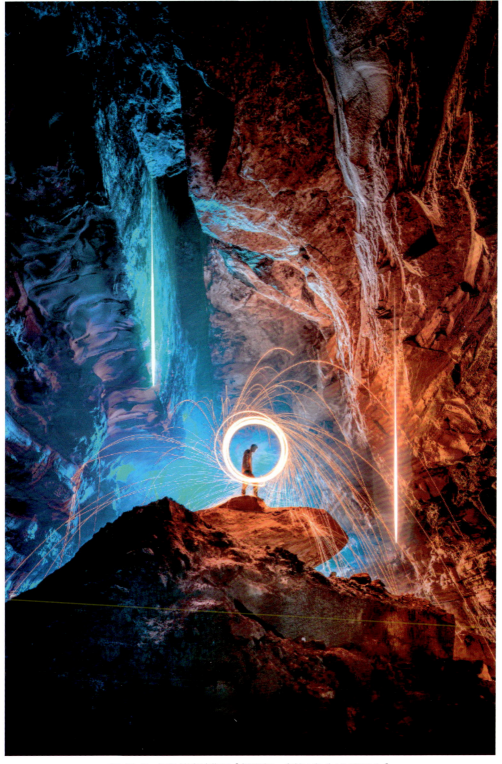

图 13-9　钢丝棉光绘作品【摄影师：余航（鱼头 YUTOU）】

需要注意的是，钢丝棉光绘摄影通常可以在黄昏和夜晚这两个时间段进行，能够获得最佳的拍摄效果，如图 13-10 所示。

图 13-10　在夜晚拍摄的钢丝棉光绘作品

13.3.2　场景 2：光绘写字

拍摄光绘写字的效果，使用手机闪光灯即可轻松实现。在拍摄过程中打开手机闪光灯，然后写出想要出现的文字或数字，或者画出相应的图案，如图 13-11 所示。需要注意的是，在写字的时候必须反着写，这样才能在手机镜头中显示正常的文字效果。

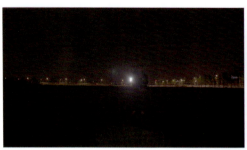

图 13-11　拍摄光绘写字的过程（摄影师：陆鑫东）

在设置快门速度时，用户可以根据要写的文字个数来适当调整其长短，通常在 2～8 秒。另外，用户可以在每写完一个字的时候，用手挡住光源，接着再移动到相应位置去写下一个字，这样可以避免出现连笔的情况。图 13-12 为使用红米 10X 手机拍摄的光绘写字效果，在拍摄时使用了多种颜色的光源进行点缀。

第 13 章 光绘摄影，创意无限

图 13-12 光绘写字效果（摄影师：陆鑫东）

13.3.3 场景 3：临摹人物形状

在拍摄临摹人物形状的光绘作品时，如果有人物作为参考，则拍摄过程相对要简单很多。让人物固定某个姿势，然后使用手电筒等光源，在人物后面沿着人物边缘"临摹"作画即可。如果没有人物作为参考，就需要拍摄者有一定的绘画功底，根据自己的想象来进行创作了，如图 13-13 所示。

图 13-13 临摹人物形状的光绘拍摄过程（摄影师：陆鑫东）

图 13-14 为使用华为 P40 手机拍摄的光绘临摹人物形状效果。需要注意的是，临摹人物形状的光绘摄影对于场景的要求比较高，环境光线不能太亮，这样光绘的人物形状才能更清晰。

图 13-14 光绘临摹人物形状拍摄效果（摄影师：陆鑫东）

13.3.4 场景 4：光绘汽车

拍摄光绘汽车这种题材时，前期很难确定曝光时间，因为光源的移动速度和汽车形状的绘制难度等因素，都会对曝光时间的长短产生影响。因此，拍摄前我们可以在脑海中提前构思一下大致的形状线条，或者先进行试拍，来确定拍摄过程所需的大致曝光时间。

同时，我们还可以根据光绘作品的拍摄效果来适当调整曝光补偿，保证画面的曝光达到正常，不会偏亮或偏暗。如果画面偏亮，就可以适当降低曝光补偿，反之则适当增加曝光补偿。

对于光绘汽车这种比较复杂的光绘作品来说，曝光时间通常需要达到 10 秒以上。如图 13-15 所示，使用华为手机的"光绘涂鸦"流光快门模式拍摄，曝光时间长达 135 秒，才能够用光线将汽车形状完整地描绘出来。

第 13 章 光绘摄影，创意无限

图 13-15 光绘汽车效果

13.3.5 场景 5：光绘人像

拍摄光绘人像作品时，由于加入了人像元素，所以需要用到闪光灯设备，在慢门拍摄结束前来照亮人物，从而让主体得到清晰的展现。拍摄光绘人像首先要选择一个简洁的场地，这样可以让光线显得更加绚丽。然后尽量选择会跳舞或体操的模特，这样能够增强人物姿势的优美度。如图 13-16 所示，首先在漆黑的环境下手持光源绘出光轨线条，然后在人物跳起摆姿势的一瞬间，开启闪光灯照亮人物。

图 13-16 光绘人像的拍摄过程（摄影师：陆鑫东）

图 13-17 为使用红米 10X 手机拍摄的光绘人像作品效果。使用红色的光源可以绘出更具速度感和运动感的线条，再搭配上美女模特舞动的姿势，展现出一种充满动感的状态。

图 13-17　光绘人像成品效果（摄影师：陆鑫东）

如果不想照亮人物主体的话，也可以采用剪影的形式，来展现人物的轮廓线条美感，效果如图 13-18 所示。

图 13-18　光绘剪影人像效果（摄影师：陆鑫东）

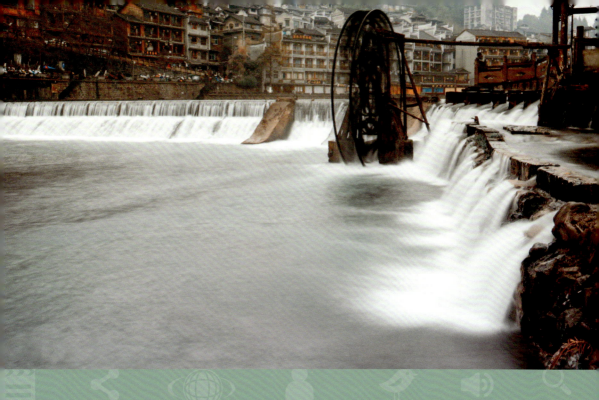

第 14 章

丝绢流水,雾状细腻

学前提示

在慢门摄影题材中,水景一直都是非常吸引人的拍摄场景。在用慢速快门拍摄水景作品时,我们可以看到各种细腻、光滑的丝绢流水,同时获得如仙境般唯美梦幻、虚无缥缈、充满动感的画面效果。那么,要如何才能拍出一幅令人心动的作品呢?本章就和大家分享一些相关技巧,来帮助大家拍出漂亮的慢门流水照片。

14.1 拍摄技巧：将流水拍出拉丝雾状效果

拉丝雾状效果是指在长时间曝光的情况下，水流变成了丝绸状，仿佛云雾一般，如图 14-1 所示。在平常看来，流水总能给我们带来喧嚣的情感，而在慢门摄影的镜头面前，流水却显得特别安静、平稳，在画面中呈现出绢丝流水之景。

图 14-1　拉丝雾状的流水效果

那么，要如何才能将流水拍出拉丝雾状效果呢？这主要依靠慢速快门来实现，能调整曝光时间的相机和手机都可以拍出这种效果。本节主要介绍用手机拍出拉丝雾状水流效果的相关技巧。

14.1.1 技巧 1：在较弱的光线下拍摄

由于慢速快门对于环境光线的要求比较高，如果在白天直接用手机进行慢门拍摄，则得到的将是一片苍白的曝光过度画面，照片中什么也看不到。因此，我们要尽量选择在弱光环境下拍摄。

如图 14-2 所示，这张照片的拍摄时间为晚上八点半左右，此时几乎已经没有任何自然光线，只有对岸的建筑霓虹灯光。在这种弱光环境下，我们可以充分延长曝光时间来拍摄出黏稠状的流水效果，如这张照片的曝光时间就长达 25 秒。

第 14 章　丝绢流水，雾状细腻

图 14-2　在弱光环境下使用慢门拍摄流水

　　如果是在光线充足的白天，如何才能拍出这样梦幻的慢门流水效果呢？大家可能会想到用 ND 滤镜减慢快门速度。ND 滤镜的镜片表面覆盖了一层黑灰色涂层，其作用就是用来减弱光线的，与我们平时带的墨镜一样，能够防止照片由于曝光时间过长而出现过曝的现象。在手机上装上 ND 滤镜后，光线减少了，快门速度自然而然就能降低，非常适合拍摄瀑布、流水等需要在白天拍摄的场景，如图 14-3 所示。

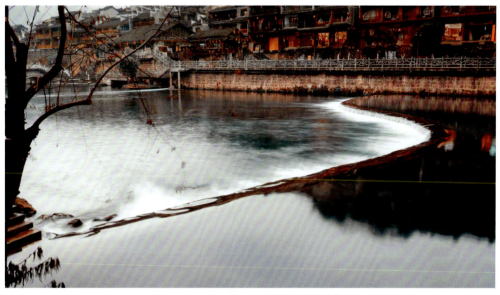

图 14-3　在白天使用 ND 滤镜拍摄流水效果

14.1.2 技巧2：调整快门速度、感光度

要拍出拉丝效果的流水，还需要调整手机相机的快门速度和感光度等参数，通常是使用慢速快门和低ISO参数，这样能够获得更好的画质。

如图14-4所示，这张照片的曝光时间为30秒、ISO为50，在这样的曝光参数搭配下，能够将流动的江水以丝线的状态呈现出来。

图14-4 使用低感光度+慢速快门拍摄的流水效果

如图14-5所示，这张照片的曝光时间为6秒、ISO为200，较低的感光度能够减少长时间曝光所产生的噪点，获得不错的画质效果。

在白天拍摄慢门流水作品时，建议使用1/8～2秒的快门速度，感光度可以调整到最低值，即可得到很好的拉丝水流效果，如图14-6所示。

> **专家提醒**
>
> 本书提供的参数建议仅供参考，用户在实际拍摄时要根据所处的环境和光线，来灵活调整快门速度、感光度和曝光补偿等参数。

第 14 章　丝绢流水，雾状细腻

图 14-5　低感光度拍摄能够提升画质效果

图 14-6　白天拍慢门流水要尽可能地降低 ISO

14.1.3 技巧3：用三脚架和耳机线拍摄

三脚架和耳机线是拍摄慢门水景的必备工具，在拍摄飞溅、雾状、丝状的水流效果时，这些工具特别方便。如图14-7所示，下面这张照片就是笔者使用这两个工具拍摄的，将效果图放大一点，可以明显看到普通的水流出现飞溅的激流效果。

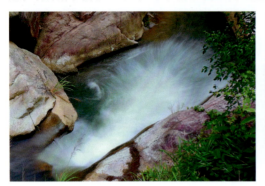 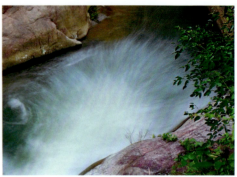

图14-7 使用三脚架和耳机线拍出飞溅的激流效果

我们平常用手机拍照，通常都是直接点击屏幕上的快门按钮，这样拍照的缺点是有时在点击屏幕时会造成屏幕的抖动或晃动。特别是在拍水流、夜景和烟花等慢门作品时，手一抖或屏幕一动，画面就很容易变模糊了。

此时，手机上的小小耳机线，就能起到很大的作用，可以将其作为快门遥控线来使用。在拍摄慢门作品时，不需要再用手去点击快门按钮，只需轻轻按一下耳机线上的控制按钮即可。

用耳机线作为手机拍照遥控快门线，其主要优点如下。

- 轻轻一按，便得一张。
- 多按几次，抓拍多张。
- 手机稳定，画面清晰。
- 遥控操作，轻松便捷。

需要注意的是，在拍慢门作品时，一定要用三脚架或八爪鱼来固定手机，这样使用耳机线作为遥控快门效果会更好。下面以华为手机为例，介绍具体的操作方法。

步骤01 将耳机线插到手机的耳机孔内。

步骤02 在手机上打开相机应用，进入拍照状态。

步骤03 按耳机线上的3个控制按钮中的任意一个：【+】键（增加音量）、【-】键（降低音量）或中间的多功能键，即可拍摄照片，如图14-8所示。

> **专家提醒**
>
> 不同的手机耳机线可能操作方法存在一些细微差别。另外，有些品牌的手机或者耳机线，可能只能用其中一个按键来控制快门，大家可以自行调试。

第 14 章 丝绢流水，雾状细腻

图 14-8 三脚架和耳机线的拍摄应用场景

14.2 拍摄场景：丝绢流水的常用拍摄题材

用手机拍慢门水景，具体可以拍什么？相信很多人都会碰到这个问题。其实，慢门强调的是动态效果，因此要尽量选择流动的水来拍，如海水、江河、瀑布、溪流和喷泉等，这样拍到的慢门流水效果会更加迷人。

14.3.1 场景 1：拍摄海水慢门效果

如果直接使用手机相机的普通拍照模式拍摄大海，画面可能会显得比较脏，灰绿的海水也难以吸引大家的眼球，如图 14-9 所示。

图 14-9 普通拍照模式拍摄的海水效果

如果使用慢门模式拍摄海水，效果就完全不同了，在长时间曝光下海水变成拉丝状，此时画面会显得更加干净，而不是浑浊的效果，如图 14-10 所示。

图 14-10　慢门海水效果

拍摄海水还需要学会选景，例如海岸线边上的礁石就是最佳的拍摄对象，能够与流动的海水形成动静结合的画面，通过对比来突出画面的主题，如图 14-11 所示。

图 14-11　岸边的礁石与流动的海水形成动静对比

另外,拍摄海水还需要善于选择时机,多观察海浪的大小和范围,以及大海上的其他元素,如轮船、海鸟、飞机和人物等。如图 14-12 所示,使用 1/3 秒的快门速度拍摄,不仅能够抓拍到空中飞翔的海鸟剪影,而且也能表现大海的动感。

图 14-12　等待时机抓拍精彩的大海画面

14.3.2　场景 2:拍摄江河慢门效果

在拍摄江河湖泊等类型的慢门流水作品时,要尽可能地避免在强光下拍摄,建议选择清晨、黄昏或夜晚等弱光环境下拍摄,这样能够获得更丰富的光影层次感。

图 14-13 为在白天拍摄的河水效果,曝光时间为 0.77 秒,水面有一些雾化效果,但流动感并不强烈。

图 14-14 为在夜晚用慢门拍摄的流动江水,曝光时间为 20 秒,江水呈现出完全雾化的现象,丝丝入扣,同时桥上的灯光效果也显得更加耀眼。

图 14-13 在白天用慢门拍摄的河水效果

图 14-14 在夜晚用慢门拍摄流动的江水

在碰到有高低落差的河流时,使用慢速快门可以将快速流动的河水拍摄得如丝绢一般唯美柔顺。如图 14-15 所示,河中的水流在长曝光下变成了顺滑的白色丝线。

图 14-15　长曝光拍出顺滑的白色水流丝线

如果远景还不太明显,则可以拉近镜头,拍摄水流的特写画面,即可看到比较明显的丝状效果,如图 14-16 所示。

图 14-16　近景拍摄出更加明显的丝状水流效果

14.3.3 场景3：拍摄瀑布慢门效果

拍摄瀑布这种慢门水景时，我们需要先观察水流的方向，找到合适的取景位置进行构图。同时，拍摄瀑布时一定要使用三脚架，因为瀑布慢门效果的曝光时间通常要超过1/4秒，很难手持拍摄出清晰的画面，而且三脚架还可以增加拍摄时的人身和设备的安全性，如图14-17所示。

竖画幅构图是拍摄瀑布时最常用的构图方式，不仅能够体现出瀑布的高度，而且还可以让画面显得更加紧凑，如图14-18所示。

图14-17　使用三脚架拍摄瀑布

图14-18　竖画幅构图拍摄瀑布

要拍出丝状或絮状效果的瀑布，曝光时间的设置是关键所在。

- 曝光时间在1/15～1秒：瀑布会呈现出丝状效果。图14-19为1/8秒的曝光时间拍摄的瀑布效果。
- 曝光时间在1～5秒：瀑布会呈现出类似棉花的丝絮状过渡效果。图14-20为3秒的曝光时间拍摄的瀑布效果。
- 曝光时间在5秒以上：瀑布呈现出絮状效果，水流会被完全雾化。

第 14 章 丝绢流水,雾状细腻

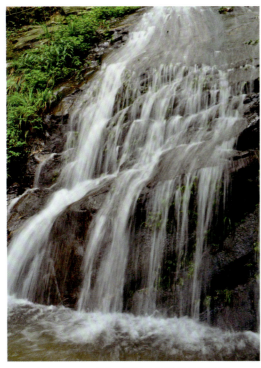
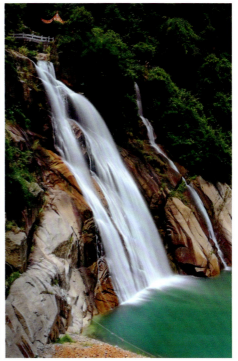

图 14-19 曝光时间为 1/8 秒的拍摄效果　　图 14-20 曝光时间为 3 秒的拍摄效果

14.3.4 场景 4:拍摄溪流慢门效果

使用慢速快门拍摄溪流场景时,可以将水流拍出拉丝般的效果,给观众带来更有冲击力的视觉感受,如图 14-21 所示。

图 14-21 使用慢速快门拍摄溪流效果

用手机拍摄溪流，ND 滤镜是必备的设备，能够让手机获得更长的曝光时间，同时可以将水流柔化，让水有着丝绸般的质感和丰富的颜色层次。如图 14-22 所示，可以看到画面中流动的溪水变成了乳白色的雾化水流效果，而潭中静止的水则显得非常碧绿，形成了明显的颜色和动静对比，将原本稀松平常的场景拍摄出不一样的美感。

图 14-22　拍摄出溪流的动静和颜色对比

另外，我们还可以根据溪流的流动方向来选择合适的构图方式。例如，溪流如果是从左至右横向流动，或者溪流比较宽，则建议使用横画幅构图拍摄，如图 14-23 所示。如果溪流比较窄，或者高低落差比较大，则建议使用竖画幅构图拍摄。

图 14-23　用横画幅拍摄较宽的溪水

在设置快门速度时，我们需要根据溪水的流动速度来进行调整。

- 如果水流速度比较快,则可以适当增加快门速度,通常为 1/20 ~ 2 秒,如图 14-24 所示。

图 14-24　曝光时间为 0.62 秒的溪流效果

- 如果水流速度比较慢,则可以适当降低快门速度,延长曝光时间,拍出溪水的流动感,如图 14-25 所示。

图 14-25　曝光时间为 3 秒的溪流效果

14.3.5 场景 5：拍摄喷泉慢门效果

在手机相机的默认拍照模式下，拍摄喷泉水滴和整个水面，水流的效果都是颗粒状的，如图 14-26 所示。

图 14-26　默认拍照模式拍摄的喷泉效果

如果采用慢门长曝光拍摄，则可以将喷泉拍摄出细腻、雾化的丝状效果，即丝绢流水效果。图 14-27 为使用华为手机的"丝绢流水"模式，在同一个场景拍摄的小喷泉和湖面的原片效果，曝光时间为 2.7 秒，水面开始呈现细腻雾状效果。

 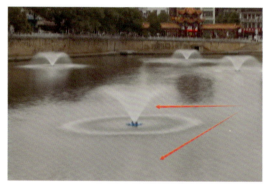

图 14-27　2.7 秒曝光时间拍摄的喷泉效果

如图 14-28 所示，曝光时间为 11.7 秒，水面的细腻雾状效果更加明显。

 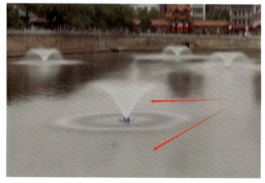

图 14-28　11.7 秒曝光时间拍摄的喷泉效果

如图 14-29 所示，曝光时间为 19 秒，能够将喷泉和水面拍摄出"丝绢状"的模糊虚化效果。

 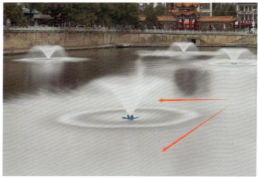

图 14-29　19 秒曝光时间拍摄的喷泉效果

通过前面的对比可以发现：曝光时间越长，水面的丝状效果越细腻、明显。华为手机的"丝绢流水"模式可以边拍摄边观看效果，觉得水面的拉丝效果满意后，停止拍摄即可。笔者后面又随机拍摄了两张，曝光时间分别为 15 秒和 24 秒，如图 14-30 所示。

图 14-30　曝光时间分别为 15 秒（左图）和 24 秒（右图）的拍摄效果

不过由于白天的天气比较阴沉，画面的色彩不够好，因此笔者决定晚上再来拍摄夜景，尝试使用更长的曝光时间。如图 14-31 所示为使用"慢速快门＋全景拼接"的方式拍摄的一组夜景喷泉效果图。该组全景图都是使用 4～5 张照片拼接而成的，原图的感光度为 64、曝光时间为 5 秒，喷泉的水丝效果非常细腻，如图 14-32 所示。同时，在拍摄全景接片时，注意每张照片一定要有 30%～50% 的重叠画面，这样后期更容易实现无缝拼接。

手机慢门摄影与后期从入门到精通：夜景、人像、车轨、烟花、星空、光绘、丝绢流水、延时视频全攻略

图 14-31 夜景喷泉效果图

第 14 章 丝绢流水,雾状细腻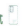

图 14-32 原图效果

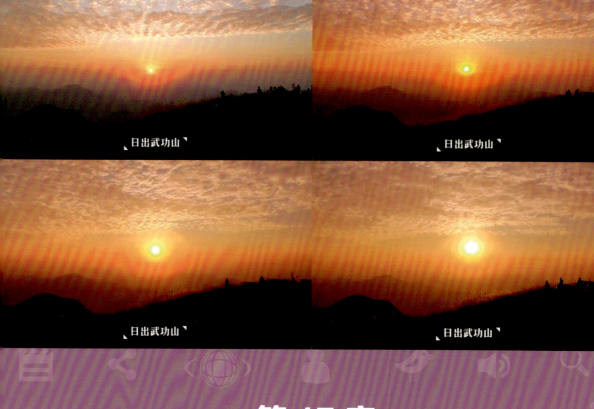

日出武功山

第 15 章

延时视频，压缩时间

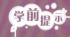

　　我们不仅可以使用单反相机拍出美丽的延时作品，而且可以使用随身携带的手机拍出精彩的延时大片。现在，很多手机都有延时摄影模式，只需要打开这个功能，即可开始拍摄延时作品，而且无须手动设置曝光参数，手机会自动进行参数调整。本章主要介绍使用手机拍摄与制作延时视频的方法。

15.1 准备工作：手机拍摄延时视频的要点

用手机拍摄延时视频不仅方便，操作也很简单，没有复杂的后期处理流程，基本上一个手机就可以完成前期拍摄与后期处理的工作。使用手机拍摄延时视频之前，先要了解一些手机拍摄延时视频的相关要点。

15.1.1 要点1：保证手机的电量充足

在拍摄延时视频之前，我们首先需要保证手机的电量充足，因为延时摄影的拍摄时间会比较长，基本在30分钟以上，如果拍到一半就突然关机了，那前面的视频都白拍了，手机不会自动保存。

特别是在温度较低的环境下，手机的放电速度也会更快一点。所以，在拍摄延时视频之前，一定要检查手机的电量。另外，用户也可以在手机上接一个充电宝，一边充电，一边拍摄延时视频。

15.1.2 要点2：将手机固定在三脚架上

如果要把手机固定在某个位置拍延时视频，就需要三脚架或者八爪鱼来稳定画面。在三脚架的顶端会有一个专门用来夹住手机的支架，可以将手机架起来，实现长时间的拍摄，如图15-1所示。

图 15-1 将手机固定在三脚架上

15.1.3 要点3：将手机设置为飞行模式

为了防止在拍摄过程中手机受到来电或短信的干扰，建议将手机设置为飞行模式。以安卓手机为例，在通知栏中点击"飞行模式"按钮，即可开启该功能，如图15-2所示。开启"飞行模式"功能后，会自动断开所有的网络连接，不用担心视频被微信或其他通知消息打断，等视频拍摄完成后，再关闭"飞行模式"功能即可。

图 15-2　开启"飞行模式"功能

15.2　实战拍摄：手机拍摄延时视频的两种方法

手机有两种方法可以拍出延时视频效果，一种是使用"延时摄影"模式直接拍摄，一次性得到成品效果；另一种是拍摄平常的普通视频，通过后期加速得到延时效果。下面针对这两种方法向大家进行相关介绍。

15.2.1 直接拍摄：一次得到延时视频成品

下面以360手机为例，介绍使用手机自带的"延时摄影"功能拍摄延时视频的操作方法，具体步骤如下。

步骤 01 架稳三脚架，将手机固定在三脚架上，打开手机相机应用，进入"拍照"界面，设置好构图，如图15-3所示。

步骤 02 点击右下角的"更多模式"按钮■进入其界面，点击"延时摄影"按钮，如图15-4所示。

第 15 章 延时视频，压缩时间

图 15-3 进入"拍照"界面

图 15-4 点击"延时摄影"按钮

步骤 03 执行操作后，进入"延时摄影"录像界面，点击"录制"按钮■，如图 15-5 所示。

图 15-5 点击"录制"按钮

步骤 04 执行操作后，即可开始拍摄延时视频，界面上方显示了拍摄的时间，如图 15-6 所示。

步骤 05 待延时视频拍摄完成后，点击"停止录制"按钮■，即可停止拍摄，在手机图库中找到刚才拍摄的那段延时视频，播放预览其效果，如图 15-7 所示。

229

图 15-6 开始拍摄延时视频

图 15-7 预览拍摄的延时视频效果

15.2.2 后期变速：普通视频进行加速处理

用户可以先用手机的"录像"功能拍摄一段普通视频，然后使用剪映 App 进行后期加速处理，来制作延时视频。下面介绍后期变速处理的具体操作方法。

步骤 01 打开剪映 App，点击"开始创作"按钮，如图 15-8 所示。

步骤 02 进入"照片视频"界面，选择需要变速的视频文件，如图 15-9 所示。

步骤 03 点击"添加"按钮，即可将视频导入视频轨道中，❶选择视频轨道中的视频素材；❷点击"变速"按钮，如图 15-10 所示。

第 15 章 延时视频，压缩时间

步骤 04 弹出相应功能按钮，点击"常规变速"按钮，如图 15-11 所示。

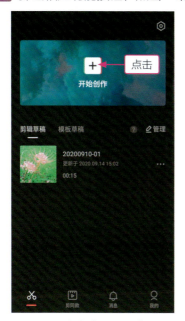

图 15-8 点击"开始创作"按钮　　图 15-9 选择视频文件

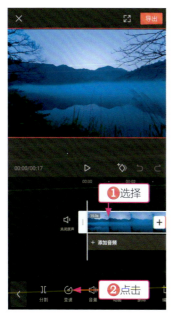

图 15-10 点击"变速"按钮　　图 15-11 点击"常规变速"按钮

步骤 05 弹出变速控制条，默认情况下是 1x，如图 15-12 所示。

步骤 06 ❶向右拖曳红色圆环滑块，设置变速参数为 2x，进行两倍加速处理；❷点击右下角的 ✓ 按钮，确认操作，如图 15-13 所示。

步骤 07 此时，17 秒的视频被加速压缩成 9 秒，导出视频并播放，效果如图 15-14 所

示。这就是将普通视频进行加速处理变成延时视频的操作方法。

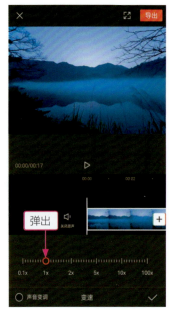

图 15-12 默认情况下是 1x

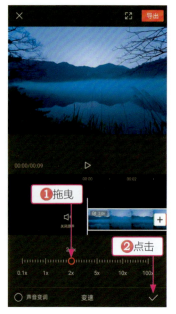

图 15-13 设置变速参数

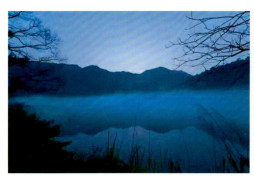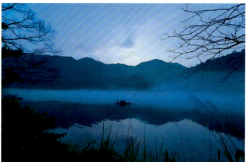

图 15-14 预览制作的延时视频效果

15.3 后期处理：使用剪映App编辑视频

本节以剪映 App 为例，讲解使用手机剪辑与处理延时视频的操作方法，包括导入、剪辑、降噪、加速、调色以及添加字幕和音频的具体操作方法。

15.3.1 导入：添加多段需要处理的视频

处理视频之前，首先需要将视频导入到剪映 App 中，下面介绍导入的方法。

步骤 01 打开剪映 App，点击"开始创作"按钮，进入"照片视频"界面，根据视频的时间顺序选择需要导入的多个素材文件，如图 15-15 所示。

步骤 02 点击"添加"按钮，即可将视频素材导入视频轨道中，同时视频的排列顺序与

添加视频时的选择顺序保持一致，如图 15-16 所示。

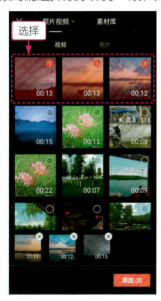

图 15-15　选择视频文件

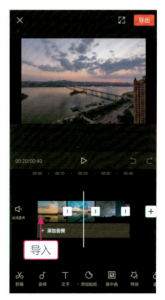

图 15-16　将视频导入视频轨道

15.3.2　剪辑：删除视频中不需要的部分

剪辑视频是指将一段延时视频剪辑成多段，然后将不需要的片段进行删除操作。下面介绍剪辑视频中不需要的部分的方法。

步骤 01　选择第 1 段视频文件，将时间轴拖曳至 5 秒的位置处，如图 15-17 所示。

步骤 02　点击"分割"按钮，即可将视频分割为两段，如图 15-18 所示。

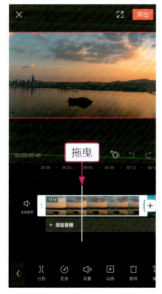

图 15-17　将时间线移至 5 秒的位置

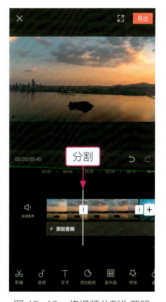

图 15-18　将视频分割为两段

步骤 03 ❶选择分割后的第一段视频；❷点击"删除"按钮，如图 15-19 所示。
步骤 04 执行操作后，即可删除不需要的视频文件，如图 15-20 所示。

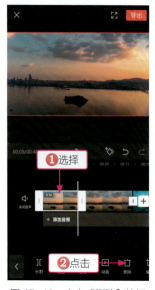

图 15-19 点击"删除"按钮

图 15-20 删除不需要的视频文件

15.3.3 降噪：一键消除延时视频的噪声

在拍摄视频素材时，视频中可能会录进去一些噪声，使用剪映 App 即可为视频进行降噪处理，下面介绍具体方法。

步骤 01 ❶选择第 2 段视频文件；❷点击"降噪"按钮，如图 15-21 所示。
步骤 02 进入"降噪"界面，点击"降噪开关"按钮，如图 15-22 所示。

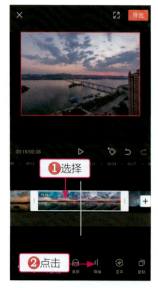

图 15-21 点击"降噪"按钮

图 15-22 点击"降噪开关"按钮

步骤 03 执行操作后，显示降噪处理的进度，如图 15-23 所示。

步骤 04 处理完成后，即可打开"降噪开关"功能，并自动播放视频，预览降噪效果，如图 15-24 所示。

图 15-23　显示降噪处理的进度

图 15-24　打开"降噪开关"功能

15.3.4　变速：对视频画面进行加速处理

延时视频通常都是快速播放的，因此需要对其进行变速处理，使正常播放速度的视频进行快动作播放，压缩视频的时长。

步骤 01 ❶选择第 3 段视频文件；❷点击"变速"按钮，如图 15-25 所示。

步骤 02 弹出相应功能按钮，点击"常规变速"按钮，如图 15-26 所示。

图 15-25　点击"变速"按钮

图 15-26　点击"常规变速"按钮

步骤 03 向右拖曳红色圆环滑块,设置变速参数为3x,如图15-27所示。

步骤 04 点击✓按钮确认操作,返回相应界面,其中显示了变速后的视频片段时长为4.4秒,如图15-28所示。完成视频的变速处理,使视频的播放速度更快。

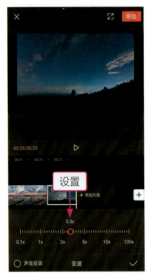

图 15-27 进行3倍变速

图 15-28 调整视频时长

15.3.5 调色:调整延时视频的色彩影调

我们用手机录制视频画面后,如果画面的色彩没有达到我们的要求,此时可以通过剪映 App 中的调色功能对视频画面的色彩进行调整。

步骤 01 ❶选择第2段视频文件;❷点击"调节"按钮,如图15-29所示。

步骤 02 进入"调节"界面,设置"饱和度"为18,加强画面色彩,如图15-30所示。

图 15-29 点击"调节"按钮

图 15-30 设置"饱和度"参数

步骤 03 设置"色温"为 9，增加暖色调氛围，如图 15-31 所示。
步骤 04 设置"色调"为 16，调整画面色调，如图 15-32 所示。

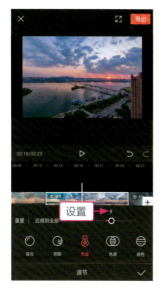

图 15-31 设置"色温"参数

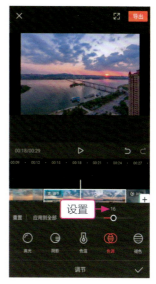

图 15-32 设置"色调"参数

15.3.6 输出：给视频添加字幕和音乐效果

在延时视频中添加各种字幕和背景音乐效果，不仅能够让观众看到、看懂更多视频内容，同时还可以让延时视频呈现出影视大片般的观赏效果。

步骤 01 将时间轴移至视频的开始位置处，点击"文字"按钮，如图 15-33 所示。
步骤 02 进入文字编辑界面，点击"新建文本"按钮，如图 15-34 所示。

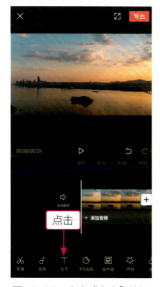

图 15-33 点击"文字"按钮

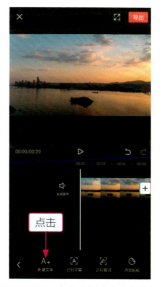

图 15-34 点击"新建文本"按钮

步骤 03 在文本框中输入符合延时视频主题的文字内容，如图 15-35 所示。

步骤 04 点击 ✓ 按钮确认输入，即可添加文本轨道，在预览区域中按住文字素材并拖曳，即可调整文字的位置，如图 15-36 所示。

图 15-35　输入文字

图 15-36　调整文字的位置

步骤 05 在时间线区域中拖曳文本轨道两侧的白色拉杆，即可调整文字的出现时间和持续时长，如图 15-37 所示。

步骤 06 点击文字右上角的 ✏ 按钮，进入"样式"界面，选择相应的字体，如"宋体"，效果如图 15-38 所示。

图 15-37　调整文字轨道

图 15-38　更改字体效果

步骤 07 切换至"花字"选项卡，在其中选择一个合适的"花字"样式效果，如

图 15-39 所示。

步骤 08 切换至"动画"选项卡，❶在"入场动画"选项区中选择"音符弹跳"动画效果；❷拖曳绿色的右箭头滑块，适当调整动画持续时间，如图 15-40 所示。

图 15-39 选择"花字"样式效果

图 15-40 设置"入场动画"选项

步骤 09 点击 ✓ 按钮确认添加文字，将时间轴移至视频的开始位置处，点击"添加音频"按钮，如图 15-41 所示。

步骤 10 进入音频编辑界面，点击"音乐"按钮，如图 15-42 所示。

图 15-41 点击"添加音频"按钮

图 15-42 点击"音乐"按钮

步骤 11 进入"添加音乐"界面，❶切换至"抖音收藏"选项卡；❷在下方的列表框中选择相应的音频素材；❸点击"使用"按钮，如图 15-43 所示。

步骤 12 执行操作后，❶即可添加相应的背景音乐；❷点击"关闭原声"按钮，将视频轨道的原声全部关闭，如图15-44所示。

图 15-43 选择收藏的音乐

图 15-44 添加背景音乐并关闭原声

步骤 13 点击"导出"按钮导出视频，预览延时视频效果，如图15-45所示。

图 15-45 预览延时视频效果